POUSSIN

WORKS ON PAPER

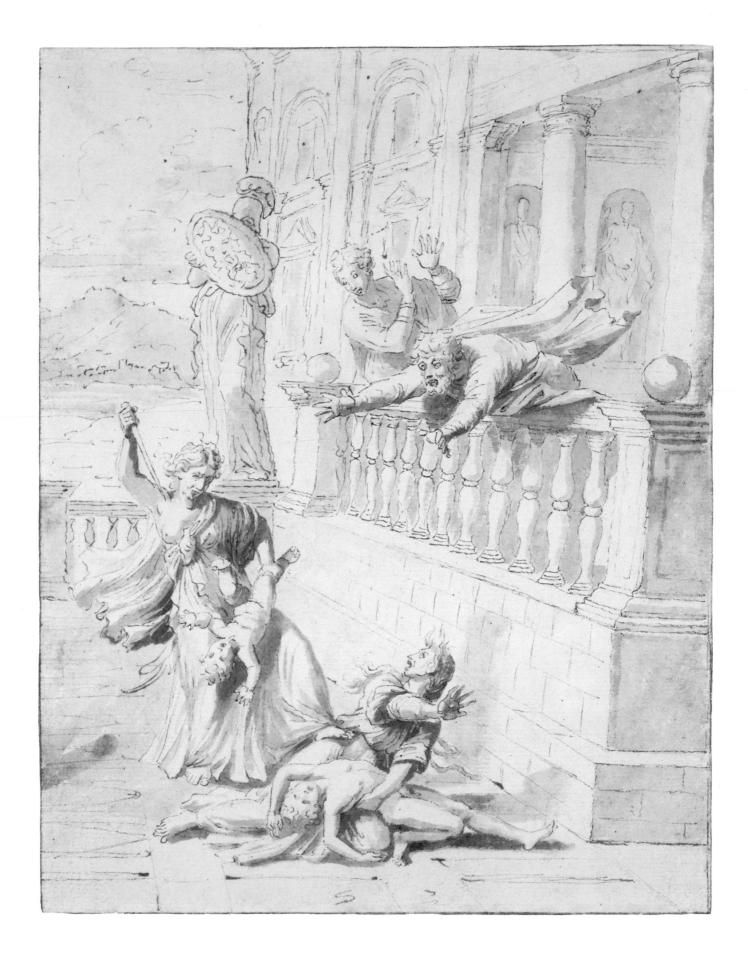

POUSSIN

WORKS ON PAPER

DRAWINGS FROM THE COLLECTION OF

HER MAJESTY QUEEN ELIZABETH II

MARTIN CLAYTON

Thames and Hudson

Published on the occasion of the exhibition
Poussin: Works on Paper. Drawings from the Collection of Her Majesty Queen Elizabeth II
organized by the Royal Library at Windsor Castle in conjunction with the Museum of Fine Arts, Houston
Dulwich Picture Gallery, London
February 16-April 30, 1995
The Museum of Fine Arts, Houston
August 27-November 12, 1995
The Cleveland Museum of Art
November 22, 1995-January 24, 1996
The Metropolitan Museum of Art, New York
February 6-March 31, 1996

LCC 94-61097
ISBN 0-500-23700-X

First published in the United States of America in 1995 by
Thames and Hudson Inc.,
500 Fifth Avenue, New York, New York 10110

Published by arrangement with Merrell Holberton Publishers Ltd., London
Designed by Roger Davies
Printed and bound by Graphiche Milani, Italy

Half title: cat. 30, study for the *Rape of the Sabine women*
Frontispiece: cat. 62, *Medea killing her children*

Photographic Acknowledgements

Bayonne, Musée Bonnat: figs. 33, 45, 60; Belvoir Castle, Leicestershire/Bridgeman Art Library, London: 41, 44; Budapest, Szépmüvészeti Muzeum: 1; Cambridge, England, Reproduction by permission of the Syndics of the Fitzwilliam Museum: 7; Cambridge, USA, Courtesy of the Fogg Art Museum, Harvard University Art Museums, The Melvin R. Seiden Fund and Louise Haskell Daly Fund: 39; Chantilly, Musée Condé/Photographie Giraudon: 18, 35, 49; Dresden, Staatliche Kunstsammlungen: 14; Edinburgh, National Gallery of Scotland: 54, 56; Kansas City, Missouri, The Nelson-Atkins Museum of Art (Purchase: Nelson Trust): 29, 31; Karlsruhe, Staatliche Kunsthalle: 42; London, Courtauld Institute of Art: 5; London, Dulwich Picture Gallery: 20; London, National Gallery: 21, 23, 25, 32, 36; London, Trustees of the British Museum: 38, 63; London, Warburg Institute: 2, 4, 8, 61; Madrid, Museo del Prado: 16; Malibu, California, Collection of the J. Paul Getty Museum: 22; Moscow, Pushkin State Museum of Fine Arts: 6, 10; Munich, Bayerische Staatsgemäldesammlungen: 11, 13; New York, Copyright © 1980 By The Metropolitan Museum of Art: 24; New York, The Pierpont Morgan Library: 55; Orléans, Musée des Beaux-Arts/Photographie Giraudon: 48; Oxford, Ashmolean Museum: 19; Paris, Ecole Nationale Supérieure des Beaux-Arts: 47; Paris, Musée du Louvre/Photographie Giraudon: 40, 51, 52, 53; Paris, Musée du Louvre/Réunion des musées nationaux: 28, 37, 48, 59; Providence, Museum of Art, Rhode Island School of Design, Anonymous Gift: 43; Rouen, Musée des Beaux-Arts: 3; The Fine Arts Museums of San Francisco, Roscoe and Margaret Oakes Collection, 52.30: 34; The Fine Arts Museums of San Francisco, Gift of the Samuel H. Kress Foundation, 61.44.30: 17; Stuttgart, Staatsgalerie: 9; Vienna, Albertina: 30

Contents

Acknowledgments

This exhibition and the accompanying catalogue are devoted to the extraordinary draftsmanship of Nicolas Poussin, who is recognized as one of the most important artists of the seventeenth century. Sixty-five of Poussin's finest sheets, selected entirely from the collection of the Royal Library, Windsor Castle, trace the artist's development throughout his exceptional career.

Along with the Louvre in Paris and the Hermitage in St Petersburg, the Royal Collection possesses one of the largest and most distinguished groups of drawings by this master of classicizing painting. Its holdings include the most important body of work that has survived from Poussin's formative years in Paris, the mythological drawings of 1622-23, executed for the poet Giovanni Battista Marino. It also includes sheets of the highest quality from the early and late Roman periods, as well as from the second Paris interlude.

The exhibition and catalogue will present information never before available to art historians. Nearly all the drawings have been lifted from their old mounts in the course of restoration, revealing watermarks and previously hidden drawings – including the first drawing certainly by Poussin from the nude model to be identified.

With our colleagues at the Dulwich Picture Gallery, the Cleveland Museum of Art, and the Metropolitan Museum of Art, we are greatly indebted to Her Majesty Queen Elizabeth II for her willingness to share these magnificent drawings.

The sheets for this exhibition have been selected by Martin Clayton, Assistant Curator of the Print Room, Windsor Castle. We are grateful to him and to his colleagues at Windsor, Oliver Everett, Librarian, Jane Roberts, Curator of the Print Room, and Theresa-Mary Morton, Curator of Exhibitions, for their friendly cooperation and efficient organization.

The catalogue was written by Martin Clayton, combining general findings published in conjunction with Poussin's four-hundredth anniversary exhibition at the Louvre with first-hand evidence from the newly lifted sheets, thus updating Anthony Blunt's catalogue of the French drawings at Windsor Castle, fifty years after its publication.

Barry Walker, Curator of Prints and Drawings, coordinated the American organization of the exhibition for the Museum of Fine Arts, Houston. The exhibition has been funded in part by the National Endowment for the Arts, a federal agency, and by the Scaler Foundation Inc.

PETER C. MARZIO
Director, The Museum of Fine Arts, Houston

ROBERT P. BERGMAN
Director, The Cleveland Museum of Art

PHILIPPE DE MONTEBELLO
Director, The Metropolitan Museum of Art, New York

GILES WATERFIELD
Director, The Dulwich Picture Gallery, London

Foreword to the Catalogue

The Royal Collection of over 30,000 Old Master drawings and watercolours is held in the Royal Library at Windsor Castle. These have been collected by successive Kings, Queens and Princes over several centuries. Italian Old Master drawings are particularly well represented and among Royal Collectors, King George III was pre-eminent.

Within the collection is an important group of drawings by Nicolas Poussin, who, although born in France, adopted Rome as his home in 1624 and lived there for most of the time until his death in 1665.

The holding of about eighty drawings by Poussin in the Royal Library is one of its greatest treasures, covering the complete range of Poussin's work, throughout his career. Most of the drawings entered the Royal Collection in the latter part of the eighteenth century.

This will be the first time that an exhibition from the Royal Library devoted entirely to Poussin's work has ever been shown. It is very fitting that this will take place so close to the four-hundredth anniversary of his birth (1594). It is also fifty years after the publication of Anthony Blunt's original catalogue raisonné of the French drawings at Windsor.

In the intervening fifty years, much international research into the work of Poussin has taken place. The results of this are, where relevant, included in the present exhibition catalogue. It also includes a great deal of original research by its author, Martin Clayton, Assistant Curator in the Print Room of the Royal Library at Windsor Castle, who is to be congratulated on his admirable work.

In addition, an extensive programme of conservation has been carried out on the drawings in the Paper Conservation Studio in the Royal Library. This has resulted in nearly all the drawings included in the exhibition being lifted from their old backing sheets. In several cases this has led to the discovery of hitherto unknown drawings.

The Royal Library has very much appreciated the close co-operation and support it has received both in the preparation of the exhibition and in the publication of the catalogue. In this respect we are particularly grateful to Dr Peter Marzio and the staff of the Museum of Fine Arts, Houston, and also to our colleagues at the Metropolitan Museum, New York, the Cleveland Museum of Art and the Dulwich Picture Gallery.

OLIVER EVERETT
Librarian, Royal Library, Windsor Castle

Author's note

Shortly before this catalogue went to press, the first of the flood of publications marking Poussin's four-hundredth anniversary began to appear, of which by far the most important for the study of Poussin's drawings will be Pierre Rosenberg's and Louis-Antoine Prat's new catalogue raisonné, superseding the hitherto invaluable corpus published over a span of thirty-five years by Walter Friedlaender and Anthony Blunt. With the kind cooperation of the authors, I have been able to include here references to the catalogue numbers in the new catalogue raisonné; but unfortunately I have only had the opportunity to study the text for the draw-

ings rejected by M. Rosenberg and M. Prat, and the present catalogue entries therefore take no account of the arguments presented for the drawings they accept.

I wish to thank for their help Sir Denis Mahon, Elizabeth McGrath, Josette Meyssard, Louis-Antoine Prat, Pierre Rosenberg, Timothy Standring, Sylvia Stevenson, Jacques Thuillier, Humphrey Wine, and all my colleagues at Windsor. But above all I am deeply grateful to Ursula Sdunnus, whose advice, erudition and encouragement throughout my work on this catalogue have been truly invaluable.

MARTIN CLAYTON

Introduction

Poussin was not a naturally gifted draftsman. This simple fact accounts for many of the unusual features of his surviving drawings, for it affected not only their physical appearance – their spontaneity and beauty (or lack of it) – but also his working methods and thus the type of drawings that he produced.

Most artists of his time worked out their designs with pen or chalk in hand, responding to and modifying the patterns as they took shape on the paper. There is rarely such a sense of exploration and improvisation in Poussin's œuvre; it often appears that the layout of each drawing was almost fully formed in his head before he committed it to paper, and a high proportion of Poussin's surviving preparatory drawings are therefore of complete compositions rather than of single figures or groups. Furthermore, the degree of finish of a drawing cannot be taken as indicative of the composition's stage of development. Some rough sketches are very close to the final design, such as those for the *Marriage of the Virgin* (cat. 48) or *Time saving Truth* (cat. 75 verso), whereas other quite carefully finished sheets are a long way from the composition as painted, such as *Hercules and Deianeira* (cat. 44) and *Christ healing the blind* (cat. 63).

There is thus little sense of a gradual refinement of detail in Poussin's preparatory works. He would repeatedly draw his compositions on the same scale with the elements shuffled around, homing in on a solution to the pictorial problem. His early biographers testify to his use of small wax models in developing these compositions, and although the preparation of individual wax figures for study was not uncommon in artists' studios, Poussin's deployment of the equivalent of a puppet theater, with interchangeable backdrops and controlable lighting, was most unusual.

There is evidence of this use of manikins from early in his career. The figure of Adonis in the drawing of the *Realm of Flora* (cat. 20) recurs in the painting (fig. 14) in exactly the same pose but turned through an angle of about a hundred and twenty degrees; one of the women in the *Dance before a herm* is seen from the back in the drawing (cat. 25) and from the front in the painting (fig. 21). In each of these cases the painting dates from some time after the drawing, suggesting that the wax was not remodeled after use but kept for future reference. The strongly plastic studies of complex groups for the *Rape of the Sabine women* (cats. 29 and 30) must also be drawn from such models. But the best example we have is the series of studies for the painting of *Confirmation* from the second set of Sacraments (cats. 56 and 57, and figs. 51–53), where we can follow Poussin's movement of the models from sheet to sheet.

Once the design crystallized, Poussin apparently proceeded very quickly to the painting, and such relatively small drawings as that for *Confirmation* (cat. 57) are, as far as we know, the final stages of preparation for the paintings. The rigor of these drawings gives them an air of finely balanced perfection, as if any variation from the design would be detrimental (but this dryness of handling led Blunt, in 1945, to reject from Poussin's œuvre a number of the more finished sheets from the 1640s, describing them instead as studio variants or copies). Many of these sheets are lightly squared in chalk, for scaling up and transfering the design accurately to the canvas (cats. 54, 55, 57, 58), and very few of the later paintings have any major pentimenti.

It is worth comparing Poussin's methods with those of his contemporaries, particularly in Italy where he spent most of his career. Nearly all artists worked in studios with a number of assistants, who participated in the execution of the paintings. This necessitated the adoption of a mechanical working method (without using the term pejoratively), whereby compositions were rapidly and efficiently formulated. Rough first sketches of the broad outlines were followed by larger and more detailed studies. Once the disposition of the figures had been established, they were studied individually from the posed model, often first in the nude to capture the articulation of the

body, then clothed, followed by detailed drawings of the heads and hands. The separate studies were usually integrated by the preparation of full-size paper "cartoons" to transfer the design to the painting surface.

Poussin was temperamentally unsuited to such an arrangement, and he had a workshop in this sense only during his unhappy spell in Paris from 1640 to 1642, when the number and scale of his commissions demanded some practical help. Not that he was averse to the use of mechanical techniques when working alone in Rome: as mentioned above, he often used a squared grid to scale up his designs; although he did not habitually make full-size cartoons, he would use this transfer method when the need arose (see cat. 23), and occasionally he would make partial tracings from his drawings, to leave some elements unchanged while altering others (cats. 41, 46–47).

A gaping hole in our knowledge of Poussin's drawings until now has been the absence of any certainly autograph studies from the nude model. His biographers state that early in his career he drew from the life in the studios of Domenichino and Andrea Sacchi, and a couple of drawings from the nude have recently been proposed as early works by Poussin, though their acceptance is very much a matter of faith. Certainly, the freshness of Poussin's handling of flesh in his early mythological pieces must indicate study from the nude model, but we have little idea of the appearance of these studies. However, recent conservation work in the Royal Library at Windsor Castle has uncovered a drawing from the nude model, preparatory for the painting of *Christ healing the blind* of 1650, on the back of a certainly autograph sheet that was formerly laid down on its old mount (cat. 64). The knowledge of this drawing led to the attribution to Poussin of another page of life studies in the British Museum in London (fig. 63), apparently by the same hand and, remarkably, preparatory for the same painting. These two sheets show that Poussin still drew from the nude model late in his career; and from this evidence he not only made studies from the life once the pose had been more or less determined by compositional drawings, in the manner of his Italian peers, but he also used the model to study the spatial problems of complex poses while devising the composition.

These life studies are in black chalk, a medium for which Poussin seems to have had little affinity. He often used black or red chalk, or graphite, for the underdrawing of his compositional studies, but the few drawings executed exclusively in chalk (many of which have recently been rejected from his œuvre by some scholars - see cats. 26 and 65) show no great feel for the qualities peculiar to the medium. Poussin's favored technique was pen and ink for the outlines of the figures, with a brown wash, usually bister, to model and shade. A few drawings from the 1620s are in pen only, heavily hatched (cat. 18), and a number of compositional drawings of the later 1640s are executed in broad brush strokes over a light underdrawing, without any use of the pen. For most of Poussin's career, with the exception of a short period in the mid-late 1630s (see the introduction to Section Two), subject, style and choice of media in Poussin's drawings were remarkably independent; matters of stylistic appropriateness could be dealt with while painting, but at the preparatory stage the pursuit of a felicitous composition to convey the full significance of the subject was of most importance.

Indeed certain themes seem to have exercised a fascination over Poussin, and he would often return to a subject after several years, investing it with his developed sense of narrative. In certain cases this was obviously at the request of a patron, and where the versions were separated by only a few years the composition would change little (for instance the two paintings of the *Infant Moses trampling Pharaoh's crown* – see cat. 55). But often Poussin worked on drawings of compositions that cannot be associated with paintings. While it must be the case that many of these drawings are simply stud-

ies for lost and undocumented works, his biographer Bellori stated that he would often make drawings of the subject of Moses striking the rock, to study the expression of human emotions (see cat. 59). This should caution against assuming that a drawing of the same subject as a surviving painting, even with a superficially similar composition, is in every case preparatory for that painting; where stylistic considerations argue against the drawing and painting being of the same date, we must consider the possibility that Poussin was returning to a subject that had previously intrigued him (see cats. 27 and 40). Further, a number of carefully cogitated drawings – especially from later in his career – may well have been made by Poussin independently of any commission; this might explain such elaborate sheets as the *Body of Darius returned to his mother* (cat. 53), *Medea killing her children* (cat. 62) and the *Sacrifice of Polyxena* (cat. 64).

I have not discussed above two other important categories of Poussin's drawings, his copies after the antique and his landscape studies. The former is poorly represented at Windsor: only two sheets are by his hand, and only one of these (cat. 69) is of the type of personal note for future reference that is found most commonly in other collections. The question of Poussin's landscape drawings remains controversial: a number of drawings in heavy wash only that have been attributed to him sit uncomfortably alongside the delicacy of sheets such as *St Mary of Egypt and St Zosimus* (cat. 32), and it may be significant that there is not one such drawing at Windsor, a collection with a provenance going back to Poussin's lifetime.

Provenance

The bulk of the Poussin drawings at Windsor entered the Royal Collection mounted on the pages of two volumes, most of the contents of which were listed in an inventory of the Collection compiled around 1800 ("Inventory A"). The first of these volumes, containing sixty-six drawings, was assembled by Cardinal Camillo Massimi (1620–1677) who became one of Poussin's most important patrons later in his career. Massimi died with large debts which his heirs liquidated by selling his collection, but we now know from documents recently discovered by Timothy Standring that the Poussin volume was not sold until 1739, when it was bought for 300 *scudi* by a certain "Enrico Mead". No Henry Mead is known, and this entry in a ledger must have been a mistake for Richard Mead (1673–1754), physician to King George II and a great collector of works of art. Mead is said to have sold items to Frederick, Prince of Wales, and George Vertue saw the Poussin album in the prince's collection, probably in 1750. When Frederick died in 1751 his drawings passed to his son, the future George III.

This volume was accompanied by a small bound catalogue giving a paragraph-long explanation of the subject of each drawing, compiled sometime between 1677 and 1700 by a Giovanni Battista Marinella. The catalogue survives in the Royal Library, and Marinella's titles are quoted in the catalogue entries below (see Blunt 1945, pp.32f; Blunt 1976; F.A.Q.R. i, ii; Friedlaender 1929).

Fifty-six of the sixty-six drawings from the Massimi album are catalogued here as autograph. According to the inscription below a (disputed) self-portrait drawing by Poussin in the British Museum, Massimi took drawing lessons from the artist as a youth, presumably in the later 1630s, and we know that the two collaborated on designs for engravings shortly before 1640 (see cats. 75–77). As most of the Massimi drawings date from before 1640, with a concentration of them from the years after 1635, it is likely that Poussin gave many of these earlier drawings to his pupil at this time; the handful of copies in the volume, and those drawings dating from the 1640s or even as late as 1650 (cats. 61, 64, C12), were probably obtained by Massimi from other sources.

The second volume listed in Inventory A (henceforth referred to as "Vol. II") was almost certainly that noted in the library of Cardinal Alessandro Albani by Johann Joachim Winckelmann in 1759. Albani's huge collection of drawings and prints was bought in 1762 by the architect James Adam on behalf of George III; among the volumes shipped to London the following year were many assembled as a "Paper Museum" by the remarkably encyclopedic collector Cassiano dal Pozzo (1583–1657), one of Poussin's closest friends and most important patrons. Vol. II was organized thematically – Old Testament, New Testament, ancient history, mythology, though with some inconsistencies – in a manner similar to Cassiano's Paper Museum volumes, and contained two antiquarian drawings (cats. 72 and 78) that bear inscribed numbers of a type found on most of the drawings in the Paper Museum (see Blunt 1945, p.33; F.A.Q.R. iii; Friedlaender 1929).

It is therefore very likely that the majority of the drawings in Vol. II were assembled by Cassiano, but how he came by them is uncertain. Although Cassiano was one of Poussin's first Roman patrons, the earliest autograph sheet from Vol. II (cat. 22) dates from around 1630, and thus he was not collecting Poussin's sketches from the beginning (but see cat. 20); likewise there is no preponderance of drawings preparatory for the many paintings commissioned by Cassiano, or by his family or his employer, Cardinal Francesco Barberini. A number of sheets (cats. 50, 52, A1, A3–A10) date from Poussin's interlude in Paris, and we know from surviving letters that he was sending drawings back to Cassiano in Rome (see cat. 52). It is also probable that he came by sheets connected with Poussin in the normal course of his collecting activities.

On Cassiano's death his collection passed to his brother Carlo Antonio, who reorganized many of the volumes and may have added some extraneous drawings to the Poussin album. Of the forty-two listed in Inventory A, only sixteen are catalogued here as autograph and nine as studio; the remainder are a mixture of drawings by artists in Poussin's circle in Rome, copies of drawings by Poussin, and a few sheets unconnected with the artist. Cassiano's volumes later passed through the hands of Carlo Antonio's son and grandson into the ownership of Pope Clement IX in 1703, and thence to the pope's nephew Alessandro Albani in 1714.

A couple of other albums recorded in Inventory A were thought to contain drawings by Poussin. Of these the most notable, here referred to as Vol. III, was entitled *Poussin, Le Sueur &c.* This held four drawings attributed to Poussin, of which one may be identifiable with an autograph drawing (cat. 42). The earlier history of this album is unknown.

Most of the albums of drawings in the Royal Library were broken up around the turn of this century, and the drawings mounted individually. At this time several became dissociated from the name of Poussin and were lost in the mass of seventeenth-century drawings at Windsor; some of the Massimi drawings were known to Friedlaender in 1929 only through their descriptions in Marinella's catalogue, and two drawings probably from Vol. II have been identified only within the last year. Several interesting versos were also lost from sight when the sheets were pasted down on to their new mounts, but a recent program of conservation in the Royal Library has seen nearly all the autograph drawings lifted and remounted, exposing these versos again (cats. 20, 25, 29, 64).

Paris 1622-1623
The Marino drawings

Poussin was born in Les Andelys, a town some fifty miles north-west of Paris, in 1594. According to his early biographer Giovanni Pietro Bellori, he was encouraged to take up painting as a career by the artist Quentin Varin, who was working in Les Andelys around 1612. Poussin left his home town for Paris (possibly via Rouen) that same year, but commissions were not easy to come by, and he seems to have traveled to where he could find work. His early artistic training was thus haphazard, for he did not settle with a single master for any length of time, and at some unknown date he even ventured as far as Florence; Bellori recorded only that he was prevented from reaching Rome "per alcuno accidente".

In March 1622 five leading Jesuits were canonized in Rome, and elaborate preparations were made by the Jesuit community in Paris for their first feast day in July of that year. At great speed, Poussin executed six large tempera paintings for the celebrations (of which all trace has vanished), illustrating the miracles of St Francis Xavier and St Ignatius Loyola. These brought him to the attention of the renowned but ailing poet Giovanni Battista Marino, who had been living in Paris since 1615 and who had a great interest in the visual arts – in 1619 he had published a volume of poems about individual paintings, some in his own collection, some imaginary. Marino invited Poussin to lodge with him, and when Marino was housebound through illness he passed the time by watching Poussin make drawings after themes from his poetry.

Bellori goes on to describe in detail one of the drawings made by Poussin at this time, the *Birth of Adonis*, which he had seen in the collection of Cardinal Massimi. This can safely be identified with cat. 1, and as the dimensions and technique of cats. 1–13 are more or less uniform, we may infer that the whole series was drawn for Marino. To these thirteen may be added a drawing in Budapest (fig. 1; F/B, no. 446; R/P, no. 18; the subject remains unclear), which is stylistically identical to the Windsor group and in the same format. But Bellori's account is not wholly reliable, for he took the *Birth of Adonis* to be an illustration of Marino's long poem *Adone*, published in 1623, and thus assumed that all the drawings were illustrations to this work.

Later biographers repeated this assumption, and Passeri went on to claim that an edition of the *Adone* was planned with engravings after Poussin's designs. In fact none of the drawings corresponds closely to known passages in Marino's poetry (though we should not discount the possibility that they illustrated lost and unpublished works). Nonetheless, Bellori's connection of the drawings with the *Adone* has proved an effective red herring for scholars examining the purpose of the sheets. Although copies of the Windsor sheets are known, we have no evidence that the compositions were ever worked up into more elaborate drawings, either to serve

as finished works of art (perhaps to accompany a manuscript of poems), or as working models for an engraver (for which the extant drawings are too imprecise – and we know from the Fitzwilliam design for the Moscow battle piece that Poussin was perfectly capable of producing highly finished drawings around this time: see cat. 11).

The early history of the so-called Marino drawings is also problematic, for it is not certain that they were ever in Marino's possession. They came to Windsor in the Massimi volume; according to a biography of Marino appended to the 1627 edition of his *Adone*, he left his collection to friends in Rome on his death, and the mythological drawings may have found their way into Massimi's hands at a later date. But it is also quite possible that Camillo Massimi obtained them directly from Poussin himself, perhaps in the late 1630s when he was taking drawing lessons from Poussin, by which time the artist must have felt little affection for these gauche compositions. If this were the case the surviving sheets might have been *modelli* (full-scale drawings for Marino's approval before Poussin executed carefully finished sheets) or *ricordi* (records of the compositions for future reference). But this is trying to shoe-horn the drawings into standard categories, and it may be better simply to accept the core of Bellori's account – that they were produced for the diversion of Marino alone, with no intention that they should have any subsequent function; perhaps Marino took some, now lost (except for the Budapest sheet?), while Poussin kept others, which years later he gave to Massimi.

Despite the solid provenance of the Windsor drawings, and their often loose underdrawing and clumsy but free outlines, they were rejected as mid-century (and implicitly Roman) copies by Oberhuber in the monograph-cum-catalogue that accompanied the 1988 Fort Worth exhibition, a stance that found some support in reviews of the exhibition (e.g. Cropper 1988, p.961; Goldfarb 1990, pp.92f). But the discovery that the paper of these drawings was produced near Paris by 1621 at the latest (Clayton 1991) must dispel any doubt that the Windsor drawings are indeed the originals.

Attempts to establish an internal chronology for the Marino drawings have likewise proved unconvincing. These attempts have usually been based on the relative success of the compositions – which ignores the extent to which Poussin was dependent upon pictorial sources at this time – or on superficial characteristics, such as the presence of antique motifs in the *Death of Camilla* (cat. 10). Neither approach is satisfactory, and the drawings themselves, when shuffled around a study table, resist all efforts to arrange them in a stylistic progression. This is hardly surprising, for the uniformity of technique of cats. 1 to 13 must indicate that they were produced within a short period, and one would not expect the relatively straightforward exercise of devising a handful of mythological scenes to transform the aesthetic sense of an artist already in his late twenties.

In failing health, Marino returned from Paris to the warmer climate of Italy in April or May 1623, and it is therefore possible to date the Marino drawings to late 1622 or early 1623. He invited Poussin to go with him; the artist was too committed to other projects to accompany Marino immediately and he followed later that year, reaching Rome by March 1624. But Marino traveled on alone to his native Naples a few months later, and died the following year. Aged thirty, Poussin found himself a foreigner with no reputation and no reliable patron in the most competitive artistic milieu in Europe.

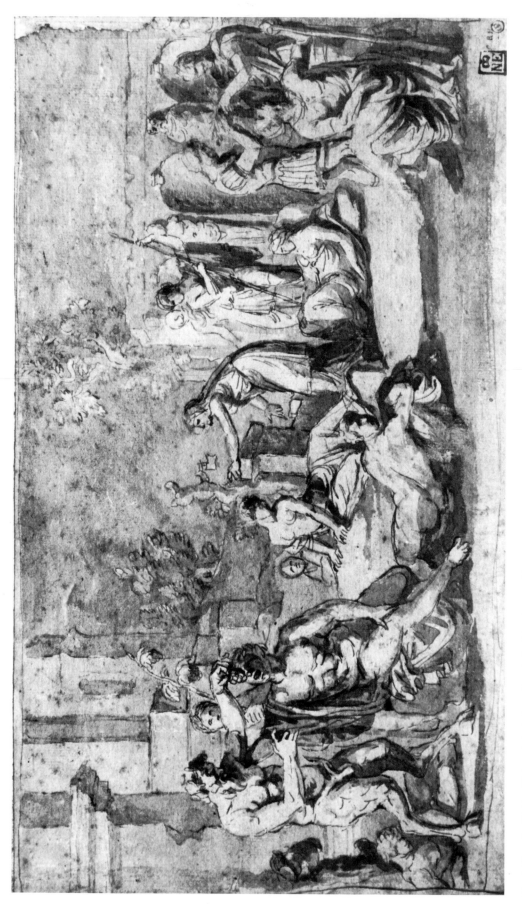

Fig. 1 Poussin, *Unidentified mythological or allegorical subject.* Pen and brown ink, gray wash. 7⅛″ × 12¹⁵⁄₁₆″ (181 × 328 mm). Museum of Fine Arts, Budapest, inv. 2880

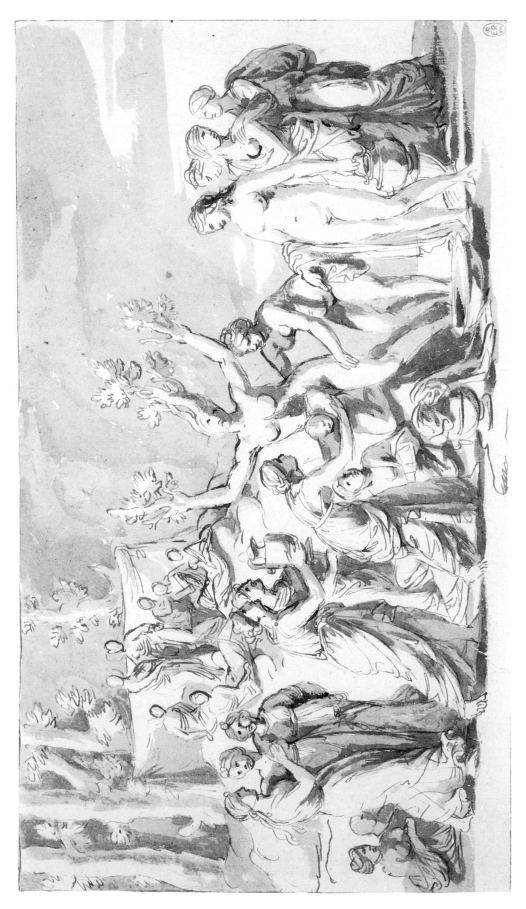

1 *The birth of Adonis*

1 *The birth of Adonis* ca. 1622–23

Pen and brown ink, gray wash
Verso: blank
7 ³⁄₁₆" × 12 ¹³⁄₁₆" (183 × 325 mm)
Watermark: Nivelle
Provenance: Massimi vol., no. 29 ("Mirra conversa in Albero")
RL 11933

The beautiful youth Adonis was born of the incest between Myrrha and her father, King Cinyras. Aided by her maid, Myrrha tricked her way into Cinyras's bed; when he discovered the deceit, he chased her from the palace and she roamed the countryside imploring the gods to end her misery. Taking pity on her, they changed her into the myrrh tree, whereupon her bark split open and the child Adonis was born.

Unlike legendary transformations into animals, the transformation of humans into trees offers the artist little pictorial license, and the various episodes in the illustrated Ovids – Myrrha, Daphne, Dryope, the Heliades and so on – uniformly show the victim with her arms raised to the sky, as her legs change into the trunk and her arms into the branches of a tree. The episode was described in detail by Ovid (*Metamorphoses*, X, 476ff; despite the title, Marino's long poem *Adone* is about much more than the life of Adonis, and he treated the birth only in passing), and this was the source for most artists' treatment of the subject throughout the sixteenth and seventeenth centuries. Naiads receive the child, and other nymphs hold a vessel to catch the tears of Myrrha – the resin of the tree from which myrrh is obtained.

The standard elements would have been known to Poussin from an engraving in one of the many illustrated editions of Ovid, such as that published in Paris in 1619 (fig. 2). He departed little from this formula, though the profusion of onlookers and the prominence of Lucina, the goddess of childbirth standing naked at the right, are somewhat unusual. Costello noted further that Poussin took the central motif from the illustration of the *Transformation of Dryope* in the 1619 Ovid, and the group of distant onlookers from *Hercules and Achelous*; Badt suggested that the pose of Myrrha might be derived from a cast of the antique *Laocoön* group then at Fontainebleau.

This drawing was seen by Bellori in the collection of Cardinal Massimi in the seventeenth century, and the detailed description of the sheet in his biography of Poussin is the only direct piece of evidence to connect the group of early drawings at Windsor with Poussin's reported collaboration with Marino.

References: Badt 1969, pp.150f; Bellori 1672, pp.410f; Blunt 1945, no. 154; Blunt 1967, p.40; Blunt 1976, p.25; Blunt 1979, p.8; Clayton 1991; Costello 1955, pp.309f; Edinburgh 1981, no. 58; F.A.Q.R. i, p.273; F/B, III, no. 154; Friedlaender 1914, p.314; Friedlaender 1929, pp.121, 235; London 1986, no. 70; Oberhuber 1988, p.55, no. D16; Oxford 1990, no. 1; Paris 1960, no. 120; Paris 1994, no. 1; R/P, no. 9; Thuillier 1969, p.104

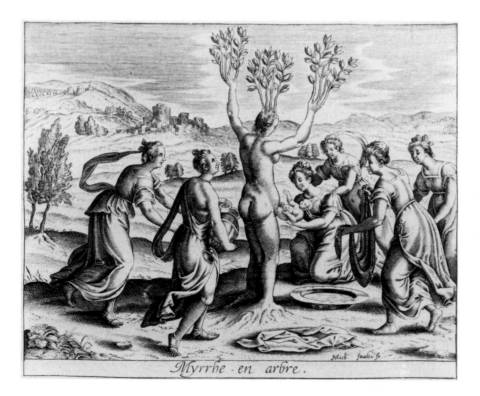

Fig. 2 Michel Faulte, *The birth of Adonis*, from *Les Metamorphoses d'Ovide*, Paris 1619. Engraving

2 *Jupiter in the guise of a bull*
ca. 1622–23

Pen and brown ink, gray wash
Verso: blank
7 ¼″ × 12 ⁹⁄₁₆″ (184 × 319 mm)
No watermark
Provenance: Massimi vol., no. 3 ("Mercurio in habito di Pastore")
RL 11947

This scene has generally been identified as Apollo guarding the herds of Admetus. Apollo had been sent by Jupiter to watch over the herds of King Admetus, but he spent his time playing the pipe, and the herds wandered off and were stolen by Mercury (Ovid, *Metamorphoses*, II, 678ff). However it would be most unusual in such a scene to show Apollo surrounded by companions, and in the Massimi catalogue Marinella probably alludes to the correct episode by calling the drawing *Mercury in the guise of a shepherd*, an oblique reference to the story of the abduction of Europa (though he goes on to identify the embracing couple as Jupiter and Maia, the parents of Mercury, an illogical piece of overinterpretation).

Having fallen in love with Europa, Jupiter changed himself into a bull, mingled with the herds of her father, King Agenor, and instructed Mercury to drive the herd to the shore where Europa was playing with her attendants. The moment in the story where Jupiter frolics at the water's edge to catch the girls' attention was very rarely represented, and Europa was usually shown climbing on to the bull or being carried off

through the waves. But Poussin follows Ovid's description of the bull very closely:

> His colour whiter than untroden snow,
> Before still-moist and thawing Auster blow.
> The flesh, in swelling rowles, adornes his neck:
> His broad-spread brest, long dangling dew-laps deck.
> His hornes, though small, yet such as Art invite
> To imitate, then shining gemmes more bright:
> His eyes no wrath, his browes no terror threat;
> His whole aspect with smiling peace repleat.
> (*Metamorphoses*, II, 836ff; trans. Sandys 1632)

This is the most open and free of the Marino drawings, its abstract qualities suggesting a radical refinement of preparatory sketches that presumably went before. A very faithful copy of the sheet is preserved in the museum at Rouen (fig. 3). Only the slickness of the wash and a certain halting quality to the line, particularly noticeable in the drapery of the maidens and the belly of the bull, distinguish it from the original (*pace* Oberhuber's analysis). A fragmentary inscription at the lower right of the Rouen sheet reads *Roma f:163. . .*, presumably indicating that the copy was made in Rome in the 1630s and thus demonstrating how early in Poussin's career facsimiles were made of his drawings.

References: Badt 1969, pp.154f; Blunt 1945, no. 155; Blunt 1971, p.215; Blunt 1976, p.20; Blunt 1979, pp.180, 183; F.A.Q.R. i, p.268; F/B, III, no. 159, V, p.105; Friedlaender 1929, p.253; Oberhuber 1988, pp.31–34, no. D10; Paris 1960, no. 123; Paris 1994, under no. 1; R/P, no. 2; Sutherland Harris 1990, p.149

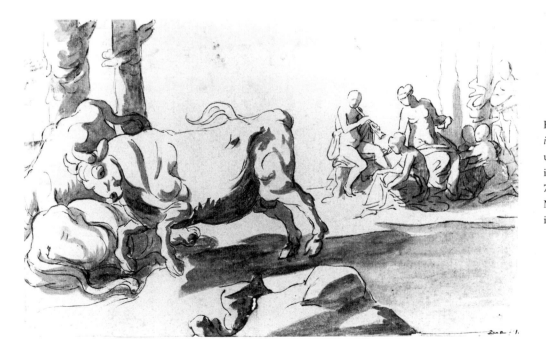

Fig. 3 Copy after Poussin, *Jupiter in the guise of a bull*. Graphite underdrawing, pen and brown ink, gray-brown wash. 7 ¾″ × 12 ³⁄₁₆″ (197 × 310 mm). Musée des Beaux-Arts, Rouen, inv. 973.11.1

2 Jupiter in the guise of a bull

3 *Dryope transformed*

3 *Dryope transformed* ca. 1622–23

Traces of graphite underdrawing, pen and brown ink, gray wash, some staining
Verso: blank
6 ³⁄₁₆″ × 13 ⅛″ (157 × 333 mm)
Watermark: Nivelle
Provenance: Massimi vol., no. 4 ("Driope Trasformata nel'Arbore Loto")
RL 11941

The nymph Dryope plucked a flower from a lotus tree, unaware that this tree was the nymph Lotis, transformed to escape the pursuit of the god Priapus. For this Dryope was herself transformed, and her last request was that her son Amphissus should be taught that all trees were originally nymphs or goddesses (Ovid, *Metamorphoses*, IX, 329ff).

Poussin does not depict the moment of Dryope's metamorphosis, but the subsequent education of her son. Presumably Amphissus is one of the children playing at the left, but the wings and trumpets seen in this group are among the puzzling features of the drawing – in particular the figures at the right of two men gazing up at another on top of a wall play no part in the action and are hard to explain.

This is the least satisfactory of the Marino drawings, with its fragmentary composition and lack of narrative clarity. Quite possibly Poussin himself was aware of these shortcomings, for the coarse line drawn along the bottom of the sheet may be a vain attempt by the artist to tighten up the composition; the sheet has thus been trimmed to an inch narrower than the others in the series.

References: Badt 1969, pp.147, 153; Blunt 1945, no. 156; Blunt 1976, p.20; Clayton 1991; F.A.Q.R. i, p.269; F/B, III, no. 157; Friedlaender 1929, p.253; Oberhuber 1988, no. D11; R/P, no. 4; Sdunnus 1990, p.314; Wild 1980, I, p.16

4 *Orpheus in Hades* ca. 1622–23

Graphite underdrawing, pen and brown ink, gray wash
Verso: blank
7 ⁷⁄₁₆″ × 12 ⅝″ (189 × 320 mm)
Watermark: Nivelle
Provenance: Massimi vol., no. 28 ("Orfeo nel'Inferno")
RL 11937

Eurydice, the wife of Orpheus, died when she stepped on a snake, and was dragged down into Hades. The stricken Orpheus descended to the court of Pluto, god of the underworld, and by the power of his music persuaded Pluto to allow her back to earth. Here Poussin shows Orpheus kneeling with a harp before the enthroned Pluto and his queen, Proserpine, the three-headed Cerberus at their feet and Eurydice standing in supplication to one side. Several of the other inhabitants of Hades are gathered around to listen to the music of Orpheus, as described by Ovid:

> While thus he sung, and struck the quavering strings,
> The bloodless Shadowes wept: nor flattering Springs
> Tempt Tantalus, Ixions Wheele stood still;
> Their Urne the Belides no longer fill:
> The Vultures feed not; Tityus left to grone:
> And Sisyphus sate listning on his Stone.
> The Furies, vanquisht by his verse, were seene
> To weepe, that never wept before. Hels Queene,
> The King of Darknesse, yeeld t'his powrefull plea.
> Among the late-come Souls, Euridice
> They call.
> (*Metamorphoses*, X, 40ff, trans. Sandys 1632)

Most northern European artists took the opportunity to depict picturesque devils, torments and panoramic infernos in the background, whereas Italian illustrations generally concentrated on the main protagonists. Exceptionally, Poussin shows the four eternally damned figures of Tityus, Ixion, Sisyphus and Tantalus prominently.

References: Blunt 1945, no. 157; Blunt 1967, p.49; Blunt 1976, p.25; Clayton 1991; Costello 1955, p.312; F/B, III, no. 161; Oberhuber 1988, p.48, no. D15; R/P, no. 8

5 *The death of Chione* ca. 1622–23

Graphite underdrawing, pen and brown ink, brown wash
Verso: blank
7 ⁵⁄₁₆″ × 12 ³⁄₈″ (185 × 315 mm)
No watermark
Provenance: Massimi vol., no. 30 ("Chiona")
RL 11935

The mortal Chione had borne children by both Apollo and Mercury, and boasted that she was fairer than Diana. Her reward was to be shot through the tongue by the goddess of the hunt (Ovid, *Metamorphoses*, XI, 301ff). Costello noted that the drawing owes more to traditional representations of the death of Procris, or of Apollo slaying Coronis, than to the depictions of the death of Chione in the illustrated editions of Ovid, which always showed Diana seated in a cloud, shooting an arrow through the mouth of a prostrate Chione. Characteristically, Poussin brings the action down to earth, and rather than illustrating the dramatic moment of the actual shooting, he concentrates on the emotional aftermath. Chione's father, Daedalion, and her two sons lament over the body, drawn with unusually stark plasticity. By way of contrast, Diana and her dogs casually amble past in the background, one of the dogs yawning – a piece of fresh observation rarely found in Poussin's drawings.

References: Badt 1969, pp.152f; Blunt 1945, no. 158; Blunt 1976, p.25; Costello 1955, p.311; F.A.Q.R. i, p.274; F/B, III, no. 156; Friedlaender 1929, pp.127, 255; Friedlaender 1966, p.15; Oberhuber 1988, no. D17; Oxford 1990, no. 2; Paris 1960, no. 121; Paris 1994, no. 2; R/P, no. 10; Wild 1980, II, no. 2d

6 *Polyphemus discovering Acis and Galatea* ca. 1622–23

Graphite underdrawing, pen and brown ink, brown wash
Verso: blank
7 ⁵⁄₁₆″ × 12 ¹¹⁄₁₆″ (185 × 323 mm)
No watermark
Provenance: Massimi vol., no. 33 ("Galathea, Aci, e Polifemo")
RL 11940

This and the next drawing form the only certain narrative pair in the Marino series (but see cat. 12). The cyclops Polyphemus had fallen in love with the nymph Galatea, and Ovid touchingly describes how he combed his hair and shaved his beard to try to win the nymph (*Metamorphoses*, XIII, 870ff). But Galatea loved the youth Acis, and when Polyphemus discovered them together he furiously hurled a boulder which crushed Acis.

From the mid-sixteenth century, illustrated editions of Ovid routinely showed Polyphemus looming over the couple and throwing a rock, with Galatea fleeing and Acis already crushed beneath a boulder (e.g. fig. 4, from the 1619 French edition). Poussin has modified the standard composition to depict the moment in the story with the greatest emotional, rather than dramatic, effect. Polyphemus has only just stumbled across the explicitly posed lovers, who are still unaware of his presence. The vertiginous perspective thus goes beyond merely emphasizing the bulk of the cyclops, giving us the view over his shoulder and compelling us to share his envy – a subtle piece of psychological manipulation for such an inexperienced artist.

References: Badt 1969, pp.148, 155; Blunt 1945, no. 159; Blunt 1976, p.25; Costello 1955, p.309; F/B, III, no. 160; Oberhuber 1988, p.50, no. D19; Paris 1960, no. 122; Paris 1994, no. 3; R/P, no. 12; Thuillier 1969, p.32, no. 46; Thuillier 1994, under no. 22

Fig. 4 Isaac Briot, *Polyphemus, Acis and Galatea*, from *Les Metamorphoses d'Ovide*, Paris 1619. Engraving

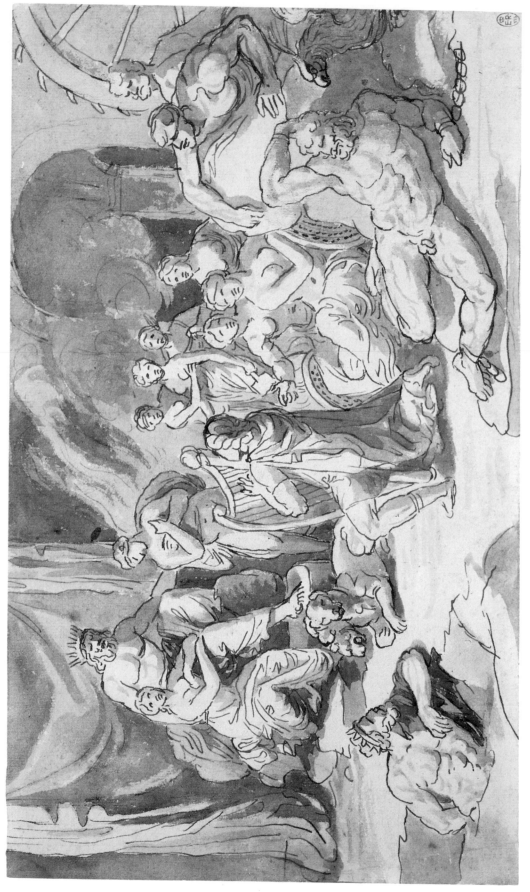

4 *Orpheus in Hades*

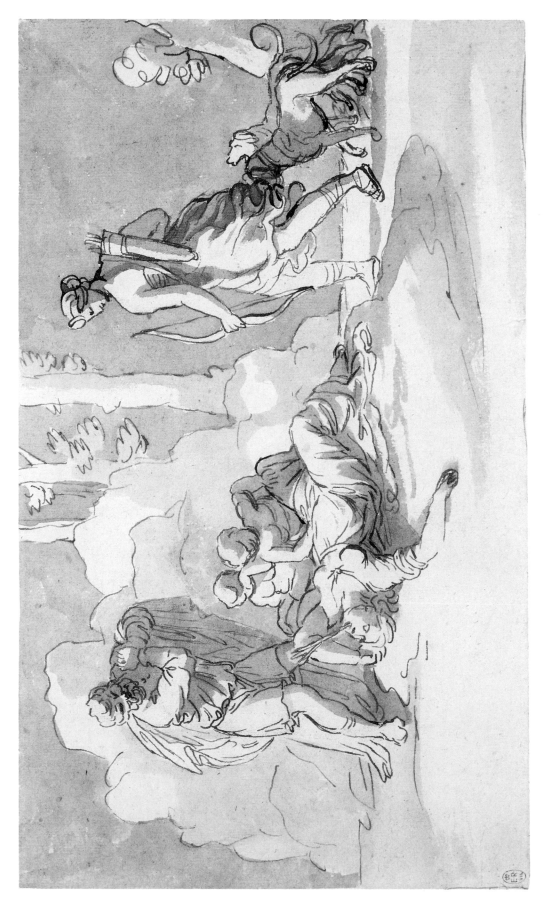

5 *The death of Chione*

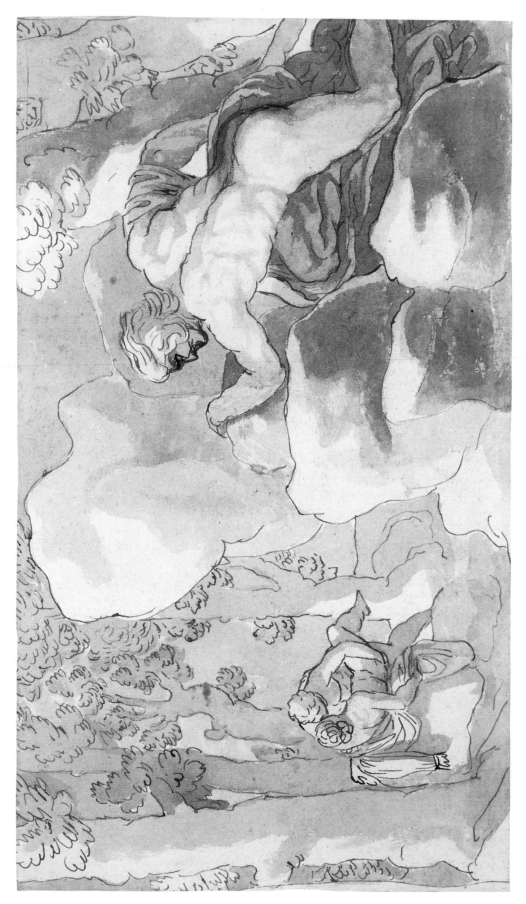

6 *Polyphemus discovering Acis and Galatea*

24

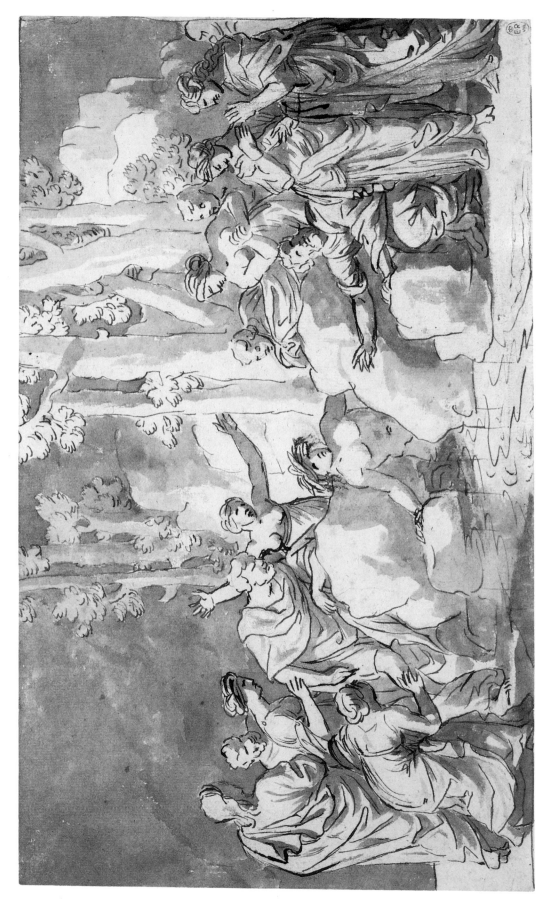

7 Acis transformed into a river-god

25

7 Acis transformed into a river-god ca. 1622–23

Graphite underdrawing, pen and brown ink, brown and gray washes
Verso: blank
7 ⁷⁄₁₆" × 12 ⁹⁄₁₆" (189 × 319 mm)
No watermark
Provenance: Massimi vol., no. 34 ("Bibli")
RL 11939

Although the Massimi catalogue describes this as the transformation of the nymph Biblis, the figure at the center is clearly a youth, not a girl. The drawing is probably a pendant to cat. 6 and shows the transformation of Acis into a river-god after he was crushed by the boulder thrown by Polyphemus:

> The purple blood from his crusht body fled;
> Which presently forsooke the native red:
> First like a raine-discoloured streame appeares,
> Then christalline. The rock in sunder teares. . ..
> From whence a youth arose above the wast,
> His horned browes with quivering reeds imbrac't.
> (*Metamorphoses*, XIII, 885ff, trans. Sandys 1632)

The bystanders shown by Poussin are not referred to in any description of the episode, but are added to convey by their responses the wondrous nature of the event.

Illustrations to Ovid normally compressed the two events of Polyphemus hurling the boulder and the transformation of Acis into a single scene (fig. 4). Only one other representation of the transformation as a separate scene is known to me, a drawing attributed to Calandrucci at Holkham Hall (fig. 5), which shows Galatea leaping from her dolphin-drawn shell chariot towards her transformed lover. It is possible that Calandrucci knew the Marino series, for the dolphins and nymphs set before an oblique shore are very similar to the Marino drawing of Thetis and Achilles (cat. 8).

References: Badt 1969, pp.153f; Blunt 1945, no. 160; Blunt 1976, p.25; F.A.Q.R. i, p.274; F/B, III, no. 158; Friedlaender 1929, p.255; Oberhuber 1988, p.52, no. D20; R/P, no. 13; Sutherland Harris 1990, p.150

Fig. 5 Giacinto Calandrucci, *The transformation of Acis*. Black chalk underdrawing, pen and brown ink, brown wash. 9 ¾" × 14 ⅝" (248 × 372 mm). Holkham Hall, Norfolk

8 Thetis bringing the armor to Achilles ca. 1622–23

Graphite underdrawing, pen and brown ink, gray wash
Verso: blank
7 ⁷⁄₁₆" × 12 ¹³⁄₁₆" (189 × 325 mm)
No watermark
Provenance: Massimi vol., no. 32 ("Theti ed Acchille")
RL 11934

Patroclus was killed by Hector while wearing Achilles's armor. The sea-nymph Thetis, mother of Achilles, persuaded Vulcan to forge a new set for her son, and dressed in this he avenged his friend and slew Hector. The scene in the forge was often depicted, with Vulcan beating out the armor as Thetis stands imploringly to one side, but the less picturesque episode of the delivery of the arms to Achilles was very rarely shown. Here Thetis and her son embrace, as a train of attendant sea-nymphs carry the armor and two Myrmidons look on.

Although Ovid describes the story of the Trojan wars in detail, this particular episode is mentioned only in passing (*Metamorphoses*, XIII, 288ff), and Poussin might have taken a fuller description from the *Iliad*, Book XIX.

References: Badt 1969, pp.157f; Blunt 1945, no. 161; Blunt 1976, p.25; Costello 1955, pp.299–302; F.A.Q.R. i, p.270; F/B, III, no. 162; Friedlaender 1929, p.253; Oberhuber 1988, p.48, no. D18; R/P, no. 11

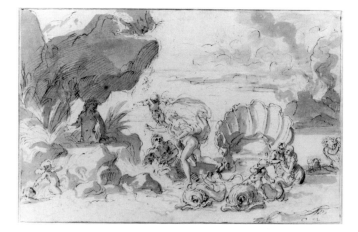

9 *The birth of Priapus*
ca. 1622–23

Graphite underdrawing, pen and brown ink, brown wash
Verso: blank
7 ⅝″ × 12 ¹¹⁄₁₆″ (194 × 323 mm)
Watermark: Nivelle
Provenance: Massimi vol., no. 14 ("La Nascita di Priapo")
RL 11938

This obscure episode is not to be found in Ovid, and the other sources disagree about the details. According to Vincenzo Cartari (*Le imagine con la spozitione de i dei de gli antichi*, first published in 1556), Venus had conceived a child by Jupiter, whose ceaselessly jealous wife Juno cursed the child, which was born monstrously deformed. Natale Conti, in his mythographic handbook *Mythologiae sive explicationis fabularum libri decem* (first published in 1551; "De Priapo", XV, 5) claimed that the father was Adonis, and Juno's curse arose out of a simple jealousy for Venus's looks. Diodorus Siculus (*Bibliotheca Historica*, IV, 6) stated that the father was Bacchus, and the presence of satyrs and Silenus types at the birth here might suggest that this is the version that Poussin knew. But his source might just as well have been Marino himself.

None of the known texts describes the scene of the birth and there was no pictorial tradition, so Poussin had to devise the composition afresh. A maiden pulls the curtain aside to reveal Venus laid on a sumptuous couch and the midwife holding the child. As usual in the Marino series, Poussin's interest was in human emotions rather than dramatic action, contrasting the reactions of fascination and horror on the faces of the nymphs with the delight and celebration of the satyrs.

References: Badt 1969, pp.151f; Blunt 1945, no. 162; Blunt 1967, p.49; Blunt 1976, p.22; Clayton 1991; Costello 1955, pp.299f; F.A.Q.R. i, p.270; F/B, III, no. 155; Friedlaender 1929, p.253; Oberhuber 1988, no. D12; R/P, no. 5

10 *The death of Camilla (?)*
ca. 1622–23

Slight graphite underdrawing, pen and brown ink, gray wash
Verso: blank
7 ⁵⁄₁₆″ × 12 ¾″ (185 × 324 mm)
No watermark
Provenance: Massimi vol., no. 44 ("Camilla Regina de' Volsci")
RL 11936

The Massimi catalogue describes this drawing as showing the death of Camilla, the daughter of Metabus, king of the Volsci, and identifies the couple riding off in the background as Camilla's companion Acca and a soldier taking the news of her death to Turnus, king of the Rutuli. As pointed out by Costello, this drawing fails to fit the detailed description of the episode in the *Aeneid* (XI, 648ff), which has Camilla going into battle with bared breast and dying in the arms of her maiden companions; it is not even certain that the dying figure is a woman. But the drawing does show classical warriors fighting against tribesmen, suggesting an episode from the battles of Aeneas in Italy, and if the Massimi identification cannot be accepted there are too few clues to suggest an alternative.

Costello also proposed that the drawing was executed later than the other Marino drawings, after Poussin's arrival in Rome, as there are several motifs which are derived from antique sarcophagi. But many drawings, engravings and even casts after ancient sculpture were circulating in France by the early seventeenth century, and Poussin need not have known the objects first-hand to have integrated figures and groups from these sources into his compositions. The style, technique and format of the sheet are identical to the other Marino drawings, and there can be no justification for dissociating it from this group.

References: Blunt 1945, no. 165; Blunt 1976, p.27; Costello 1955, pp.303–05; F.A.Q.R. ii, p.177; F/B, II, no. 113, V, p.93; Friedlaender 1929, p.256; Oberhuber 1988, p.48, no. D24; Oxford 1990, no. 4; Paris 1960, no. 126; Paris 1994, no. 4; R/P, no. 17

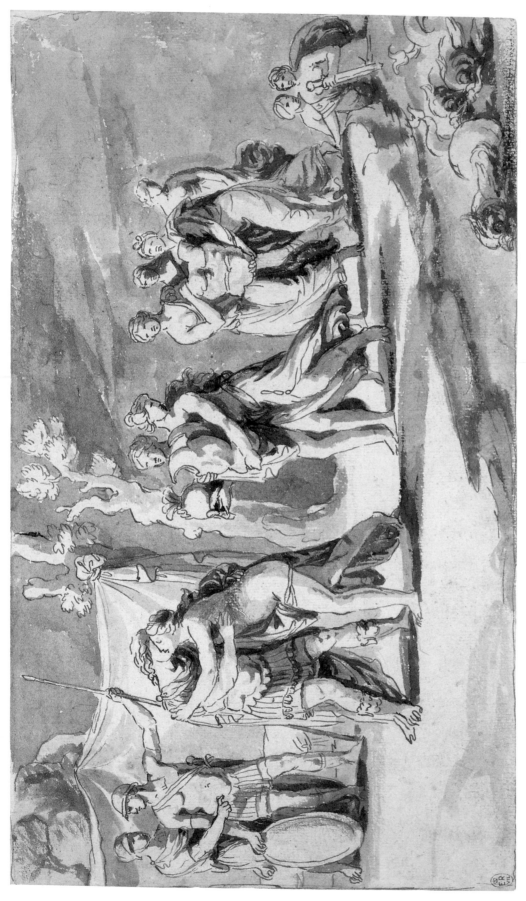

8 *Thetis bringing the armor to Achilles*

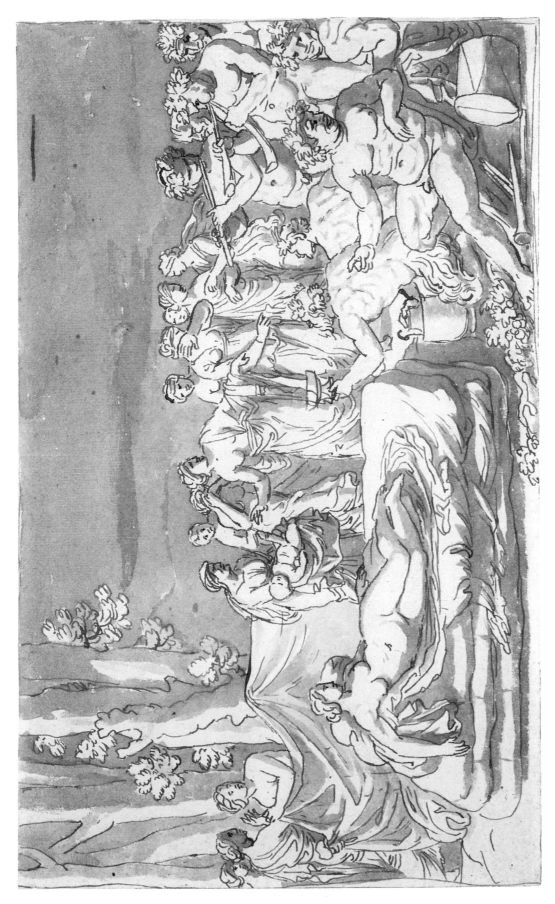

9 The birth of Priapus

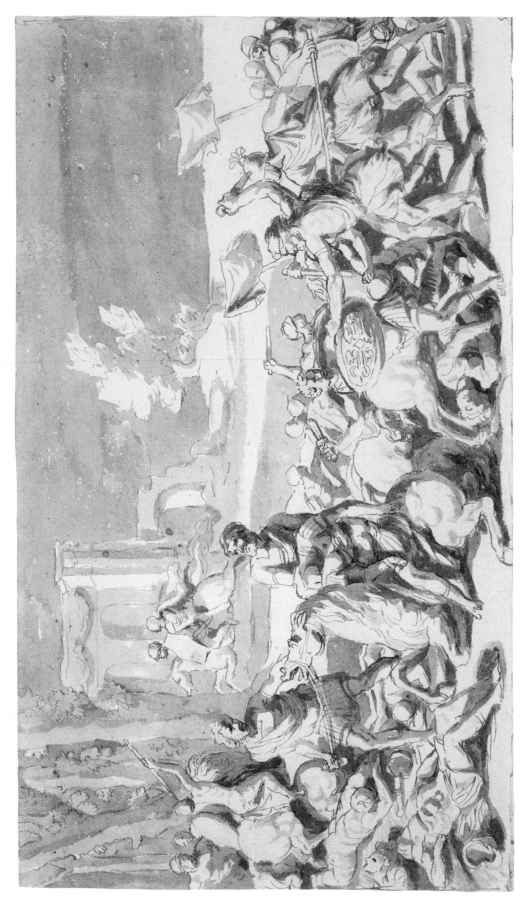

10 *The death of Camilla (?)*

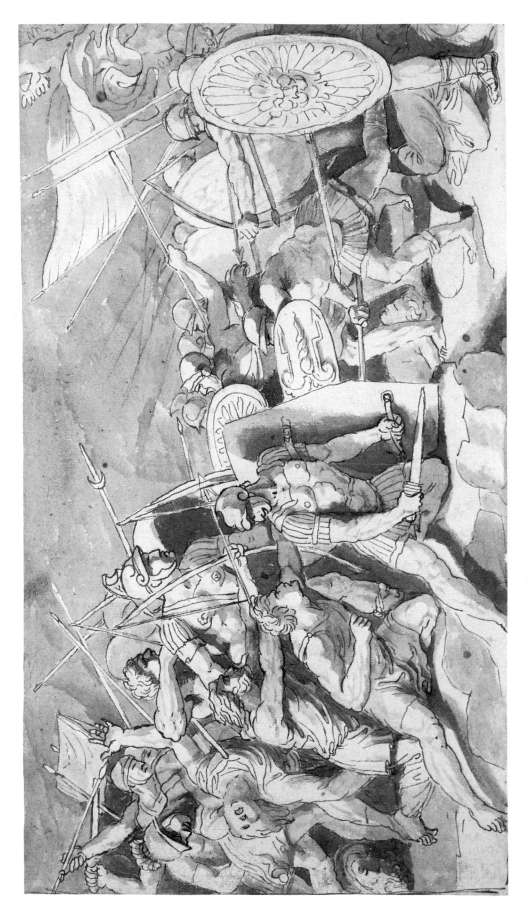

11 *The battle of the Rutuli against the Trojans*

11 *The battle of the Rutuli against the Trojans* ca. 1622–23

Slight graphite underdrawing, pen and brown ink, brown and gray
washes
Verso: blank
7 ³⁄₁₆" × 12 ¹³⁄₁₆" (182 × 326 mm)
No watermark
Provenance: Massimi vol., no. 39 ("Altra Battaglia")
RL 11944

According to the Massimi catalogue, this drawing represents
the attack of the Latin allies of the Sabines against the Romans,
with the Volsci dressed in the manner of barbarians (that is,
bearded and in long trousers). Livy mentions the Caenin-
enses, another tribe of Latium, in this context rather than the
Volsci, though this might simply have been confusion on
Marinella's part. But betrousered warriors are to be seen on
both sides, and this detail led Costello to identify correctly the
episode depicted.

In the *Metamorphoses*, Ovid recounts the adventures of
Aeneas in Italy, after the Trojan wars and his subsequent voy-
ages around the Mediterranean. He landed at the mouth of the
Tiber and was made welcome by Latinus, king of Latium, who
betrothed his daughter Lavinia to Aeneas. But Turnus, king of
the Rutuli, had earlier been promised her hand, and he thus
made war on the Trojans. The passage illustrated here
describes how both armies recruited foreign soldiers, explain-
ing the presence of classical warriors and tribesmen on each
side:

> Warre with a furious Nation is commenst,
> Sterne Turnus for his promist wife incenst,
> While all Hetruria to Latium swarmes,
> Hard victorie long sought with pensive armes.
> To get Recrutes from forraine States they trie,
> Nor Troians, nor Rutulians want supplie.
> (*Metamorphoses*, XIV, 450–55; trans. Sandys 1632)

One of the persuasive ideas in Oberhuber's controversial
book on the early years of Poussin was the dating of a pair of
battle paintings, now in Russia, to his time in Paris rather than
to his first Roman years. These represent the *Battle of Joshua
against the Amalekites* (Hermitage, St Petersburg) and the *Battle
of Joshua against the Amorites* (Pushkin Museum, Moscow; fig.
6). The usual date of 1625–26 for this pair was based on a men-
tion in Bellori's biography of Poussin (1672, p.411) of two
battle pieces that the straitened artist was reduced to selling
for the paltry sum of seven *scudi* each, during Cardinal Bar-
berini's absence from Rome between March 1625 and the end

of 1626. The size of those canvases, four *palmi* high, corre-
sponds to the Russian paintings, but also to another Old
Testament battle piece in the Vatican, and indeed a format of
close to 39" × 53" (98 × 135 cm) is very common in Poussin's
earlier works (the Fort Worth *Venus and Adonis*, the Moscow
Rinaldo and Armida, the Munich *Apollo and Daphne* and *Midas
before Bacchus*, the London *Cephalus and Aurora* and so on).

A few motifs are common to a battle painting and a Ma-
rino drawing, such as the archers in cat. 11 and the Hermitage
painting, and the twisting warrior at the far left of cat. 12 who
reappears on the left of the Moscow painting; but the warrior
is a direct quotation of a famous figure in a fresco by Polidoro
da Caravaggio, widely known through prints and copy draw-
ings, and too much should not be read into this connection.
Much more significant is the style of the battle pieces. The
impossibly crowded structure of the Russian paintings, where
coherent space appears to be abandoned and the bulging
figures pile up towards the top of the canvas, is also found in
cats. 11–13. Seen together with other paintings from Poussin's
early years at the recent exhibition in Paris, it was very clear
that a fundamental shift had taken place in the artist's vision
between the execution of these dense paintings in cold, dry
metallic colors, and the spacious, luxuriant early mythological
pieces, where the impact of Venetian painting on Poussin is
plain to see. It is possible to say, without over-simplifying,
that the battle scenes look essentially northern, and the early
mythological paintings essentially Italian. I believe that one
must dissociate the Russian paintings from those described by
Bellori, and date them to Poussin's years in Paris.

Furthermore, I fail to see the radical change in style
between the Russian and Vatican paintings (which is not the
same thing as a more successful composition) pointed to by
Oberhuber, and the identification of the Vatican piece with
one of those mentioned by Bellori is not as secure as he made
out. Indeed Sutherland Harris, in concurring with the re-
dating of the Russian pieces to the French period, suggested
that Poussin may also have painted the Vatican canvas in
France and taken it to Rome with him in 1624, with the inten-
tion of selling it and establishing a reputation.

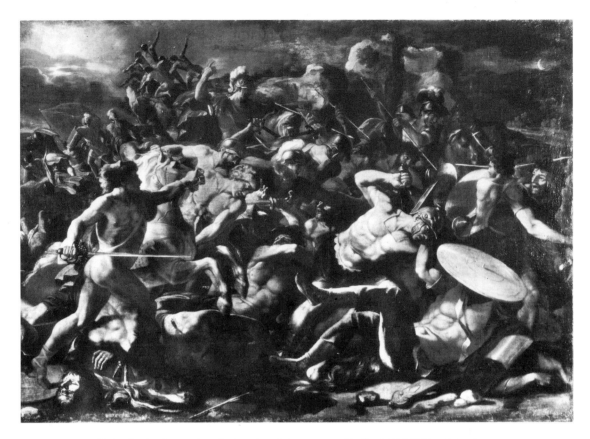

Fig. 6 Poussin, *The battle of Joshua against the Amorites*. Oil on canvas. 38 ½″ × 52 ¾″ (97.5 × 134 cm).
Pushkin Museum, Moscow

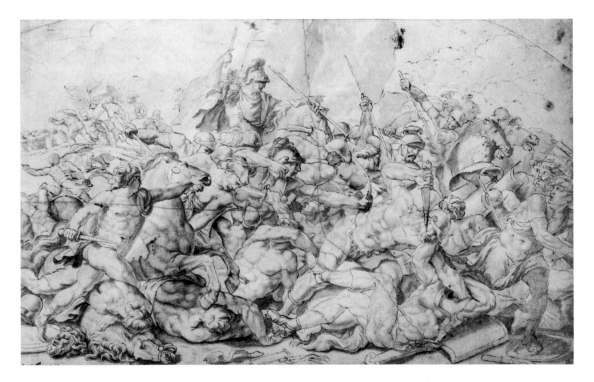

Fig. 7 Poussin, *The battle of Joshua against the Amorites*. Pen and brown ink, gray wash. 9 ¹¹⁄₁₆″ × 15 ³⁄₈″ (246 × 391 mm).
Fitzwilliam Museum, Cambridge, inv. 2606

Of course the Marino battle drawings are in no sense preparatory for the Russian paintings, but one drawing connected with the Moscow painting does survive, in the Fitzwilliam Museum in Cambridge (fig. 7; F/B, no. 388; R/P, no. R217). This sheet is large and highly finished, of a type that Poussin commonly executed in the latter part of his career (cats. 58, 60, 62), but we have nothing like it from his earliest years and it has been rejected by some scholars. The drawing style is quite unlike the Marino sheets, but if it were a copy one would expect the copyist to transcribe the details as carefully as he handled the pen and wash, and there are major differences between drawing and painting. This last consideration strongly suggests that the Fitzwilliam drawing is an original of a type unique from Poussin's earliest years – but this very uniqueness prevents us from dating it (and thereby the Russian paintings) by comparison with other surviving sheets.

References: Blunt 1945, no. 168; Blunt 1976, p.26; Blunt 1979, p.13; Costello 1955, pp.302–04; F.A.Q.R. ii, p.176; F/B, II, no. 110, V, p.93; Friedlaender 1929, p.256; Oberhuber 1988, p.48, no. D22; Oxford 1990, no. 5; Paris 1960, no. 125; R/P, no. 15; Sutherland Harris 1990, p.148; Wild 1980, II, no. 16

Fig. 8 Orazio Borgiani after Raphael, *Joshua commanding the Sun and Moon to stand still*. Engraving

12 A battle between Latins and Trojans (?) ca. 1622–23

Graphite underdrawing, pen and brown ink, gray-brown wash
Verso: blank
7 ⁷⁄₁₆″ × 12 ¹¹⁄₁₆″ (189 × 322 mm)
Watermark: Nivelle
Provenance: Massimi vol., no. 42 ("Battaglia fra Latini e Troiani")
RL 11942

The Massimi catalogue identified the subject of this drawing as an attack of Latin forces on the fortifications of the newly founded Troy. Costello proposed instead that the episode depicted is, like cat. 11, from the adventures of Aeneas in Italy, and shows the Trojans attacking the stronghold of Evander. The relevant single line of Ovid (*Metamorphoses*, XIV, 456) follows straight on from those illustrated by cat. 11, but Costello's suggestion depends on Poussin misunderstanding the line, rendered by Sandys (1632) as "Nor to Evanders towne Aeneas went / In vaine": Aeneas went to Evander's town not to attack it, but to seek help during his battle against the Rutuli. The title given in the Massimi catalogue would thus be more or less correct, but the explanation of the scene wholly wrong. However, there are too few clues in the drawing either to accept or reject Costello's proposal.

The figure at the far left of this drawing is copied from a design by Polidoro da Caravaggio (see cat. 11), and the central warrior with his back turned is taken from a print after Raphael's *Joshua commanding the Sun and Moon to stand still*, in the Vatican Loggie (fig. 8). Several sets of prints after the Loggie frescoes were published in the early seventeenth century, and Poussin must have owned such a set as throughout his career quotations can be found from Raphael's designs – for instance, the warrior kneeling, twisting and cowering beneath a shield at the left of fig. 8 was transformed years later into the satyr supporting a flat basket of flowers in the Richelieu *Triumph of Pan* (see cats. 36 and 37).

References: Blunt 1945, no. 166; Blunt 1976, p.26; Costello 1955, p.304; F.A.Q.R. ii, p.176; F/B, II, no. 112, V. p.93; Friedlaender 1929, p.256; Oberhuber 1988, p.46, no. D23; R/P, no. 16

13 A battle between Romans and Sabines (?) ca. 1622–23

Graphite underdrawing, pen and brown ink, gray wash
Verso: blank
7 ¹⁄₁₆″ × 12 ⅜″ (179 × 315 mm)
Watermark: Nivelle
Provenance: Massimi vol., no. 38 ("Battaglia fra Romani e Sabini")
RL 11943

The Massimi catalogue describes this chaotically violent drawing as showing the battle between the Romans and the Sabines, after the rape of the Sabine women (see cat. 22). There are no details which might confirm this identification or suggest an alternative, and it will have to serve as a provisional title.

References: Blunt 1945, no. 167; Blunt 1976, p.26; Clayton 1991; Costello 1955, p.306; F.A.Q.R. ii, p.175; F/B, II, no. 111, V, p.93; Friedlaender 1929, p.256; Oberhuber 1988, no. D21; R/P, no. 14; Sutherland Harris 1990, p.150

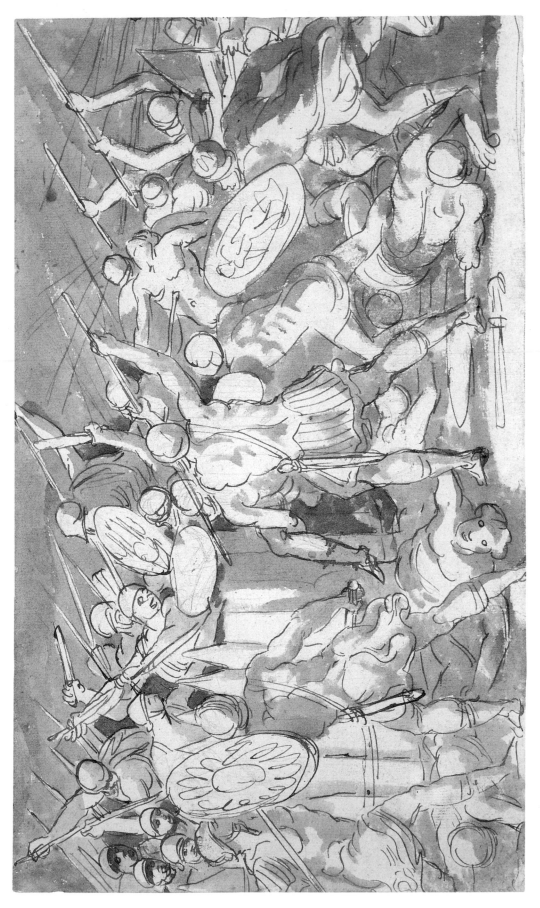

12 *A battle between Latins and Trojans (?)*

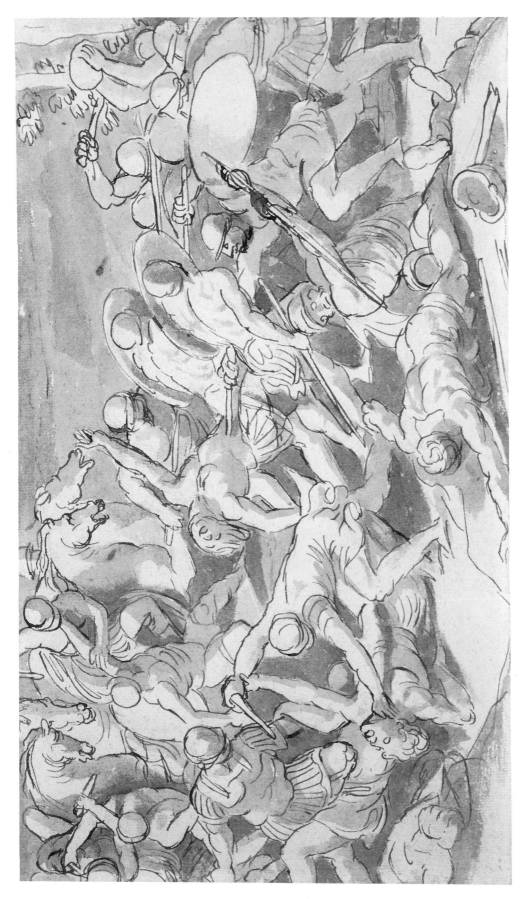

13 *A battle between Romans and Sabines (?)*

14 *Pallas and the Muses* ca. 1622–23 (?)

Black chalk (?) underdrawing, pen and brown-gray ink, gray wash
Verso: blank
12″ × 8 ¾″ (305 × 222 mm)
No watermark
Provenance: Massimi vol., no. 24 ("Pallade e le Muse")
RL 11946

Fig. 9 Copy after Poussin, *Apollo slaying Python*. Paper washed blue-gray, pen and brown ink, brown wash, white heightening. 11 ⅝″ × 8 ⅜″ (296 × 213 mm). Graphische Sammlung der Staatsgalerie, Stuttgart, inv. 1384

A spring known as the Hippocrene flowed from a rock on the sacred Mount Helicon, home of the Muses, after it was struck by the hoof of the winged horse Pegasus. Ovid describes how Pallas, the goddess of learning and the arts, visited the Muses to inspect the miraculous fountain (*Metamorphoses*, V, 250ff). Poussin usually depicts deities standing firmly on the ground in scenes where the traditional representations show them floating through the air, yet here, where it was usual for Pallas to be shown standing among the Muses, he has somewhat perversely drawn her flying through the air towards them.

Although they still have the feel of stage sets, the landscapes have more depth in this drawing and in cat. 15 than in the other early mythological drawings. This may be explained here by the need to localize the scene by drawing attention to the mountain behind – though the spring itself, central to the episode, receives only the most cursory treatment; or, as suggested by Friedlaender (F/B, III), it may be due to the unusually graphic nature of Ovid's text:

> Then Pallas to the sacred Spring convay'd,
> Shee admires the waters by the horse-hoofe made;
> Survay's their high-grown groves, coole caves, fresh bowrs,
> And meadowes painted with all sorts of flowers.
> (trans. Sandys 1632)

This drawing and cat. 15 form a pair, but in format and technique are not *en suite* with the Marino series. The use of a thick reed pen and much bolder chiaroscuro makes it difficult to compare their style with that of the Marino drawings, but the handling and figure types are cruder than anything definitely from Poussin's Roman years, and a date around the same time as the Marino series seems most likely. It is hard to follow Badt's argument that cat. 15 is "different in every respect" from cat. 14 and therefore not by Poussin; similarly Oberhuber's dismissal of the pair as copies is no more convincing than his rejection of the majority of the early drawings at Windsor.

A drawing in Stuttgart showing *Apollo slaying Python* (fig. 9), while not by Poussin, may well be a copy of a lost sheet that once accompanied cats. 14 and 15. In size it falls between the two Windsor drawings, the figuration and rudimentary landscape are very similar, the subject is Ovidian, and the elaborate technique emulates their heavy chiaroscuro. Like the Budapest sheet (fig. 1) for the Marino drawings, the Stuttgart sheet would demonstrate that cats. 14 and 15 formed part of a series that was once more extensive than the pair of drawings now at Windsor.

References: Badt 1969, pp.158f; Blunt 1945, no. 164; Blunt 1976, p.25; Costello 1955, p.312; F.A.Q.R. i, p.272; F/B, III, no. 163; Friedlaender 1929, p.254; Oberhuber 1988, pp.52, 55, no. D14; Paris 1960, no. 124; R/P, no. 7; Sutherland Harris 1990, p.150

14 *Pallas and the Muses*

15 *Mercury slaying Argus* ca. 1622–23

Black chalk (?) underdrawing, pen and brown-gray ink, gray wash
Verso: standing figure seen from behind
Black chalk
10 ⅝″ × 7 ¹⁵⁄₁₆″ (270 × 201 mm)
No watermark
Provenance: Massimi vol., no. 17 ("Ioo, Mercurio ed Argo")
RL 11945

15 verso (detail)

To frustrate Jupiter's adulterous intentions, his wife Juno changed Io into a white cow and set as a guard the giant Argus, who had a hundred eyes and thus was always on watch. Jupiter sent his messenger Mercury disguised as a shepherd to lull the giant to sleep with his music and kill him (Ovid, *Metamorphoses*, I, 668ff). Two episodes of this story are commonly shown, first Mercury playing his pipes as the giant's head starts to loll, and then, as here, the god changed back into his usual guise and about to strike Argus with his sword.

Poussin's illustration is unusual in depicting Argus as an ordinary two-eyed human (it was his habit to avoid supernatural elements, even though Argus's hundred eyes are essential to the story), and in showing Mercury with his back turned in such an dramatic way. The muscularity of this figure is that of the northern Mannerists such as Muller or Goltzius, but the pose is almost a repetition of the warrior at the center of cat. 12, copied straight from a print after Raphael (fig. 8), and as pointed out by Blunt, the figure of Argus is probably taken from an etching by Parmigianino of the *Entombment*. Such source-spotting can become tedious, but here shows how the young artist was, in visual terms, gamely speaking broken Italian. Fluency would not come until he immersed himself in the language a couple of years later.

On the verso of the sheet is a slight sketch of a standing man seen from behind. This bears a certain resemblance in pose to figures in early paintings such as the *Death of Germanicus* (Minneapolis), but is too generalized to be considered a study for that or any other painting.

References: Badt 1969, pp.158f; Blunt 1945, no. 163; Blunt 1960b, p.169; Blunt 1967, p.40; Blunt 1976, p.22; Costello 1955 pp.311, 317; F.A.Q.R. i, p.271; F/B, III, no. 164 (recto), V, no. 375 (verso); Friedlaender 1929, p.253; Oberhuber 1988, p.53, no. D13; Oxford 1990, no. 3; R/P, no. 6; Sutherland Harris 1990, p.150

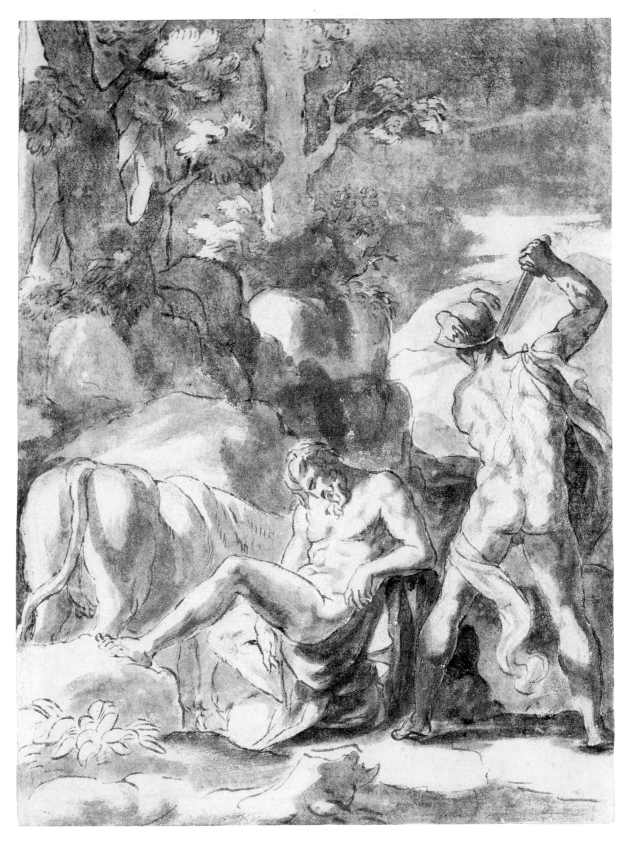

15 *Mercury slaying Argus*

SECTION TWO

Rome 1624–1640

Poussin's first few years in Rome must have been a heady and somewhat disorientating experience, for his sudden immersion in the greatest works of art of the previous two millennia was countered by the immediate need to earn a living. He was approaching his thirtieth birthday when he arrived in the city, an age by which most artists of note had established themselves as independent masters, but Poussin's only contact (apart from other French artists who had settled in Rome) was Giovanni Battista Marino, who died in 1625. However, Marino's good connections secured an introduction through the patron Marcello Sacchetti to Cardinal Francesco Barberini, nephew of Pope Urban VIII, and his secretary Cassiano dal Pozzo.

Several of Poussin's earliest Roman paintings were executed for one or other of these two, even though they were absent from the city during most of 1625 and 1626; from Barberini came the commission for the *Death of Germanicus* (Minneapolis), paid for in January 1628, the first firmly datable painting by Poussin to have survived. By then Poussin must have established a solid reputation, for the following month he received his most important commission of the 1620s, the large altarpiece of the *Martyrdom of St Erasmus* for St Peter's in Rome, finished by the summer of 1629. But his effort was coolly received, and when in 1630 his compatriot Charles Mellin was awarded a commission to fresco the French church in Rome, San Luigi dei Francesi, in preference to Poussin, he must have begun to realize that he was unsuited to the large public projects that occupied most of the artists' workshops of Rome.

The chronology of Poussin's other early paintings has been hotly debated during the last thirty-five years, and no consensus has emerged. One of the stumbling blocks has been the identification of a pair of battle scenes now in Russia (fig. 6) with those mentioned by his biographer Bellori as having been sold by Poussin during Cardinal Barberini's absence from Rome in 1625–26, for this would require an extremely rapid stylistic development between these paintings and the *Death of Germanicus* of 1627. But if one accepts the redating of the battle paintings to Poussin's years in Paris (see cat. 11), it becomes much easier to account for the large number of relatively small scale, highly chromatic paintings that must have been executed in the intervening years.

According to a brief note on Poussin written by Giulio Mancini in 1627–28, he visited Venice on his journey to Rome. There is no documentary evidence to support this statement, and rather than crossing the Alps in winter, one would have expected him to have taken the sea route from southern France down the west coast of Italy. But Poussin's early Roman paintings do speak of an intense encounter with the art of sixteenth-century Venice. The Caen *Venus mourning*

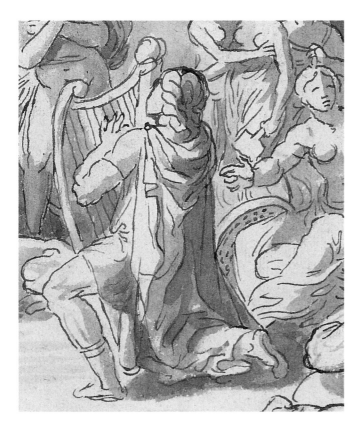

4 detail

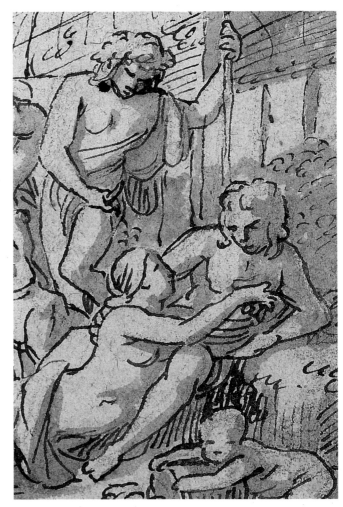

20 detail

paintings (fig. 6) read as flat pattern with almost no spatial logic, there is a clear attempt in paintings such as *Apollo and Daphne* (fig. 11) and the Dresden *Finding of Moses* to construct a continuous space from relatively large tactile forms. Comparing details from *Orpheus in Hades* (cat. 4), from the Marino series, and the *Realm of Flora* (cat. 20) of perhaps five years later, it can be seen how the simplification of the broad reed pen allowed Poussin to treat bodies as graphic building blocks, not as assemblages of detail. Many of these early drawings thus have the appearance of schemata rather than autonomous images.

Poussin suffered from a serious illness in 1630, probably syphilis, from which he never fully recovered. He was nursed back to health in the house of Jacques Dughet, a French cook living in Rome, and in September that year married his young daughter, Anne-Marie. These events, and the rejection for the San Luigi dei Francesi commission, seem to have caused

Adonis, in particular, retains northern skies and a composition close to the principles of the Marino drawings, but overlaid with saturated color and a powerful sense of the physicality of paint.

It is impossible to chart in detail Poussin's evolution as a draftsman during these early years, for the paucity of documented paintings has left us with very few preparatory studies datable by association. Nonetheless, a rough outline of his development, along the same lines as that apparent in his paintings, may be proposed. The starting point is of course the Marino series (cats. 1–13) of 1622–23, where concentration upon the narrative overrides a concern for beautiful draftsmanship. This may simply have been due to the function of the sheets, but although they show Poussin's innovative use of compositional sources, they also betray both his lack of natural ability in the rendering of the human form and the erratic training that had left him technically far behind his Italian peers.

In his earliest Roman years Poussin seems to have favored a reed pen (cats. 16–20, 66–67), rather than the more common pliable quill pen. The resultant breadth of handling parallels the openness that he was pursuing in the early mythological paintings: whereas the Marino drawings generally appear as isolated stages populated by manikins, and the Russian battle

27 detail

Poussin to reconsider his vocation, for his subsequent paintings display a more thoughtful approach: the *Plague at Ashdod* and the revised *Realm of Flora* (fig. 14) of late 1630 and early 1631, the *Parnassus* and *Triumph of David* (fig. 20) of around 1631–32, the *Crossing of the Red Sea* and *Adoration of the Golden Calf* from before 1634, all feature complex, many-figured compositions that must have taken much effort to orchestrate.

A reed pen would have been too coarse to study such compositions in detail, and during the early 1630s Poussin generally used the narrow, wiry line of the quill pen, together with a much more intelligent application of wash. During the 1620s, wash had been dragged perfunctorily along the contours of a figure simply to model the forms; but by the time of the *Nymph and satyr* (cat. 27), perhaps 1631–32, it also evoked the effect of light as an independent and ephemeral entity, playing around the solid forms and bringing the background to life.

The newly liberated wash soon began to play an important role in Poussin's drawings. In the *Saving of the infant Pyrrhus* (cat. 31) of 1633–34, the bold patterns of light and shade are essential in carrying the distraught mood of the composition beyond the bare narrative of the pen outlines. *St Mary of Egypt receiving communion from St Zosimus* (cat. 32) is primarily a landscape study, the flickering sun on the foliage conveyed by layered dabs of wash. These drawings and others of the mid-1630s (cats. 33–35) are the highest points of Poussin's career as a draftsman, combining lucid compositions with an exhilarating sense of the beauty of pure light. His heightened awareness of surface pattern is best seen in the studies for the *Bacchanals* (cat. 36) of 1635–36, mainly executed in pen and ink only, but knitting patches of parallel hatching into the solid forms to create complex figurative drawings that are also masterpieces of abstraction.

These last drawings were preparatory for Poussin's most prestigious commission to date, a pair of paintings to be sent to Paris for the powerful Cardinal Richelieu, Louis XIII's chief minister (figs. 31, 32). Many studies for these paintings were executed; perhaps too many, for the intense effort that Poussin devoted to the compositions resulted in an almost total absence of animation in the meticulously painted, highly patterned canvases. Although they seem to have been well enough received in Paris – the French court spent the next few years persuading him to return to work for the king – the evidence of Poussin's subsequent drawings suggests that he was dissatisfied with the extreme contrivance of the *Bacchanals*, and tried to move away from abstraction for its own sake. In the couple of years after 1636, particularly well represented at Windsor, we find for the first time a relationship between style and subject matter in the drawings.

Before 1636, Poussin could prepare studies in a single style

38 detail

45 detail

for subjects as different in intensity as, for instance, the *Saving of the infant Pyrrhus* (cat. 31) and the *Adoration of the Magi* (Chantilly; F/B, no. 37; R/P, no. 72), both of around 1633. But after the Richelieu *Bacchanals*, we find that studies of dramatic subjects have hard, broken outlines and vigorous passes of dark wash, such as *Camillus and the schoolmaster of Falerii* (cat. 41) and the *Ritual dance before a temple* (cat. 38). Calmer subjects, on the other hand, were treated with soft contours and short strokes of pale wash, as seen in the *Holy Family* (cat. 43) and *Confirmation* (cat. 45). The example of *Moses and the daughters of Jethro* is particularly revealing, for he switched between styles in separate studies of the girls (cat. 46) and Moses attacking the shepherds (fig. 43).

The development of Poussin as a draftsman in the late 1630s is more difficult to follow, for we have fewer datable drawings from this period than from the mid-thirties. But it appears that his adoption of a subject-dependent style was short-lived, as studies for paintings as lyrical as the *Marriage of the Virgin* (cat. 48) and the *Dance to the music of time* (Edinburgh; F/B, no. 149; R/P, no. 144) have regained a robust edge. Such drawings set the scene for the increasingly severe works of the 1640s. But first Poussin was to undergo the ordeal of a journey back to Paris to work for the king, and a return to the type of public painting he had abandoned in 1630. After much negotiation, a formal offer of a five-year contract came from the *surintendant des bâtiments* François Sublet de Noyers in January 1639, though Poussin managed to find enough excuses to delay his journey until the end of 1640. For most artists a return to their native capital to be appointed *premier peintre du roi* would have been a triumph; for Poussin it was one of the most onerous experiences of his life.

16 "Amor vincit Pan" ca. 1625–27

Slight graphite underdrawing, pen and gray-brown ink, gray-brown wash
Verso: fragment of an inscription beginning "le"
Pen and ink
4 ½" × 5 ⁹/₁₆" (115 × 141 mm), upper right corner made up
Watermark: saint in shield (cut)
Provenance: Massimi vol., no. 6 ("Pane e Venere")
RL 11980

A lascivious struggle between a nymph and a satyr was a common motif in bacchic scenes, but Poussin here follows a more erudite adaptation of the theme. The winged cupid represents Eros, spiritual love, whereas the satyr with pipes and a goat's feet and horns – the attributes of Pan – symbolizes Anteros, or physical desire. The scene thus illustrates the triumph of noble love over the animal passions. Such depictions were commonly given the punning title *Amor vincit Pan*, or "Love conquers Pan", with "Pan", Greek for "all", being substituted into the commonplace Latin motto *Amor vincit omnia*, "Love conquers all".

The most celebrated version of this subject was the medallion by Agostino Carracci, frescoed on the ceiling of the gallery of the Farnese Palace in Rome, which was probably known to Poussin both first-hand and through engraved variants by the Carracci and others. Unusually, the present drawing shows Pan reaching for a flask of wine held by the nymph, rather than attempting to assault her (as in cat. 49). It is possible that there is some strand of meaning here that has not been elucidated, for this feature relates the drawing to a painting (known in several versions, of which those in the Pushkin Museum in Moscow, fig. 10, and the Prado in Madrid have good claims to be originals) that shows an identically garlanded satyr drinking out of a flask held by a putto, as a nymph sits to one side and directs proceedings. The date of the painting is controversial, but the consensus is around 1626–27 (Rome 1977, no. 9; Thuillier 1994, no. 45), and the drawing displays the heavy reed-pen line, rudimentary draperies and narrowed facial features typical of the mid-1620s. Even if the drawing cannot be considered directly preparatory for the painting, it is clearly a manifestation of a theme which Poussin was turning over in his mind at this time.

References: Bardon 1960, p.130; Blunt 1945, no. 176; Blunt 1967, p.110; Blunt 1976, p.20; F.A.Q.R. i, p.269; F/B, III, no. 209; Friedlaender 1929, p.253; Martin 1965, p.161; R/P, no. 55

Fig. 10 Poussin, *A nymph and a drinking satyr*. Oil on canvas. 30 ¼" × 24 ½" (77 × 62 cm). Pushkin Museum, Moscow

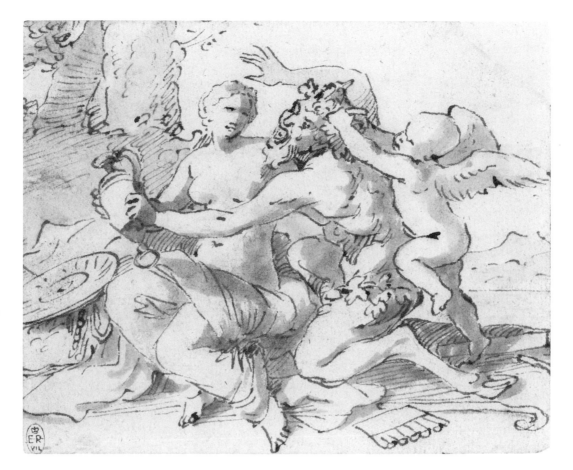

16 *"Amor vincit Pan"*

17 *Achelous* ca. 1625–27

Red chalk underdrawing, pen and brown ink, brown wash
Verso: blank
4 ¹³⁄₁₆″ × 5 ³⁄₈″ (122 × 137 mm), arched top
No watermark
Provenance: Massimi vol., no. 5 ("Acheloo sedente, appoggiato al'Urna")
RL 11986

Hercules was a rival of the river-god Achelous for the hand of Deianeira. The episode is recounted by Achelous himself in Ovid's *Metamorphoses* (IX, 1ff): in a fight for Deianeira's affections, Achelous transformed himself first into a serpent and then into a bull, but Hercules overpowered him in this form, breaking off one of his horns. Nymphs retrieved the horn, and filling it with fruit and flowers made the cornucopia, or "horn of plenty", its mouth overflowing with the earth's bounty.

This drawing shows the defeated Achelous back in his original guise as a river-god, reclining on the urn from which his waters flow, as a putto brandishes the cornucopia at him and two nymphs lounge in the background. The drawing has clearly been cut down, and it has been suggested that it is a fragment of a larger composition, possibly showing Hercules carrying off Deianeira (see cat. 44). But the composition seems to be self-contained, and is quite possibly a simple depiction of Achelous, with the cornucopia as his attribute.

A stylistically identical drawing showing Pan carrying the infant Bacchus (see cat. 67) is in the Fondazione Horne in Florence (F/B, no. 434; R/P, no. 53). Although the sheet itself is square, the composition is drawn with an arched top, as here, and it is probable that cat. 17 and the Horne drawing relate to a single project. It was proposed by Blunt (in F/B, V) that both are early copies of lost originals, but the handling of the extensive underdrawing and the thick reed-pen are typical of Poussin's drawings of the mid-late 1620s, and there seems no reason to doubt their authenticity.

References: Blunt 1945, no. 173; Blunt 1976, p.20; F.A.Q.R. i, p.269; F/B, III, no. 220, V, pp.106, 111; Friedlaender 1929, p.253; R/P, no. 54

17 *Achelous*

18 *The death of Actaeon* ca. 1625–27

Pale blue paper, slight graphite (?) underdrawing, pen and brown ink
Verso: blank
5 ⅞″ × 9 ⁵⁄₁₆″ (150 × 236 mm)
No watermark
Provenance: Massimi vol., no. 16 ("Diana Cervicida")
RL 11985

The Massimi catalogue describes this drawing simply as Diana hunting, though goes on to refer to the legend of Actaeon. Most later writers have dismissed the Actaeon connection; but Diana, rising from kneeling, and the semi-naked nymphs reclining around large vessels cannot be engaged in a hunt, and the scene must be that of the transformation and death of Actaeon, who while out hunting with his dogs came upon the naked Diana as she was bathing with her attendants. Outraged, she transformed him into a stag, and he was torn to pieces by his own hounds (Ovid, *Metamorphoses*, III, 138ff).

It is highly unusual for depictions of the episode to show Diana firing arrows after the fleeing Actaeon, but the great painting by Titian now in the National Gallery in London shows exactly this. The whereabouts of this painting in the early seventeenth century are not firmly established, but Poussin was heavily influenced by Titian's mythological paintings in the earlier part of his career and may well have known the original or some copy of it.

Unusually, the drawing is executed in pen and ink only, on blue paper, a distinction it shares with the *Peasant women sewing* (cat. 66). The heavy reed-pen is characteristic of Poussin's early years in Rome. The oblique composition and the scale and types of the figures are very close to paintings such as the Munich *Apollo and Daphne* (fig. 11), which, although in bad condition, must be a work of the mid-late 1620s. The present sheet has clearly been cut down along the top, and reconstructing the sheet with a small addition along the top would give the drawing the same proportions as the Munich painting. It is not inconceivable that the present drawing is a study for a pendant to the *Apollo and Daphne*, each showing one of the most popular metamorphoses in mythology.

An accurate copy of the drawing is preserved in a private collection (F/B, no. A178; R/P, no. R968). Such copies are hard to date, but this must have been made after the present drawing was trimmed, as it is cropped to exactly the same extent. Perhaps the trimming was done by Poussin himself, experimenting with the proportions of the figural composition.

References: Blunt 1945, no. 178; Blunt 1971, p.215; Blunt 1976, p.22; Blunt 1979, pp.20, 27, 180ff, 199; F.A.Q.R. i, p.270; F/B, III, no. 200, V, p.109; Friedlaender 1929, p.253; London 1986, no. 69; Paris 1960, no.129; R/P, no. 42

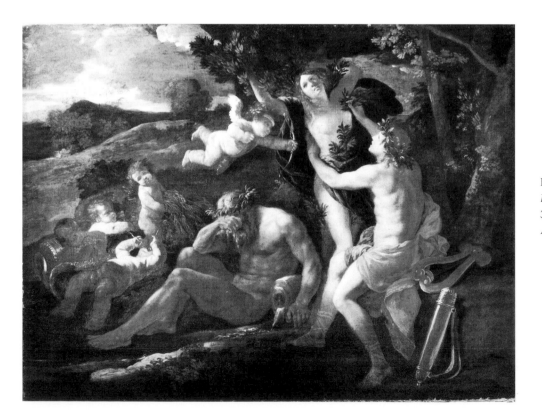

Fig. 11 Poussin, *Apollo and Daphne*. Oil on canvas. 38 ¼″ × 51 ½″ (97 × 131 cm). Alte Pinakothek, Munich

19 Perseus and Andromeda: The origin of coral ca. 1627

Pale buff paper, red chalk underdrawing, pen and brown ink, brown wash
Verso: blank
8 ⅞″ × 12 ¹⁄₁₆″ (225 × 307 mm)
No watermark
Provenance: Massimi vol., no. 23 ("Perseo ed Andromeda")
RL 11984

The rescue by Perseus of the princess Andromeda, chained to a rock to be devoured by a sea-monster, was one of the most popular tales of classical mythology. But Poussin here presents a rarely depicted episode of the story: while washing his hands after slaying the monster, Perseus laid on the ground the head of Medusa, whose glance turned living things to stone, and whom Perseus had slain earlier. The blood of the gorgon spilled on to the seaweed, which was thus transformed to blood-red coral. Poussin illustrated the mythological origins of natural forms in two other compositions, the *Realm of Flora* (cat. 20) and *Venus and Adonis hunting: The coloring of the rose* (cat. C7). Coral held a peculiar fascination for the seventeenth century, and many precious *objets d'art* incorporating coral, such as figures of the transformed Daphne or Actaeon, alluded to its reputed metamorphic nature.

The principal source for the story was Ovid's *Metamorphoses* (IV, 740ff; the legend can also be found several times in the poetry of Marino), and it is evident from certain features of the drawing that Poussin was using the widely read Italian translation of the *Metamorphoses* by Giovanni Andrea dell'Anguillara, who altered many of the details of Ovid's stories and added much picturesque incident. He (and not Ovid) described how, having slain the monster, Perseus flew to an island where he tied his steed, the winged horse Pegasus, to a palm tree. Only after washing his hands, in Anguillara's version, did he return to free Andromeda, who can be seen still chained to the rock in the distance, with the monster dead before her. Sea-nymphs play with the newly transformed coral, but the role of the figures to the left of the composition – including a river-god and two or more naiads – is not clear. Perseus's protectors Mercury and Pallas, visible in the clouds, are mentioned in an earlier verse of Anguillara's translation, but no textual source refers to an *amor* pouring the water for Perseus: here Poussin based his figure on that of a putto untying Andromeda in the illustrated French edition of Philostratus, *Les Images ou Tableaux de plate peinture des deux Philostrates* (Paris 1614).

A large finished version of the *Origin of coral* survives at Windsor (fig. 12, cat. C5), as for the drawing of the *Realm of Flora* (see cat. 20). There is no associated painting by Poussin,

Fig. 12 Copy after Poussin, *Perseus and Andromeda: The origin of coral*. Black chalk underdrawing, pen and brown ink, brown wash. 13 ¹³⁄₁₆″ × 20 ¼″ (351 × 515 mm). Cat. C5

18 *The death of Actaeon*

19 *Perseus and Andromeda: The origin of coral*

but the composition was nonetheless known outside Poussin's immediate circle. Although differing in many details, a painting in Munich by Sébastien Bourdon (fig. 13) of this rare subject has an obvious link with Poussin's design. The compositional principles are very similar, and the distinctive palm and flying Victory are direct quotations. It is unclear how Bourdon could have known the composition, for although he was in Rome between 1634 and 1637 he seems not to have fraternized with Poussin, nor with Cassiano dal Pozzo, from whose collection the finished versions ultimately came to Windsor.

The association of a second painting with the composition is rather easier to explain. A coastal landscape of the *Origin of coral* painted by Claude in 1674 and now at Holkham Hall shows Perseus washing his hands in a stream of water poured by an *amor* – an exact reversal of the group in Poussin's com-

position – with Pegasus tied to a rather prominent palm tree behind and nymphs playing with the coral to the left. The present drawing was almost certainly known to Claude, for it was then in the collection of Cardinal Camillo Massimi, who commissioned the painting from Poussin's compatriot and old friend nine years after Poussin's death.

The drawing must be of the same date as its companion, cat. 20.

References: Bardon 1960, p.129; Bellori 1672, p.443; Blunt 1945, no. 170; Blunt 1960b, p.170; Blunt 1967, pp.119f; Blunt 1976, pp.23–25; Blunt 1979a, pp.27, 162f, 177, 197; F.A.Q.R. i, p.272; F/B, III, no. 224; Friedlaender 1929, pp.127, 254; Oberhuber 1988, p.30, no. D190; Oxford 1990, no. 18; Paris 1994, no. 15; Rosenberg 1991, p.211; R/P, no. 36; Simon 1978; Sydney 1988, no. 35; Thuillier 1969, p.105; Worthern 1979, p.587

Fig. 13 Sébastien Bourdon, *Perseus and Andromeda: The origin of coral*. Oil on canvas. 43 ¾" × 55 ½" (111 × 141 cm). Alte Pinakothek, Munich

20 *The realm of Flora* ca. 1627

Pale buff paper, red chalk underdrawing, pen and brown ink, brown
wash
Verso: sketch for the same
Red chalk
8 ⁵⁄₁₆″ × 11 ⁷⁄₁₆″ (211 × 291 mm), upper corners cut
No watermark
Provenance: Massimi vol., no. 35 ("La trasformatione de' Fiori")
RL 11983

At the trial for fraud of the Sicilian diamond dealer Don
Fabritio Valguarnera in July 1631, Poussin testified that he had
recently painted for Valguarnera "un giardino di Fiori". This
can be identified with a canvas now in Dresden (fig. 14), gen-
erally known as the *Realm of Flora*, which depicts the goddess
in a bowered garden, surrounded by figures whose legends
account for the origins of certain flowers. The specific flowers
produced often varied in different renderings of each myth,
and attempts have been made to identify a source for the pic-
ture, in translations of Ovid's *Metamorphoses* or *Fasti*, or in
Marino's *Adone*, *Europa* or *La Rosa*. But no one text fully
accounts for all the features of the painting, and it must be
regarded as a visual assemblage of stories rather than as an
illustration of a single literary passage.

Reading from the left, we see Ajax, who threw himself on
his sword and whose blood gave rise to a flower that varies
from version to version, shown as a carnation in the Dresden
painting; Clytie, who pining for the love of Apollo watched
his sun-chariot cross the sky day by day, and turned into a
sunflower or marigold; Narcissus, who was caused to fall in
love with his own reflection as a punishment for spurning the
affections of the water-nymph Echo (supporting the bowl),
and who on his death was changed into the flower that bears
his name; Flora herself, dancing in the drawing, scattering
flowers in the painting; Hyacinthus, struck on the head by a
discus thrown by Apollo, and whose blood yielded the hya-
cinth; Adonis, source of the anemone when his blood struck
the ground after he was gored in the thigh by a boar while
hunting; and the lovers Crocus and Smilax, turned into the
crocus flower and the yew respectively for their impatience.

Any doubts about the authenticity of the drawing, as
expressed by Oberhuber along with his dismissal of the entire
Marino group as copies, must be dispelled by the large, rough
preparatory drawing for the composition that was revealed
on the back of the present sheet when it was lifted from its old
mount during recent conservation. In this indistinct sketch the
essence of the composition is already apparent, but there are
fewer figures. Flora, surrounded by a ring of dancing putti,
stands with both arms outstretched at the center; Apollo rides
his chariot through the sky, and the composition is framed by

a tree on the left and a bower on the right. Ajax falls on his
sword to the left, and before him are Crocus and Smilax. To
the right the sketch becomes extremely rough, but a seated
figure resting on its right elbow, not included in the final com-
position, may be discerned among the tangle of lines.

The present drawing is obviously connected with the
Dresden painting, although there are many differences of
detail between the two. It would be simplest to assume that it
is directly preparatory for the painting, and thus of late 1630
or early 1631, but there are difficulties with this. First, the
drawing is one of a group of three illustrations of mythologi-
cal transformations. *En suite* with the present sheet is a study
for a depiction of *Perseus and Andromeda: The origin of coral* (cat.
19), and also in the British Royal Collection are large, carefully
drawn versions of these two compositions (cats. C5 and C6,
figs. 12 and 15) and a third, of *Venus and Adonis hunting: The
coloring of the rose* (cat. C7), all described by Bellori (without
making it clear whether he refers to a painting or drawing of
Flora). The three compositions must have been devised at the

20 verso: schematic diagram

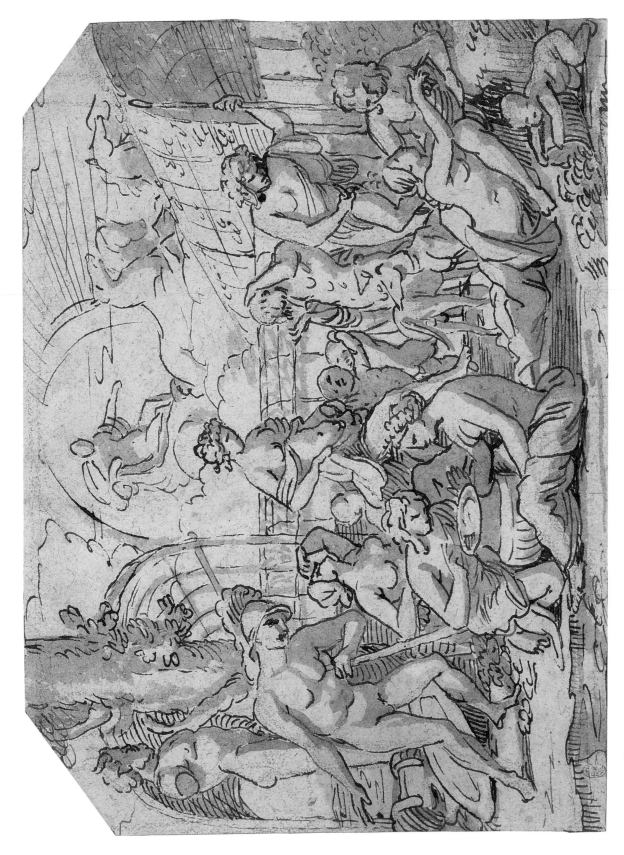

20 *The realm of Flora*

same time, but there is no indication that the painting in Dresden was ever intended to form part of a set, and it would be most unusual for an artist to formulate two pendant compositions while devising a single projected painting.

As the drawing was thus probably conceived independently of the painting, we must consider what its style can tell us, and it has often been noted that it is aesthetically much less accomplished than the painting. In its handling of space the drawing is closer to paintings such as the Louvre *Triumph of Flora*, of around 1627; the figure of Flora on the recto of cat. 20 is an exact reversal of Primavera in that painting, and the Flora on the verso, with arms outstretched, is in the pose of Flora in the Louvre painting. The claustrophobic composition of the drawing has been so expanded and lightened in the painting, and the spatial relationships between the figures have been so refined, that one must conclude that some time elapsed between the conception of the drawing and the execution of the painting. Blunt (1960b) was overstating his case to claim that the style of the drawing is almost exactly that of the Marino group, but Sterling's response (*Actes* 1960) that Poussin was deliberately drawing in an outdated style is unarguable. Although the wash is different in character, the handling of the pen here is close to that in the damaged study in the British Museum for the *Death of Germanicus* (F/B, no. 129; R/P, no. 27), a drawing of late 1626 or 1627, and a date of around 1627 for both cats. 19 and 20 would also fit their heavily figurated compositional style.

The three compositions of the *Realm of Flora*, the *Origin of coral* and the *Coloring of the rose* were therefore probably conceived as an autonomous series around 1627: but why? The existence of the set of carefully finished versions of the compositions could provide the answer. These drawings very probably came from the collection of Cassiano dal Pozzo, whose wide-ranging and erudite interest in antiquity and natural history is well known, and who was at this time beginning to assemble his enormous "Paper Museum", the bulk of which is now also at Windsor. Cassiano was one of Poussin's most supportive patrons in his early years, and nothing would be more natural than for him to commission from the young artist a set of finished drawings of what might be termed "mythological natural history".

This set of drawings may perhaps be connected with those mentioned in a letter from Poussin to Cassiano, undated but probably of 1627 (see Mahon 1962, p.133). Having referred to the composition of *Hannibal on an elephant* (Fogg Art Museum) that he was painting for Cassiano, Poussin wrote: "As to your drawings, I think of them every day, and soon I will finish something." (Jouanny 1911, pp.1–3.) This has been taken to refer to drawings after the antique for Cassiano's Paper Museum, but there is no hard evidence that Poussin contributed

any such drawings, and it may be that the drawings of which he writes were finished figural compositions. The coincidence of the probable date of the letter with the date suggested by the style of cats. 19 and 20 might lead one to conclude that they were preparatory for the drawings mentioned in the letter.

The only problem is that the large finished drawings, cats. C5–C7, do not appear to be by Poussin. They are usually described simply as copies (although Oberhuber suggested that they might be autograph *modelli* – somewhat perversely, having dismissed cats. 19 and 20 as crude copies); Blunt hazarded the name of Pierre Lemaire for these and a heterogeneous group of other drawings at Windsor, and Brigstocke (in Oxford 1990) proposed Pietro Testa as the author, whose graphic style is typically much richer than these rather dry affairs. Stylistically they are unlike anything certainly by Poussin known to us, with each line slowly and carefully drawn, and shaded with a combination of wash and fine parallel hatching replicating the effect of an engraving. Only in the foreground does the draftsman loosen up, and there the handling of both pen and wash is close to autograph drawings such as cats. 25 and 27. But although it would make perfect sense, methodologically, to attribute the three finished sheets to Poussin himself, these small areas are insufficient to justify such an attribution when set against the expanses of ponderous figuration. Perhaps they are copies made for Cassiano by one of his stable of young draftsmen, from originals, now lost, in his own collection; it is unlikely we will ever know.

The question remains of the circumstances in which the Dresden painting was commissioned. The two preparatory drawings, cats. 19 and 20, come from the Massimi collection and were therefore probably in Poussin's possession until at least the later 1630s, when Massimi took drawing lessons from the artist. Valguarnera appears not to have been in touch with Poussin until late 1630, but as he ordered the painting of the *Plague at Ashdod* (Louvre) around that time, it seems reasonable to suppose that he saw a drawing for the *Realm of Flora* in Poussin's workshop and asked the artist to execute a painted version of the composition. Naturally, Poussin would revise the composition in the light of his developing aesthetic sense, thus explaining the increase in sophistication in the painting over the drawing.

References: *Actes* 1960, I, pp.174f; Badt 1969, pp.139, 200; Blunt 1945, no. 169; Blunt 1958, p.76; Blunt 1960b, p.170; Blunt 1961; Blunt 1966, under no. 155; Blunt 1967, p.106; Blunt 1976, p.26; Blunt, 1979a, pp.27, 160, 163, 194, 197ff; Costello 1950; F.A.Q.R. i, p.274; F/B, III, no. 214, V, p.111; Friedlaender 1929, p.255; Kauffmann 1965; Mahon 1960, p.292; Mahon 1962, pp.86–92; Oberhuber 1988, pp.28, 247, no. D188; Oxford 1990, under no. 18; Paris 1960, under no. 20, no. 127; Paris 1994, no. 14, under no. 44; R/P, no. 30; Simon 1978; Spear 1965; Thomas 1986; Wild 1980, I, pp.46–49, II, p.34; Worthern 1979

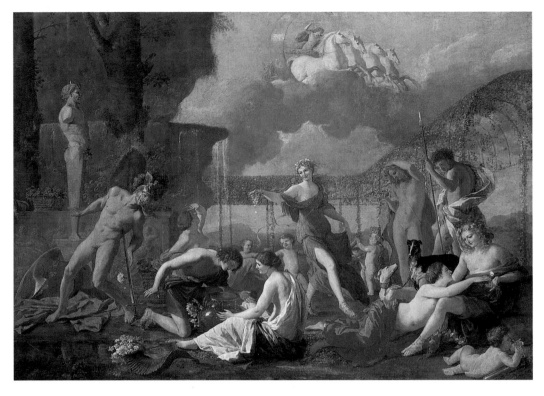

Fig. 14 Poussin, *The realm of Flora*. Oil on canvas. 51 ½" x 71 ¼" (131 × 181 cm). Gemäldegalerie Alte Meister, Dresden

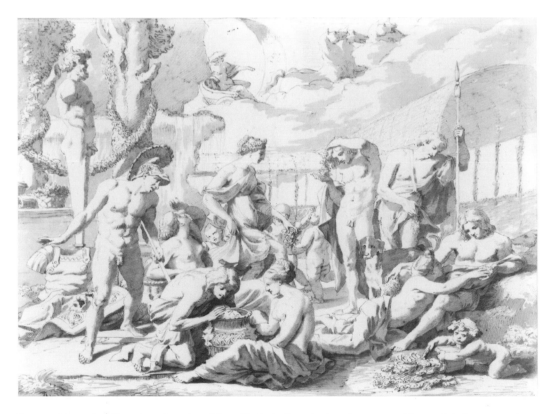

Fig. 15 Copy after Poussin, *The realm of Flora*. Black chalk underdrawing, pen and brown ink, brown wash. 13 ¾" x 18 ¾" (349 × 476 mm). Cat. C6

21 *The triumph of Bacchus and Ariadne* ca. 1627

Pale buff paper, red chalk underdrawing, pen and gray-brown ink,
pale gray-brown wash
Verso: blank
4 ¹⁵/₁₆″ × 16 ⁵/₁₆″ (126 × 414 mm)
No watermark
Provenance: Massimi vol., no. 18 ("Il Choro di Bacco")
RL 11990

Abandoned by her lover Theseus on the island of Naxos,
Ariadne was discovered by Bacchus and his followers (see
cats. 33 and 34 verso), who received her into the chariot of the
god (Ovid, *Metamorphoses*, VIII, 176ff). Although not strictly
part of a narrative, the so-called *Triumph* of either Bacchus
alone or Bacchus and Ariadne in a chariot, accompanied by a
procession of nymphs, satyrs, centaurs, putti and all sorts of
animals, was a picturesque and popular decorative subject,
and was often found on the sides of antique sarcophagi.
Poussin has adopted this frieze-like format, and indeed
several of the motifs of the drawing – the leopards leading the
procession, the centaur before the chariot, the maenads fol-
lowing – are closely modeled on Roman sculpture.

The function of the drawing is not at all clear. It is not con-
nected with any known painting, and indeed such a long can-
vas would be very unusual (though the *Meleager and Atalanta
hunting* in the Prado and the *Dance in honor of Priapus* in São

Paulo approach these proportions). The drawing is hard to
date on account of the rather scratchy pen-nib which affected
Poussin's usual fluency of line, but the figure types and the
handling of the wash are very close to works of the mid-late
1620s such as the *Origin of Coral* (cat. 19). Brigstocke (in Oxford
1990) suggested that the drawing might be close to the Kansas
City study for the Richelieu *Triumph of Bacchus* of 1635–36 (fig.
29), but the resemblances are superficial and the style of the
present drawing precludes such a late dating.

A painting in the Prado (fig. 16), which has in recent years
been widely accepted back into Poussin's corpus, shows
Bacchus receiving Ariadne into his chariot. It has been gener-
ally dated to Poussin's first Roman years, as early as 1624 by
Rosenberg (Rome 1977, no. 1), but more reasonably to around
1627 by Mahon (1962, pp.17f) and others. The painting was
therefore probably produced in the same span of years as the
present drawing, and although it is compositionally quite dis-
similar, the figure types and treatment of space of the two have
much in common – well characterized by Mahon as Poussin's
"exuberant weaknesses". It is quite possible that, while not a
preparatory study for the Madrid painting in the strictest
sense, the present drawing represents Poussin's first thoughts
about the theme, attempting to come to terms with the antique
tradition before remodeling the subject in his own idiom.

References: Blunt 1945, no. 172; Blunt 1976, p.22; Blunt 1979, p.101;
Edinburgh 1981, no. 19; F.A.Q.R. i, p.271; F/B, III, no. 183;
Friedlaender 1929, p.253; Oxford 1990, no. 39; Rosenberg 1991,
pp.211–12; R/P, no. 61

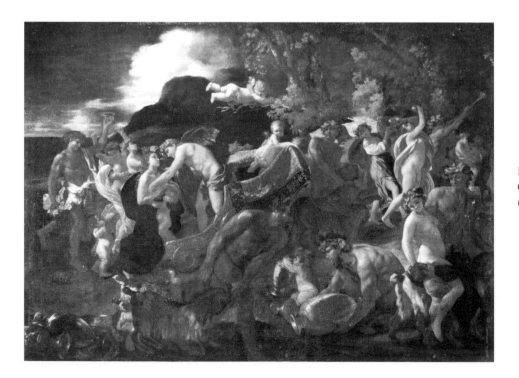

Fig. 16 Poussin, *Bacchus and Ariadne*.
Oil on canvas, 48″ × 66 ½″
(122 × 169 cm). Prado, Madrid

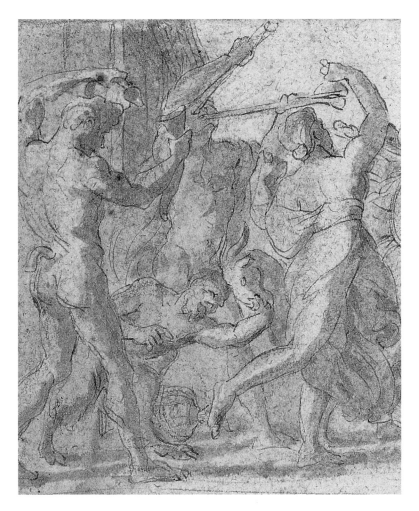

21 detail

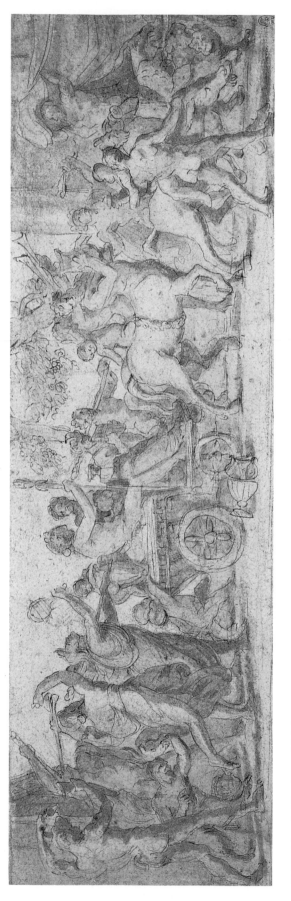

21 *The triumph of Bacchus and Ariadne*

22 *The intervention of the Sabine women*

22 The intervention of the Sabine women
ca. 1630

Graphite underdrawing, pen and brown ink, brown wash, stained at
upper center
Verso: *The Adoration of the Golden Calf*
Black chalk
6 $^7/_{16}$" × 11" (163 × 280 mm)
No watermark
Provenance: Vol. II, p.13
RL 11884

The subject of this drawing is not altogether clear. It has been
identified as the victory of the Israelites over the Midianites, as
described in Numbers (31:1–12); but the only pictorial details
mentioned there are the ceremonial objects and trumpets car-
ried into battle by the priest Phinehas, which hardly accords
closely enough with the drawing. Further, the Biblical account
states that the victors took captive the women and children of
the enemy, whereas the women seen here respectively pray to
the heavens, are reunited with a husband, or rush towards the
battle.

The presence of the women suggests one episode in classi-
cal legend, the intervention of the Sabine women in the battle
between Romans and Sabines. Livy (I, 9) and Plutarch (*Life of
Romulus*, 14) relate how, shortly after its founding, Rome
attracted refugees and vagrants from beyond its borders, and
its population became predominantly male. In a ruse to cor-
rect this imbalance, Romulus invited neighboring tribes to a
festival in the city; at a given signal, the young Romans broke
into the crowd, some carrying away the unmarried women,
others fighting off their menfolk (for this scene, see cats. 30
and 31). The Sabine women were married to the Romans and,
accepting their situation, ensured the future population of the
city. When some time later a Sabine force attacked Rome, the
women intervened in the battle between their husbands and
their siblings, so bringing peace between the tribes.

Poussin's treatment of the scene here is far from success-
ful, the women being merely appended to the tangled compo-
sition of the battle, but his handling of space is much more
resolved than in the battle pieces of the Marino group (cats.
10–13). No painting by Poussin of the subject is known; the
drawing's resemblance to the battle pieces in Russia (fig. 6)
and the Vatican is merely generic.

A rough sketch in black chalk on the verso of the sheet rep-
resents the *Adoration of the Golden Calf*. It is related to a paint-
ing of the same subject in the M.H. de Young Memorial
Museum in San Francisco (fig. 17), formerly accepted as auto-
graph but now generally, and rightly, considered to be the
work of an imitator of Poussin (the Neapolitan painter Andrea

di Lione has been suggested). There are significant differences
between the figuration of the two, and it is hard to believe that
such an imitator would – or could – have devised his compo-
sition having seen only this vaguest of outlines. Poussin must
have developed the composition further in more careful
drawings, and conceivably in a painting, known to the *pasti-
cheur* but now lost.

The San Francisco painting bears an inscription, which
was formerly read as either *NP 1626* or *NP 1629* – the last digit
has since disappeared during cleaning. None of Poussin's
early paintings is dated, and it is possible that the date was
totally spurious. But it is much easier to reconcile the design
of the San Francisco painting with Poussin's increasingly open
compositions of the years around 1630 than with the some-
what irrational space of the mid-1620s, and the figure types of
the drawing on the recto have more in common with those in
the looser and increasingly wiry drawings of the late twenties
and early thirties than with the heavy figures of the mid-
1620s. The sheet must date from around 1630, and if the
inscription on the San Francisco painting had any basis in fact,
it presumably read *NP 1629*.

References: Blunt 1945, no. 180; Blunt 1966, under no. 25; Blunt 1973;
Blunt 1974, p.761; Blunt 1979a, pp. 27, 160–62, 177, 195; F.A.Q.R. iii,
p.110; F/B, I, no. 22 (verso), V, no. 387 (recto); Friedlaender 1929,
p.258; Mahon 1960, p.291; Mahon 1962, p.6; Oberhuber 1988, pp.28,
232, 245, no. D176; Paris 1973, p.66; Paris 1994, under no. 9; R/P, no.
24; Sutherland Harris 1990, p.150; Wild 1980, II, under no. 23, no. 63a

Fig. 17 Copy after Poussin, *The Adoration of the Golden Calf*. Oil on canvas. 39 ¼″ × 50 ½″ (99.5 × 128.5 cm).
M.H. de Young Memorial Museum, San Francisco

22 verso *The Adoration of the Golden Calf*

23　Study for the *Triumph of David*
ca. 1631–32

Graphite underdrawing, pen and brown ink, brown wash
Verso: blank
4 ¼″ × 3 ¾″ (108 × 95 mm), arched top
No watermark
Provenance: Massimi vol., no. 50 ("Le Donne Israelite")
RL O37

This is a study for the figures in the left foreground of the painting of the *Triumph of David* (fig. 20), now in the Dulwich Picture Gallery. Poussin devoted much effort to this group; an earlier study for the same figures in red chalk at Chantilly (fig. 18; F/B, no. 29; R/P, no. R253) bears a pattern of pinholes exactly corresponding to the bare arm of the woman at the far left and the upper back and head of her companion in the painting. The technique of pricking full-scale designs on large sheets of paper ("cartoons"), then pouncing dust through the holes to transfer the design to the painting surface, was common practice in the artists' workshops of the Renaissance and Baroque, but this is the only surviving instance in the whole of Poussin's œuvre. X-ray images of the Dulwich picture reveal the reason for this mechanical operation: the group of three women originally stood as close to the kneeling mother in the painting as they do in the present drawing, some eight inches to the right of their present position, and the cartoon process was used to move them *en bloc* during the execution of the painting.

There are other major pentimenti in the painting visible both with X-rays and the naked eye, notably among the background figures and architecture, and this led Blunt to propose that the painting was worked on over a period of several years. But pentimenti alone are not sufficient to prove a prolonged execution, and I fail to see any significant variations of style across the surface of the painting. Poussin certainly worked intently on the composition, but there is no good reason to suppose that he returned to it after a hiatus and altered the details. In style the painting falls between the 1630–31 *Realm of Flora* and the 1633 Dresden *Adoration*; a date of ca. 1631–32 for the two drawings thus seems probable.

However, the authenticity of both the Windsor and Chantilly sheets, and indeed the painting itself, has recently been repeatedly questioned. Thuillier (1974) tentatively suggested an attribution of the painting, and implicitly the Windsor and Chantilly drawings, to Charles Mellin (though he is now inclined to accept the painting as by Poussin, while still rejecting the drawings). Rosenberg and Prat also reject both sheets, while accepting the painting. I remain baffled by these views. The painting is perfectly compatible with Poussin's work of around 1632. Likewise, cat. 23 is absolutely in the style of Poussin's drawings of the early 1630s. Finally, the pricking of the Chantilly sheet, when taken with the evidence of the X-rays, makes it methodologically very difficult to doubt, and an unusual technique – in this case the use of red chalk – cannot disqualify a drawing.

The three women, and indeed the whole composition, are closely based on a print by Giorgio Ghisi, after a design by Giulio Romano for one of a series of tapestries illustrating the exploits of the Roman general Scipio Africanus (fig. 19). The differences between Poussin's painting and the engraving are illuminating: a loosely squared tiled floor is introduced to give the middle ground some structure; the rabble of a procession is calmed down and spaced out; the background architecture is enlarged in scale to eliminate the fussy line of columns of the print. By the early 1630s Poussin was pursuing space, order and dignity in his compositions, as can also be seen by contrasting the drawing of the *Realm of Flora* (cat. 20) of ca. 1627 and the subsequent painting of 1630–31 (fig. 14).

References: Badt 1969, pp.203, 614; Blunt 1945, no. 182; Blunt 1966, under nos. 33 and 146; Blunt 1967, pp.70f; Blunt 1976, p.29; Blunt 1979, p.27; Chantilly 1994, under no. 119; F.A.Q.R. ii, p.178; F/B, I, no. 30, V, p.70; Friedlaender 1929, p.256; Mahon 1960, p.294; Mahon 1962, pp.30ff, 89; Paris 1960, under no. 9; R/P, no. R1287 and under no. R253; Thuillier 1974, under no. B26; Thuillier 1994, under no. 91; Wild 1980, I, p.42, II, under no. 41

Fig. 18 Poussin, Study for the *Triumph of David*. Red chalk, with pin holes. 4 ¾″ × 6 ½″ (120 × 165 mm). Musée Condé, Chantilly, inv. 193

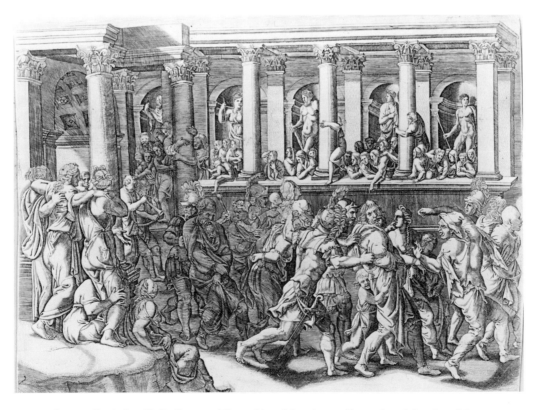

Fig. 19 Giorgio Ghisi after Giulio Romano, *The mocking of the prisoners*. Engraving. Ashmolean Museum, Oxford

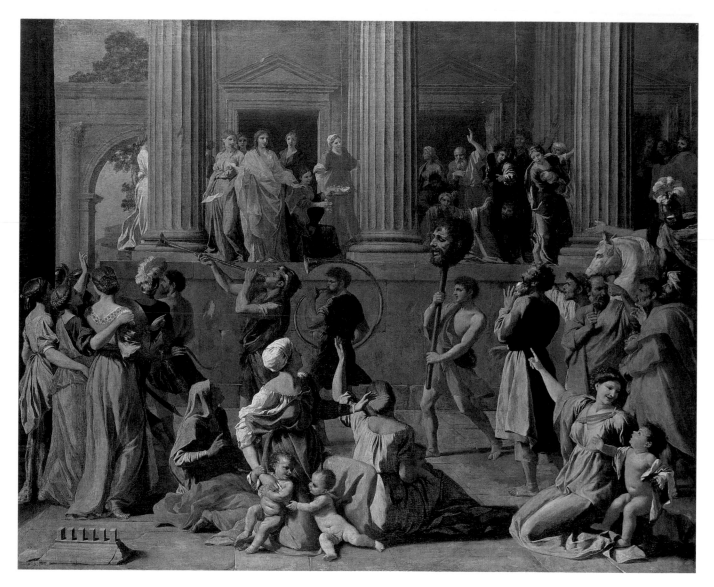

Fig. 20 Poussin, *The triumph of David*. Oil on canvas. 46" × 57 ½" (117 × 146 cm). Dulwich Picture Gallery, London

23 Study for the *Triumph of David*

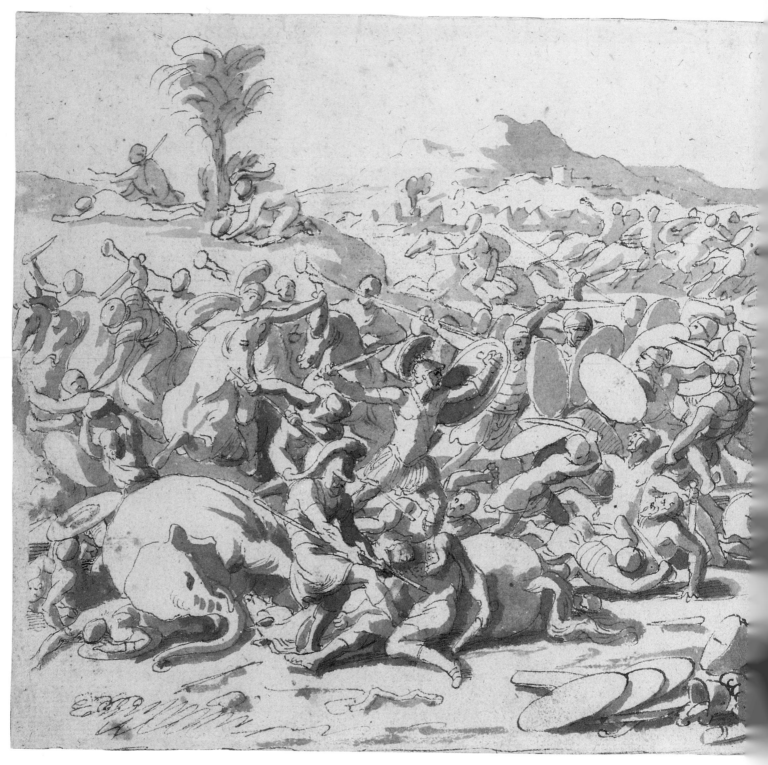

24 *The victory of Godfrey of Bouillon*

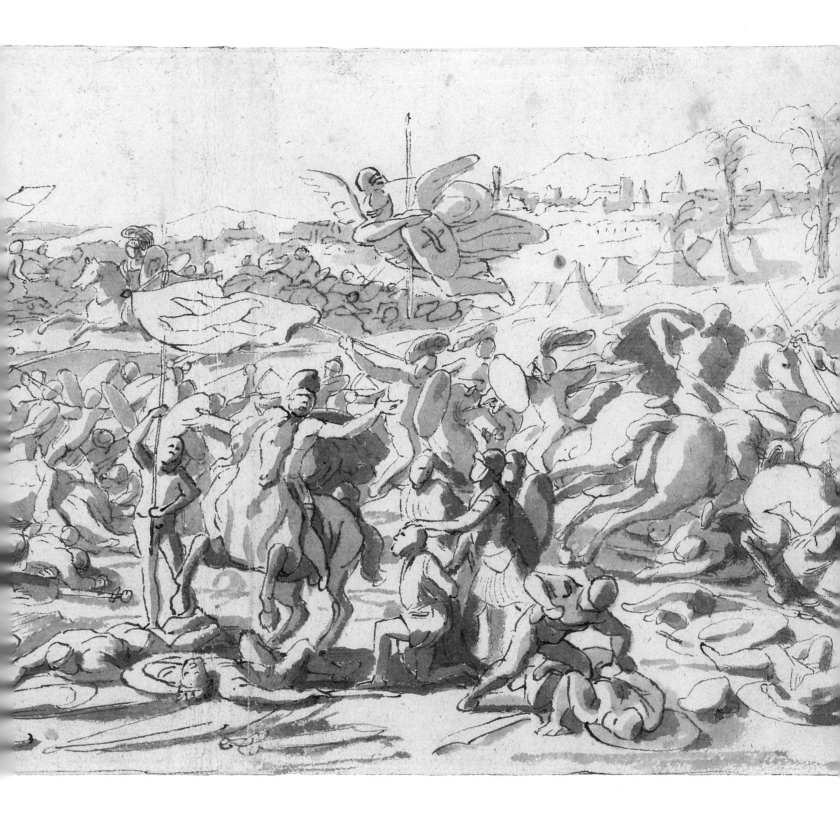

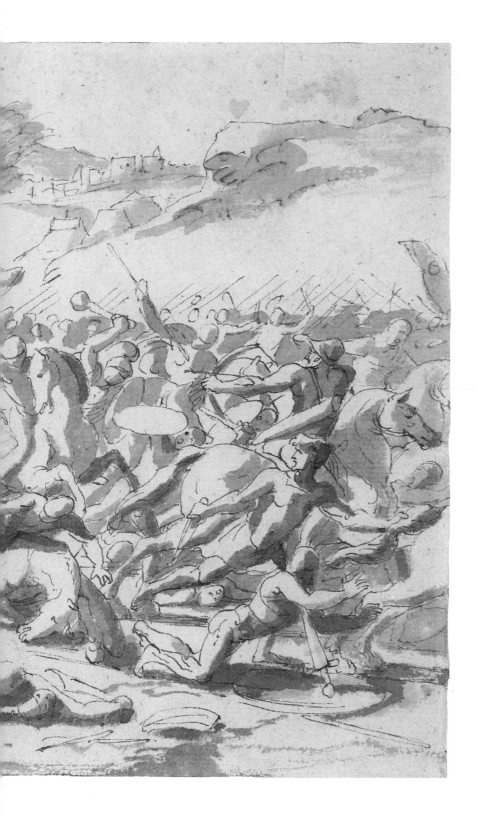

25 *A dance before a herm of Pan*
ca. 1631–32

Slight graphite underdrawing, pen and brown ink, pale brown wash
Verso: sketch for a *Holy Family*
Red chalk
8 ⅛″ × 12 ⅞″ (206 × 327 mm)
Watermark: saint in shield
Provenance: Massimi vol., no. 20 ("Le Ceremonie di Pane")
RL 11979

This careful drawing depicts a ritual dance before a herm, as
one of the dancers pours a libation at the base of the statue and
a satyr assaults a nymph. The pipes and shepherd's crook at
the base of the herm identify the honored god as Pan, though
the composition has strong bacchic undertones: a putto drinks
from an urn behind the herm, while the nymph spills her vase
of wine – a visual pun on the depiction of naiads with vases as
the sources of springs.

 The immediate purpose of the drawing is unknown. It has

Fig. 21 Poussin, *Dance before a herm of Pan*. Oil on canvas.
39 ½″ × 56″ (100 × 142 cm). National Gallery, London

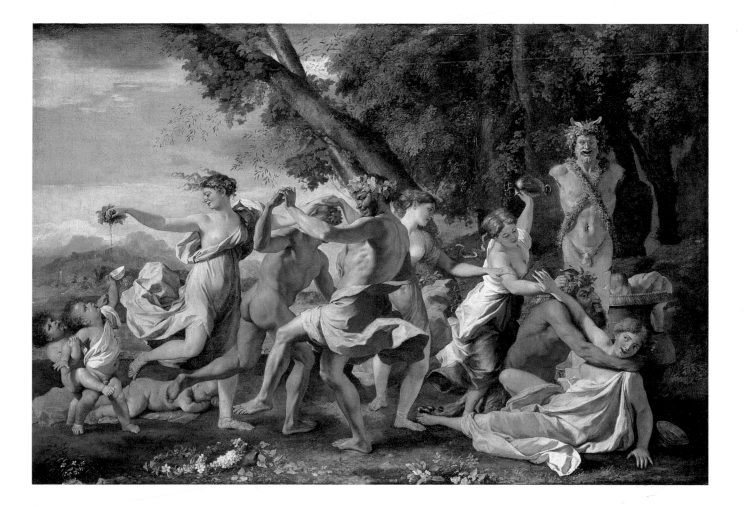

none of the qualities of a sketch, and the few visible traces of underdrawing are quite without spontaneity; only the foreground objects and the herm display Poussin's usual lively touch. It is obviously related to a painting in the National Gallery in London (fig. 21) that uses many of the same motifs, but they have been rethought and rearranged to such an extent that one cannot describe the drawing as preparatory for the painting in the usual sense. The composition has been reversed, and the two groups have been integrated by turning one of the dancers to restrain a nymph who threatens to break a vase over the satyr's head. The ritualistic references in the drawing have been played down: instead of pouring a libation the dancer squeezes grapes into a bowl held by one of the putti, another of whom sleeps drunkenly on the ground, and the theatrical masks (alluding to the reputed origins of Attic drama in bacchic ceremonies) have been removed.

The loose structure of the dancing group in the drawing has been tightened up in the painting, with the casual arrangement of arms and feet remodeled into meticulous abstract patterns. The central figure is preserved with little change other than the position of his right arm, and the woman with outstretched arm is in exactly the same pose but seen from the front, indicating the use of a three-dimensional model by Poussin.

This dancing group is taken one step further in the foreground of the National Gallery *Adoration of the Golden Calf*. Three of the dancers there mirror those in the painted *Dance before a herm*, but the pattern of arms and legs is even more contrived, with the feet in a long regular V-shape. Logically, this would suggest that the *Golden Calf* was devised *after* the *Dance*. We know that the *Golden Calf* was painted before 1634, as it was recorded in an inventory of the collection of Amadeo dal Pozzo, cousin of Cassiano, in that year. The *Dance* has been

dated as late as the end of the 1630s, but the consensus is now for shortly before the *Golden Calf*, and thus around 1632–33 (Mahon 1962, p.83; Thuillier 1994, no. 87; Paris 1994, no. 47 etc.).

The greater pictorial sophistication of the painting suggests that some time elapsed between the execution of the present drawing and the conception of the painting, but sophistication is not quantifiable and one can only guess how many months or years separated them. The figure types and handling of line and space in the present drawing are close to sheets such as the study for the *Triumph of David* (cat. 23), probably of the early 1630s, and a dating of cat. 25 to ca. 1631–32, and of the painting to ca. 1632–33, does not seem unreasonable.

A very slight sketch was discovered on the verso of the sheet when it was recently lifted from its old mount during conservation. The red chalk lines are hard to pick out, but appear to show the Madonna seated with the infants Christ and St John standing either side of her lap, while another figure, presumably a saint, kneels before her at lower right. This is not connected directly with any surviving work, but the strongly diagonal composition is close to several paintings of the end of the 1620s, such as the large *Virgin appearing to St James* in the Louvre or the Karlsruhe *Holy Family*. It is probable that the sketch on the verso was executed before the *modello*-like drawing on the recto, but how long before cannot be known.

References: Blunt 1945, no. 174; Blunt 1966, under no. 141; Blunt 1976, p.22; Blunt 1979a, pp. 95f, 99; Bologna 1962, p.155, no. 181; Edinburgh 1981, no. 16; F.A.Q.R. i, p.271; F/B, III, no. 196; Friedlaender 1929, p.254; Leicester, 1952, no. 46; London 1938, no. 524; London 1986, no. 72; Mahon 1962, pp.86ff; Oberhuber 1988, p.30; Oxford 1990, under no. 37; Paris 1960, under no. 50; Paris 1994, under no. 47; R/P, no. 57; Wild 1980, II, p.49

25 verso (detail): sketch for a *Holy Family*

26 *The Ascension* ca. 1630–34

Red chalk
Verso: blank
5 ¹¹⁄₁₆″ × 10 ⅜″ (145 × 263 mm), upper right corner made up
No watermark
Provenance: Massimi vol., no. 61 ("Li Apostoli nel' Monte Oliveto")
RL O749

The subject of the Apostles on the Mount of Olives, watching the Ascension of Christ forty days after the Resurrection (Acts 1:9–11), was increasingly exploited in the seventeenth century for dramatic compositions resplendent with theatrical light effects and cavorting angels. It has been proposed that this drawing is a fragment of a larger composition, having lost the full-length figure of Christ above. But the scale of the figures suggests instead that Poussin was reverting to the old pictorial tradition showing only Christ's feet as He ascends through the clouds, and that the drawing is missing just a narrow strip at the top. No related painting or drawing is known.

Drawings executed solely in red chalk are unusual in Poussin's œuvre, but are found occasionally in the first half of the 1630s: the sketch at Chantilly for the *Triumph of David* (fig. 18) is self-evidently autograph (but see cat. 23); the British Museum holds a preparatory drawing for the Kassel *Nymph on a satyr's back* (F/B, no. 229; R/P, no. 32) and the celebrated but disputed *Self-portrait* (F/B, no. 379; R/P, no. R489); and a sketch for the *Crossing of the Red Sea* (fig. 22; F/B, no. 386; R/P, no. R580), now in the Getty Museum, is hard to explain as

other than an original preparatory work. Of these only the Kassel drawing was accepted by Rosenberg and Prat, but the group seems too homogeneous, and has too many independent connections with Poussin, to reject all but one from his œuvre. An argument, occasionally advanced, that Poussin rarely used red chalk and that the drawings therefore cannot be by him is of course logically nonsensical (the same reasoning has been applied to his drawings on blue paper).

Many of the stylistic quirks of the Getty drawing are found repeated in this drawing – a rather nervous, scratchy outline, oval heads coarsely defined with repeated strokes, and long diagonal passes to shade the larger areas. Comparisons with Domenichino's red chalk drawings have been made, but one needs only to place the present sheet next to even Domenichino's strongest such studies to see how much more robust is the sense of structure here. The local spatial distortions are unusual in Poussin's drawings, and in many ways resemble the sketches of Castiglione, whose red chalk style is similarly obscure; but in the downwards-curving composition and the agitated figure types, the present drawing is close in spirit to the *Saving of the infant Pyrrhus* (cat. 31), which has a substantial underdrawing in red chalk of very similar character to the first outlines here. It is impossible to be dogmatic about the dating of this drawing, but like the sheets discussed above it is probably a work of the earlier 1630s.

References: Blunt 1945, no. 183; Blunt 1976, p.30; Blunt 1979a, p.90; F.A.Q.R. ii, p.180; F/B, I, p.34, V, no. 403; Friedlaender 1929, p.257; R/P, no. R1289

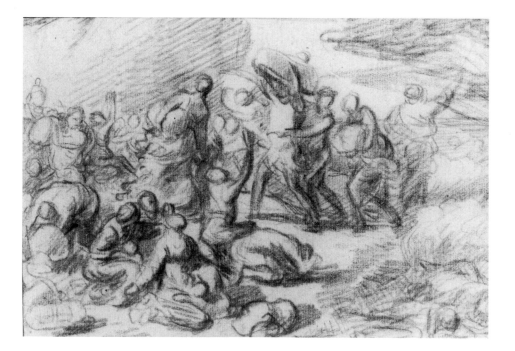

Fig. 22 Poussin, *The crossing of the Red Sea*. Red chalk. 6″ × 8 ⅞″ (152 × 225 mm). J. Paul Getty Museum, Malibu, inv. 86.GB.466

27 Nymph and satyr (Jupiter and Antiope?) ca. 1631–32

Slight black chalk (?) underdrawing, pen and brown ink, brown wash
Verso: blank
5 ¹¹/₁₆″ × 10 ⁵/₁₆″ (144 × 262 mm), irregular upper edge
Watermark: crown and star
Provenance: Massimi vol., no. 13 ("Venere che dorme, scoperta da un' Satiro")
RL 11987

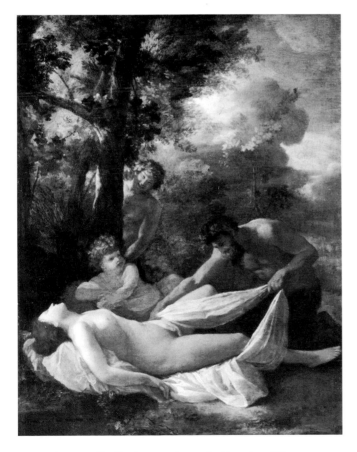

Fig. 23 Poussin (?), *Sleeping nymph surprised by satyrs*. Oil on canvas. 26″ × 20″ (66 × 51 cm). National Gallery, London

The subject of a sleeping woman or nymph being leered at or unveiled by satyrs was one of the staples of seventeenth-century Roman painting, the woman commonly being identified as Venus, which is how the Massimi catalogue describes this drawing; but it may equally well depict the story of the nymph Antiope, who was seduced by Jupiter in the form of a satyr as she slept in a wood. Artists often made this subject obvious by including details such as Cupid firing his arrows at Jupiter, or the god's attribute of an eagle, but the texts (e.g. Ovid, *Metamorphoses*, VI, 110f) do not demand any such accessories. A large portion of the sheet has been cut away, and this may well have depicted a flying cupid or other satyrs looking on, which would have determined the subject either way.

The drawing was rectangular when it entered the Royal Collection, a fragment from the top right of the sheet having been shaped, inverted and fitted into the upper center, a mutilation that was rectified during recent conservation. Cat. 49, also from the Massimi collection, has similar patching, using typically seventeenth-century wheat paste, and it was presumably when in the Cardinal's possession that these "restorations" were carried out. The remaining portion of the sheet is undamaged, and there is no way of knowing why Massimi altered the sheet so drastically.

The drawing is related thematically to a painting of a satyr unveiling a sleeping nymph, known in several versions – that in the National Gallery in London (fig. 23) has usually been dismissed as the work of a follower, but may well be autograph, as claimed recently by Rosenberg (Paris 1994, p.22). But the similarities are generic and the composition is otherwise not particularly close; a common subject alone does not mean that a drawing is a preparatory study for a painting, as Poussin often treated a theme more than once. In fact the painting belongs to the group of moodily colored mythological pieces of the mid-late 1620s, whereas in its figure types and wiry line the drawing is close to such sheets as the study for the *Rape of the Sabine women* (cat. 29), though not quite as confident in handling, and a date in the early 1630s seems most probable. (Oberhuber's attempt to date the drawing to the spring of 1626 is hardly convincing when compared to less accomplished sheets such as the *Realm of Flora*, of ca. 1627.) The dabbed wash thus prefigures the great luminous pieces of the mid-1630s, such as *St Mary of Egypt and St Zosimus* (cat. 32).

References: Blunt 1945, no. 186; Blunt 1976, pp.21f; F.A.Q.R. i, p.270; F/B, III, no. 211; Friedlaender 1929, p.253; Oberhuber 1988, pp.98–109, no. D64; Oxford 1990, no. 9; R/P, no. 50, Sutherland Harris 1994, pp.37f

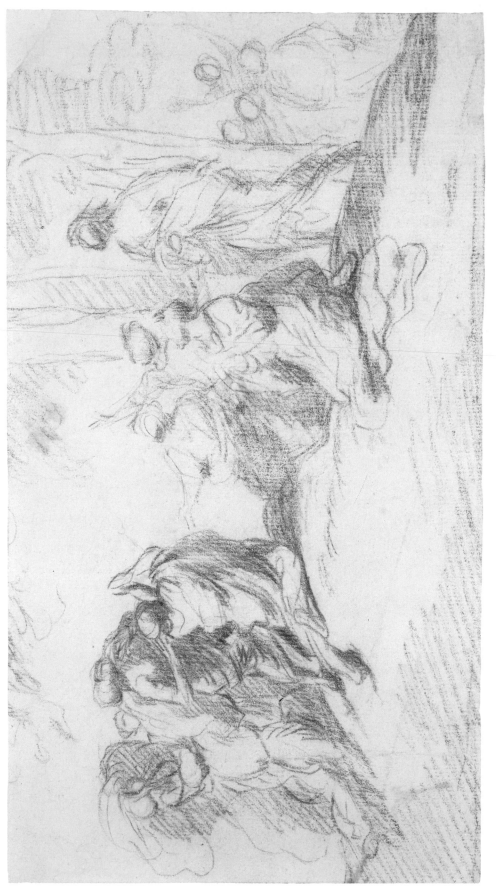

26 *The Ascension*

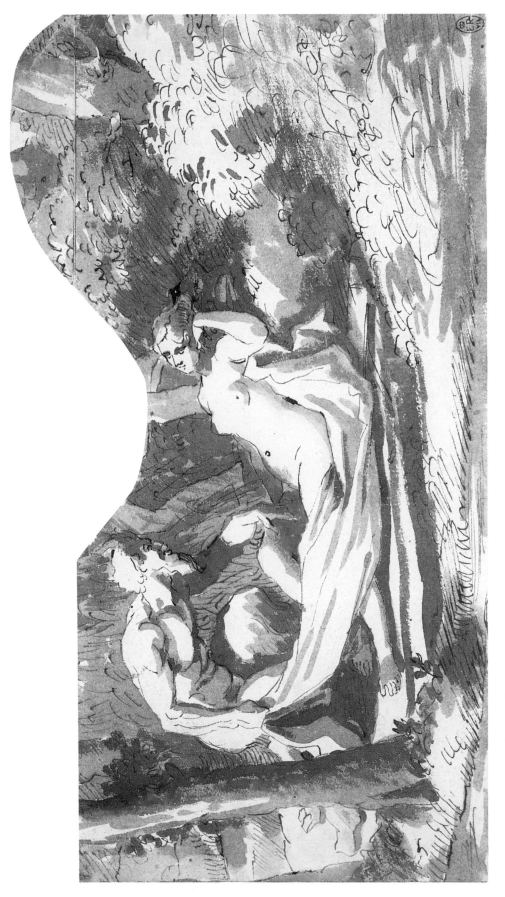

27 *Nymph and satyr (Jupiter and Antiope?)*

28 *Tyro and the nymphs (?)* ca. 1632–34

Slight graphite underdrawing, pen and brown ink, brown wash
Verso: illegible faint sketch
Black chalk (?)
5 $\frac{3}{16}$" × 5 $\frac{13}{16}$" (131 × 147 mm)
No watermark
Provenance: Massimi vol., no. 10 ("Tyro e le Ninfe")
RL 11914

Three nymphs recline by a stream, their attention apparently drawn by a river-god among the trees in the distance. The Massimi catalogue states that the subject is the story of the nymph Tyro seduced by Neptune, who had assumed the form of her lover, the river-god Enipeus (Homer, *Odyssey*, XI, 235); but the drawing is a fragment, and the surviving portion does not give enough detail either to confirm Marinella's identification or to suggest an alternative subject. The wiry line and free wash are typical of Poussin's drawings of the early mid-1630s; the figures are particularly close to the study for the *Rape of the Sabine women* (cat. 29).

The drawing is connected, thematically but not by motif, with several other works. Around 1633–34, Poussin painted a composition of women bathing in woodland for the maréchal de Créqui, now lost but known through engravings and a ruined canvas whose authorship is impossible to determine, to which Blunt (1966) further related a stylistically very similar drawing of a river-god and putti gathering grapes, formerly at Holkham Hall (F/B, no. 236; R/P, no. 62). The present sheet may also be compared with sketches on the verso of the cartoon in the British Museum for the London *Dance before a herm* (F/B, no. 235; R/P, no. R517 – this sheet was rejected by Rosenberg and Prat). These sketches show nymphs and a reclining river-god pointing to some incident to the left, and as the British Museum sheet is datable to the same span of years as the present drawing, it is conceivable that both are studies for the two flanks of the same mythological subject.

References: Badt 1969, p.247; Blunt 1945, no. 187; Blunt 1966, under no. L117; Blunt 1976, p.21; F.A.Q.R. i, p.269; F/B, III, no. 227; Friedlaender 1929, pp.127. 253; Paris 1960, no. 136; Paris 1994, no. 40; R/P, no. 28

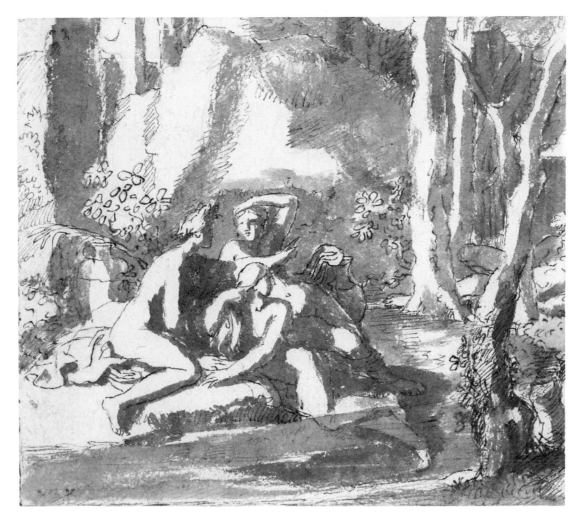

28 *Tyro and the nymphs (?)*

29 *The rape of the Sabine women*
ca. 1633

Slight black chalk underdrawing, pen and brown ink, brown wash
Verso: *The Adoration of the Shepherds*
Black chalk
4 ⁷⁄₁₆″ × 7 ⅝″ (113 × 194 mm)
No watermark
Provenance: Massimi vol., no. 37 ("Il ratto delle Sabine")
RL 11903

30 Study for the *Rape of the Sabine*
women ca. 1633

Slight black chalk (?) underdrawing, pen and brown ink, brown wash
Verso: fragmentary figure study
Black chalk
5 ⁹⁄₁₆″ × 3 ³⁄₁₆″ (116 × 81 mm)
No watermark
Provenance unknown (but probably Vol. II, pp.39–43)
RL 11904

For the subject of this drawing, see cat. 22. The *Rape of the Sabine women* allowed the depiction of a whole range of emotions and of intricately posed groups of bodies in violent action, and was thus a perfect subject for the artist to prove his skills. Poussin painted two versions, one now in the Metropolitan Museum in New York (fig. 24) for the maréchal de Créqui in 1633–34 (see Boyer/Volf 1988, pp.32, 39), the other in the Louvre for Cardinal Aluigi Omodei, at a date unknown but probably shortly after the New York version.

In the confidence with which Poussin treated complex spatial relationships, and in the sureness of his line and the application of wash, the three main figure groups of cat. 29 bear every sign of having being drawn from small three-dimensional models. The soldier lifting the woman into the air at the left was carried over unchanged (except for the addition of drapery) to the New York painting; the other two groups were not used in either composition. The figures in the background, fitted around the washed nude groups, are much more sketchily drawn but in places are very close to the painting, and it seems likely that Poussin was here simply filling in detail from an earlier compositional sketch to try the effect of the figure groups against a tangled background. Indeed the painting works more successfully when considered as an assemblage of independent groups in space rather than as flat pattern.

Cat. 30 is another study for a *Rape of the Sabine women*, and with the absence or obscuration of the maiden's left forearm

Fig. 24 Poussin, *The rape of the Sabine women*. Oil on canvas. 60 ½″ × 81″ (154 × 206 cm). Metropolitan Museum of Art, New York, Harris Brisbane Dick Fund, 46.410

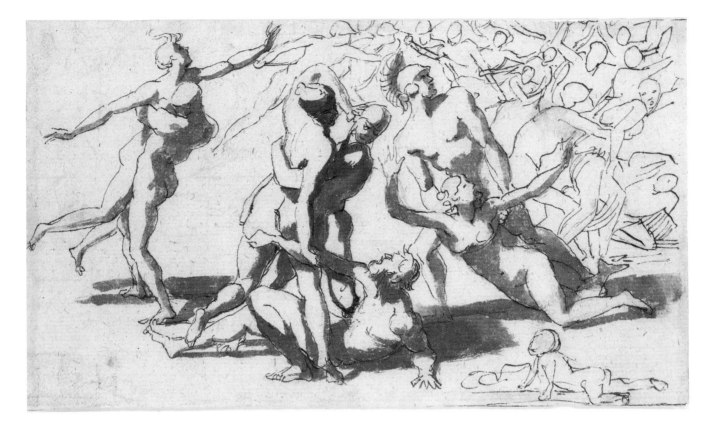

29 *The rape of the Sabine women*

Fig. 25 Poussin, *The Adoration of the Shepherds*. Oil on canvas. 38 ½" × 29 ¼" (98 × 74 cm). National Gallery, London

29 verso *The Adoration of the Shepherds* (retouched photograph)

and the rapid yet accurate recording of the fall of light on the torsos, it too must have been drawn from a small model. The group is not found in exactly this form in either painting, though it does have some connection with the pair of soldier and maiden depicted in the left foreground of both compositions, and we therefore have to rely on its style to arrive at a date. In fact the handling of pen and wash is identical to that of the previous drawing, and it must also have been drawn in connection with the New York painting. The group is derived from the *Hercules and Antaeus* designed by Poussin for the illustrated edition of Leonardo's *Treatise on Painting* (see cat. 31).

When cat. 29 was lifted from its old mount during recent conservation, a very faint preparatory drawing for the London *Adoration of the Shepherds* (fig. 25) was discovered on the verso. The scratchy black chalk is swamped by the ink staining through from the recto, and is too weak to reproduce; illustrated here is a schematic drawing over a photograph. Despite its tenuousness, the figural part of the composition is drawn in virtually its final form, with the Madonna kneeling over the Child in the lower right, Joseph and a donkey behind her, the shepherds bowing down at the center and a maid approaching with a basket of fruit. The function of the drawing is hard to discern, as it is not a sketch, but rather appears to be an abandoned underdrawing for a finished, *modello*-like sheet. Just such a drawing for this composition is in the British

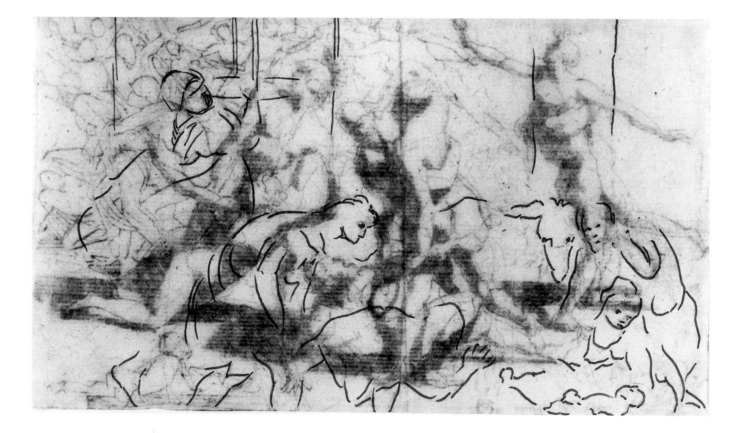

30 Study for the *Rape of the Sabine women*

Museum (F/B, no. A6; R/P, no. 75) – the authorship of this has been disputed, but it does seem to be autograph, the rather formal handling being explained by the function of the sheet.

The sketch on the verso of cat. 29 must have been executed before the drawing for the *Rape of the Sabine women* on the recto, for the strength of the ink on the recto would prevent the artist drawing in chalk as lightly as here, even allowing for increased staining through with time. Thus the planning of the *Adoration of the Shepherds* had reached an advanced stage before that of the New York *Rape of the Sabine women*, and it follows that the London painting was designed (and, in the absence of any evidence to the contrary, executed) by 1633 at the latest. This is in accord with the recent consensus on the dating of the London painting; some of the darker pigment has sunk into the ground, giving it the paler tonality typical of the later 1630s, but the figure types and the handling of flesh, drapery and landscape are very similar to the London *Adoration of the Golden Calf*, finished by 1634, and the Dresden *Adoration of the Magi*, dated 1633.

Cat. 30 also yielded a faint black chalk sketch on its verso when it was lifted from its old mount. This seems to show a fragment of a reclining figure from the knees down, with the left (near) knee raised and a hand resting on that shin. It has not been possible to connect the drawing (of an unusually large scale for Poussin's preparatory sheets) with any painting.

References: Cat. 29: Blunt 1945, no. 191; Blunt 1966, under no. 180; Blunt 1976, p.26; Blunt 1979a, pp.41, 187, 189; Costello 1947; F.A.Q.R. ii, p.175; F/B, II, no. 117; Friedlaender 1929, p.255; Mahon 1962, p.93; Oberhuber 1988, p.248; Paris 1960, no. 156; Paris 1994, no. 76; R/P, no. 80

Cat. 30: Bialostocki 1960, p. 138; Blunt 1945, no. 192; Blunt 1966, under cat. 179; Blunt 1979a, p.41; F.A.Q.R. ii, p.175; F/B, II, no. 116; Friedlaender 1914, pp.318f; Friedlaender 1929, pp.127, 255; Oxford 1990, under no. 28; Paris 1960, no. 147; Paris 1994, no. 75; R/P, no. 79

30 verso

31 *The saving of the infant Pyrrhus*
ca. 1633–34

Red chalk underdrawing, pen and brown ink, brown wash
Verso: sketch for the same
Slight black chalk underdrawing, pen and brown ink
8 ¹/₁₆″ × 13 ⁹/₁₆″ (206 × 345 mm)
No watermark
Provenance: Massimi vol., no. 41 ("Pirro inseguito da Molossi")
RL 11909

This magnificent sheet is the only surviving preparatory study for a painting for the Abate Gian Maria Roscioli of Foligno, who noted the payment of seventy *scudi* in his account book on 2 September 1634. It depicts an episode from the life of Pyrrhus, who as an infant was carried to safety at Megara when his father King Aeacides was driven from Epirus. His protectors found the river outside the city impassable, but with the enemy in close pursuit, they threw across messages attached to a stone and a spear, and the Megarans sent a boat to rescue the child (Plutarch, *Life of Pyrrhus*, 2).

The sheet comes close to the peak of Poussin's mature graphic style. The long-limbed figures are constructed with fast, flowing strokes of the pen, and the rich wash, which covers most of the drawing's surface, articulates the composition with strong rhythmic contrasts across the agitated figure group. The stormy background is an almost uniform layer of wash, the ragged fringes of white paper around trees and buildings giving a powerful *contre-jour* effect.

Perhaps more importantly, the drawing also represents one of the high points of Poussin's lifelong pursuit of the depiction of human emotion, which flows through the figures with frantic intensity. The lunging figure at the right, pointing behind to the pursuing forces, pushes forward the youth who holds Pyrrhus. At the center, another strides forwards, at once pointing at the infant and exhorting the two at the front of the group, who strain their muscles in opposing actions to fling the messages across the river to the agitated crowd beyond. The composition falls downwards and outwards at its edges, and there is a sense that Poussin is barely in control of the pictorial forces at his disposal.

The drawing on the verso in vigorous pen and ink, upside-down with respect to the recto, represents an earlier stage of development of the design. Poussin builds up the group figure by figure in semi-abstract outlines and blocks of parallel hatching, giving some odd disparities of scale. Interestingly this suggests that he was not at this point thinking in terms of the overall composition, but was primarily concerned with the human responses of the figures as a chain of actions and reactions. In the painting (fig. 28) much of this energy has been arrested. The surging flow of the drawing is broken as two maidens look backwards and upwards in anguish at the fighting, now visible at the far right, and the message-hurlers have raised their aim, giving an overall upwards curve to the composition which now comes to rest at the edges of the picture.

The figures of the two message-throwers are related to drawings added by Poussin to a manuscript of Leonardo da

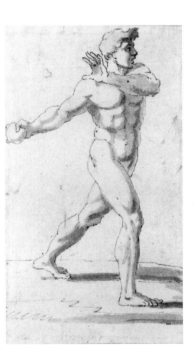

Fig. 26 Copy after Poussin, *A man throwing a stone*. Pen and brown ink, gray wash. 4 ⁷/₁₆″ × 2 ½″ (113 × 63 mm). Royal Library, Windsor, inv. 11953 (cat. C8)

Fig. 27 Copy after Poussin, *A man hurling a spear*. Pen and brown ink, gray wash. 4 ¹⁵/₁₆″ × 5 ¼″ (126 × 133 mm). Royal Library, Windsor, inv. 11956 (cat. C8)

Vinci's *Treatise on painting*, copied by Cassiano dal Pozzo from an earlier (and incomplete) version in the Barberini library. Cassiano intended that Poussin's designs should be engraved and the treatise published, but it did not appear until 1651. It was presumably only the enthusiasm of his friend and patron that led Poussin to become involved – he had little time for Leonardo's treatise, claiming that "all that is of value in that book could be written on one sheet of paper in large letters." Nonetheless, Leonardo's interest in the externalization of emotion through expression and pose was very close to Poussin's preoccupations in the *Pyrrhus* composition.

The original Cassiano/Poussin manuscript of the *Treatise* is in the Ambrosiana Library in Milan, though four sets of copies of the drawings are known, including a series of sixteen at Windsor (cat. C8). The two figures in the *Pyrrhus* drawing correspond to those (figs. 26 and 27) illustrating a paragraph on the stance of bodies in action beginning "A man who wishes to throw a spear or a rock . . ." Either the *Treatise* drawings were borrowed from pre-existing compositions, or the *Pyrrhus* figures were adapted from the *Treatise* drawings, and as a pair they illustrate the passage so closely that the latter must be the case. It may thus be concluded that the Leonardo illustrations had been designed by 1634, the year of the *Pyrrhus* painting, providing an important *terminus ante quem* for the whole *Treatise* project.

References: Barroera 1979; Bialostocki 1960, p.138; Blunt 1945, no. 189; Blunt 1966, under no. 178; Blunt 1976, p.26; Blunt 1979, pp.41, 43, 187; Bologna 1962, no. 185; Bristol 1956, no. 62; Edinburgh 1947, no. 86; F.A.Q.R. ii, p.176; F/B, II, nos. 108, 109; Friedlaender 1929, pp.128, 256; Oxford 1990, no. 27; Paris 1960, no. 157; Paris 1994, no. 52; R/P, no. 76; Wild 1980, II, under no. 47

Fig. 28 Poussin, *The saving of the infant Pyrrhus*. Oil on canvas. 45 ¾″ × 63″ (116 × 160 cm). Louvre, Paris

31 verso

32 *St Mary of Egypt receiving communion from St Zosimus* ca. 1634–36

Pen and brown ink, brown wash
Verso: blank
8 ⁷⁄₈" × 12 ³⁄₁₆" (225 × 310 mm)
No watermark
Provenance: Massimi vol., no. 66 ("S. Maria Egittiaca nel Deserto")
RL 11925

St Mary of Egypt was a fifth-century prostitute who was converted to Christianity while in Jerusalem, living as a hermit in the wilderness for the rest of her days. In her old age she was discovered by the abbot Zosimus, who gave her communion. Poussin's depiction of the scene appears at first glance merely an excuse to portray a wooded landscape and the dappling of light through the trees. The sheet is in excellent condition, and the combination of white paper with an equal area of liquid pale wash, and patches of darker wash dragged over the surface, gives the drawing an unrivaled freshness and luminosity.

Even though clearly not a trial sketch but a definitive study, the open composition and the wash are handled with a freedom typical of Poussin's sheets of the mid-1630s, when landscape was beginning to play a greater role in his paintings. A very similar landscape in the Louvre, recently published by Sutherland Harris (R/P, no. 114), shows the light fragmenting further and appears to be slightly later, closer to *Hercules and Deianeira* (cat. 44). The question of Poussin's landscape drawings has been hotly debated over the last thirty years, and the present sheet is invaluable in being certainly autograph and fairly accurately datable.

The drawing was related by Blunt (1959) to a series of paintings of hermits commissioned in the 1630s by Philip IV of Spain, for his palace of Buen Retiro. Three paintings from this series now in the Prado carry traditional attributions to Poussin, only one of which – *St Jerome in the wilderness* – appears to be authentic. Also in the Prado are three paintings by Claude of very similar dimensions and complementary subjects, noted at Buen Retiro in an inventory of 1700, and a further two by Jan Both. No painting of the present subject from the series is known, but the 1700 inventory recorded a landscape "with St Mary of Egypt and the Abbot Zosimus, when she ascended to heaven" ("con Santa Maria Egipciaca y el Abad Socimas, quande la vió subir al cielo"; this might be a misreading of the scene – it more probably depicted her being borne across the Jordan by angels to receive communion from Zosimus a second time).

We therefore have a series of paintings of hermits to which Poussin contributed, which included a representation of St Mary of Egypt and St Zosimus, and which was predominantly painted in the mid to late 1630s. The proportions of the paintings are a little different from the drawing, but this consideration did not trouble Poussin in his preparatory works (see cat. 36 verso), and it is quite possible that the present sheet is connected with the Buen Retiro commissions – perhaps as a *modello* for the approval of the patron's agent.

Shearman suggested an alternative scenario, that the drawing was supplied by Poussin as a model for a painting of the subject by Gaspard Dughet, his brother-in-law. Dughet's painting now hangs in the Galleria Doria-Pamphilj in Rome, but it is too far away from the present composition for the hypothesis to carry much weight.

References: Badt 1969, I, p.247; Blunt 1944, p.155; Blunt 1945, no. 195; Blunt 1959; Blunt 1966, under no. L40; Blunt 1971, p.215; Blunt 1976, p.30; Blunt 1979a, pp.55, 122; Bologna 1962, no. 183; Borenius 1928, p.18; Edinburgh 1947, no. 82; Edinburgh 1981, p.104, no. 59; Edinburgh 1990, no. 7; F.A.Q.R. ii, p.180; F/B, IV, no. 275; Friedlaender 1929, p.257; Leicester 1952, no. 48; London 1932, no. 624; London 1938, no. 503; London 1949, no. 509; London 1969, no. 155; London 1986, no. 73; Oxford 1990, no. 43; Paris 1960, no. 152; Paris 1994, no. 84; R/P, no. 128; Shearman 1960, p.181; Sutherland Harris 1994; Wild 1980, II, no. 73

32 *St Mary of Egypt receiving communion from St Zosimus*

33 *Bacchus discovering Ariadne*

34 *The death of Virginia*

34 verso *Bacchus discovering Ariadne*

35 The finding of Queen Zenobia
ca. 1634–36

Pen and brown ink, brown wash
Inscribed by the artist: *artaxata*, [*arxo* deleted], *araxo*, *Zenobia*
Verso: blank
6 ¼" × 7 ⅞" (158 × 200 mm)
No watermark
Provenance unknown (but probably Vol. II, pp.39–43)
RL 11895

King Rhadamistus and his wife Zenobia fled Artaxata, the capital of Armenia, after an uprising. The pains of childbirth came upon Zenobia during their flight, and she pleaded with her husband to kill her rather than let her fall into the hands of their pursuers. Stabbing her, he threw her into the river Araxes, but she was discovered by shepherds and revived (Tacitus, *Annals*, XII, 51). Poussin shows the moment of the recovery of the queen from the river, indicated by the reclining river-god with *araxo* written by his urn; in the background Rhadamistus gallops to the right followed by his pursuers, with the city of Artaxata on the hill in the distance. The drawing has been dated as late as the 1650s (Wild 1980), but it belongs to the group of free and luminous sheets of the mid-1630s. Another study of the same subject at Chantilly (F/B, no. 131; R/P, no. 119) shows the group of Zenobia and her supporting shepherd in virtually the same pose as the dying Virginia in cat. 34.

A number of other renderings of the episode have been attributed to Poussin. In addition to the Chantilly sheet, two other drawings are certainly by the master, one on the verso of a landscape drawing of around 1650 in Düsseldorf (F/B, no. 422; R/P, no. 348v), the other in a private collection (F/B, no. A35; R/P, no. 347), in Poussin's agitated style of the late 1640s. Both of these drawings show the shepherds mounted on horseback, and only the subject connects them with the Windsor and Chantilly sheets.

Another two drawings are more problematic. One, a peculiar drawing in the Hermitage (F/B, no. A34; R/P, no. 121), appears to be a pastiche of Poussin – the background is very close in style to that of our cat. 22, the figure of Zenobia is taken from the antique *Sleeping Ariadne* sculpture, and a shepherd is in the pose of Perseus in the drawing of the *Origin of coral* (cat. 19). The drawing seems too feeble to be by Poussin, but is just conceivably an original of around 1630. The second is a scribbly drawing in Stockholm from the perplexing Crozat group (F/B, no. 133; R/P, no. 120), which seems rather weakly structured but is similar in its abbreviations to some sheets of the late 1630s. The composition of this study is very close to a painting in the Hermitage (Paris 1994, no. 79) that has been claimed for Poussin himself (as unfinished, or damaged and overpainted). It is difficult to judge this painting behind its layer of brown varnish, but it looks much too cumbersome to be autograph. No convincing account of the evolution of Poussin's treatment of this subject has yet been advanced.

References: Badt 1969, p.221; Blunt 1945, no. 216; Blunt 1966, under no. L82; Blunt 1979a, pp.166–70; Chantilly 1994, under no. 24; F/B, II, no. 132, V, pp.96–97; Oxford 1990, no. 53; Paris 1960, no. 169; Paris 1994, no. 82; R/P, no. 122; Wild 1980, II, no. 170

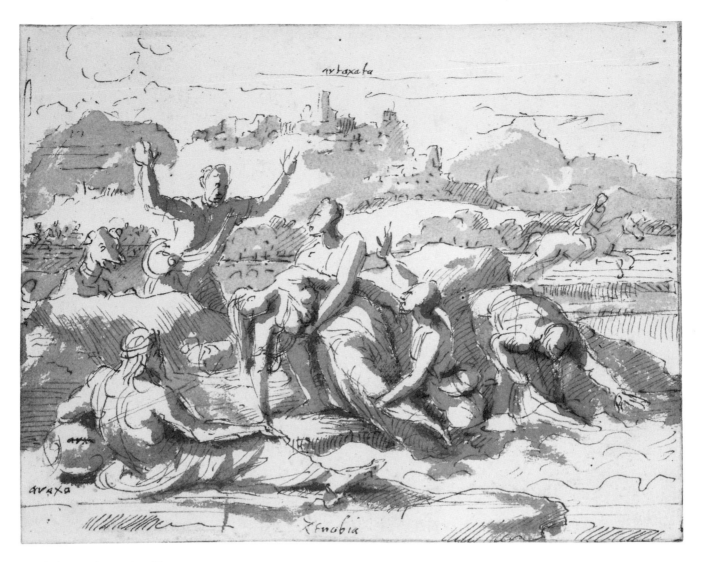

35 *The finding of Queen Zenobia*

36 *The triumph of Bacchus* ca. 1635–36

Pen and brown ink
Verso: *The triumph of Pan*
Pen and brown ink, with some black chalk underdrawing on the
smaller sketch
7 $^{15}/_{16}$″ × 12 $^3/_8$″ (202 × 314 mm)
No watermark
Provenance: Massimi vol., no. 21 ("Bacco Vittorioso dell'Indie")
RL 11905

The vigorous drawings on both sides of this sheet are prepara-
tory for a pair of paintings of Bacchanals executed for the
French Minister of State, Cardinal Richelieu, and dispatched
from Rome in May 1636. They were to hang in the Château de
Richelieu alongside paintings by Andrea Mantegna, Lorenzo
Costa and Pietro Perugino from the *studiolo* of Isabella d'Este,
that were presented to Richelieu as a diplomatic gift by the
Duke of Mantua. It is inconceivable that Poussin would have

kept such an important patron waiting any longer than neces-
sary, and the drawings may safely be dated to the latter part
of 1635 or early 1636.

The *Triumph of Bacchus* on the recto of the sheet is actually
quite unlike the painting as executed, which is in the Nelson-
Atkins Museum in Kansas City – now usually, but not uni-
versally, accepted as the original after years of doubt (fig. 31).
Poussin started here with a diagonal composition, the proces-

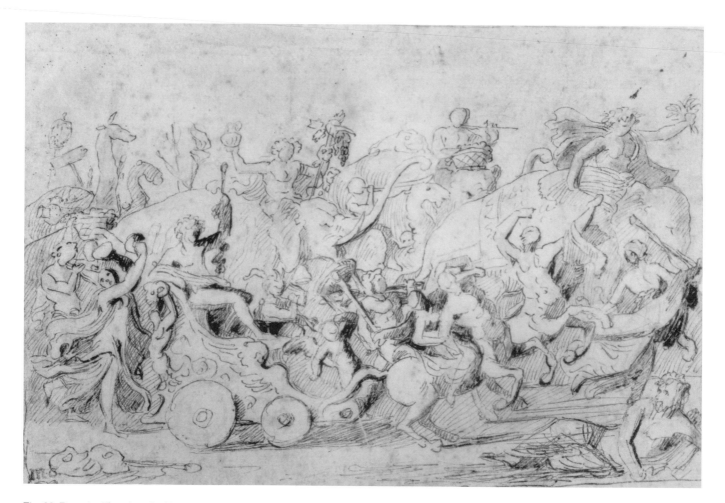

Fig. 29 Poussin, *The triumph of Bacchus*. Pen and brown ink. 6 $^1/_4$″ × 9″ (159 × 229 mm).
Nelson-Atkins Museum of Art, Kansas City, Purchase: Nelson Trust, 54–83

sion moving obliquely outwards towards the viewer; there is no underdrawing, and he presumably built up the composition figure by figure, as in the early sketch for the *Saving of the infant Pyrrhus* (cat. 31 verso). The sketches to the right of the composition are presumably first thoughts for the details of Bacchus's chariot.

The difficulties in maintaining the coherence of spatial structure and picture surface with this diagonal device must have been readily apparent to Poussin, for the figuration to the right of Bacchus becomes quite chaotic. In the other surviving preparatory drawings (e.g. fig. 29; F/B, no. 436; R/P, no. 88), he abandoned this ambitious compositional scheme for a more conventional frieze-like procession, parallel to the picture plane. Intriguingly, when Annibale Carracci designed a *Triumph of Bacchus* for the ceiling of the Farnese Gallery, his first scheme featured just such a diagonal composition, which also evolved into a frieze. One of Annibale's preparatory drawings, now in the Albertina (fig. 30), is so close in layout and in some of its motifs to the present drawing that it is likely that Poussin knew this very sheet, and based his first ideas on it.

The exact subject of this drawing is in fact the Indian triumph of Bacchus, as shown by the camel, giraffe and elephants in the background, an allusion to the god's journey to the East and the spread of his cult there. Panthers draw Bacchus's chariot, Silenus is supported on his donkey by two youths (eliminated in the painting, and reintroduced in the later *Triumph of Silenus* – see cat. 39 verso), and the rest of the train blow trumpets and crash cymbals. The faded preparatory drawing in Kansas City (fig. 29), in which most of the figures have found their final positions, still shows a herd of elephants, camels and giraffes in the background; but the effect is more of a stampede than a procession, and in the painting Poussin eliminated all the animals, reducing the subject to a simple *Triumph of Bacchus*. This last-minute change of emphasis suggests that Richelieu was not overly concerned with the detailed iconography of his paintings.

The drawings on the verso of the sheet are studies for the pendant painting of the so-called *Triumph of Pan*, now in the National Gallery in London (fig. 32). The exact subject of the composition is impossible to determine: it might equally well

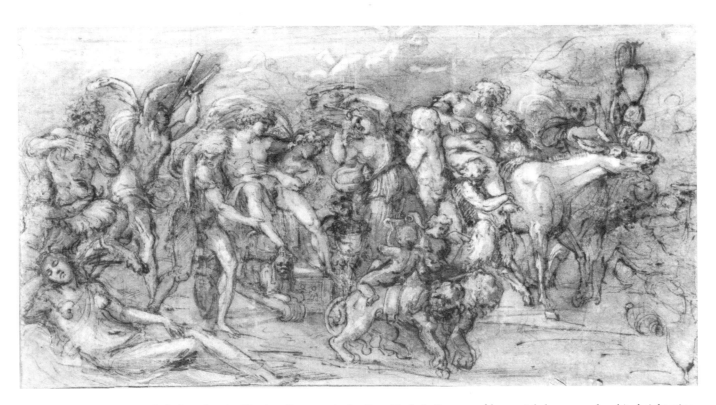

Fig. 30 Annibale Carracci, *The Indian triumph of Bacchus*. Paper washed yellow, black chalk, pen and brown ink, brown wash, white heightening. 12 ¹⁵/₁₆″ × 16 ¹³/₁₆″ (328 × 427 mm). Graphische Sammlung, Albertina, Vienna, inv. 23370

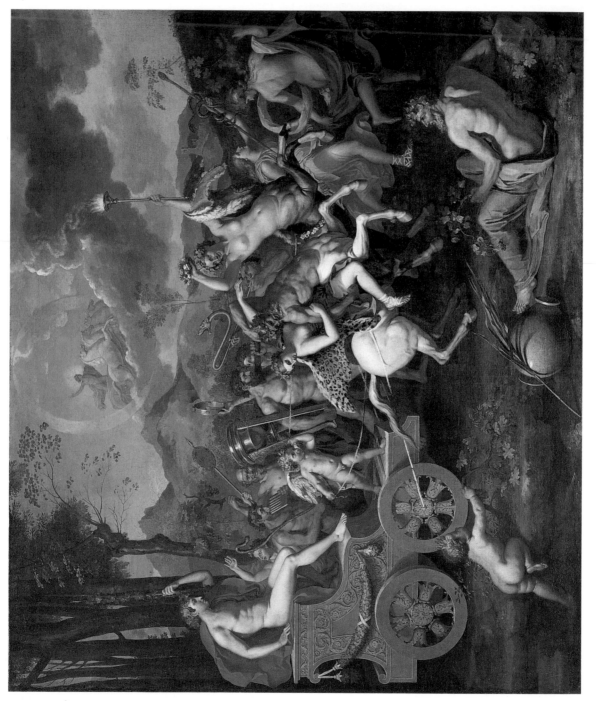

Fig. 31 Poussin, *The triumph of Bacchus*. Oil on canvas. 50 ½" × 59 ½" (128.5 × 151 cm). Nelson–Atkins Museum of Art, Kansas City, Purchase: Nelson Trust, 31–94

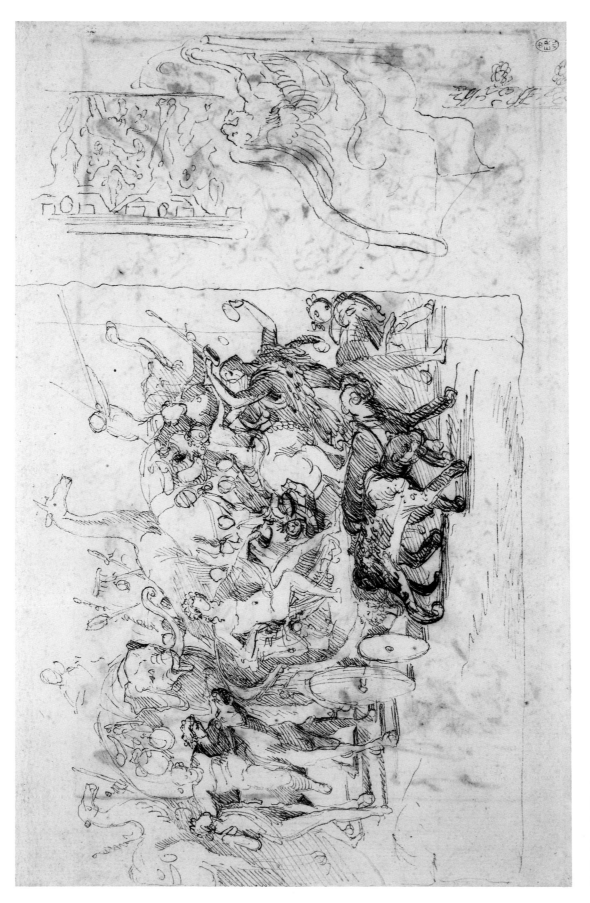

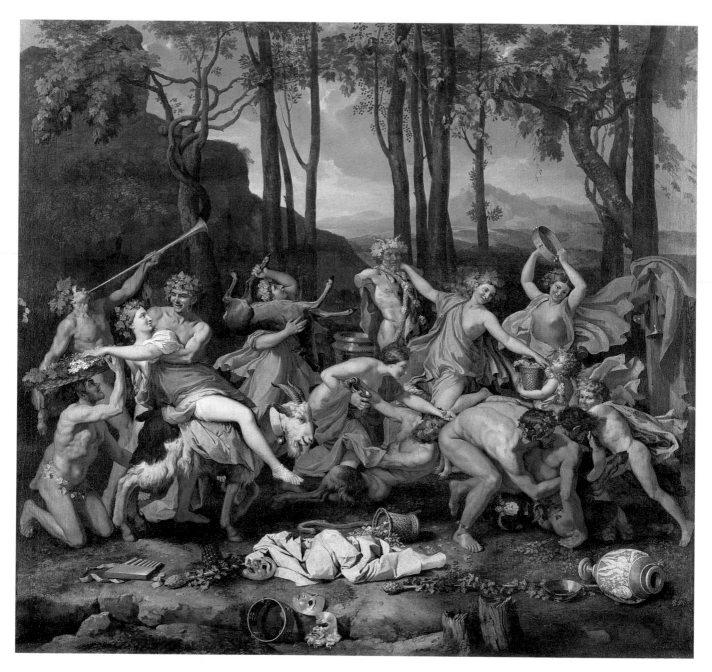

Fig. 32 Poussin, *The triumph of Pan*. Oil on canvas. 52 ¾″ × 57″
(134 × 145 cm). National Gallery, London

36 verso

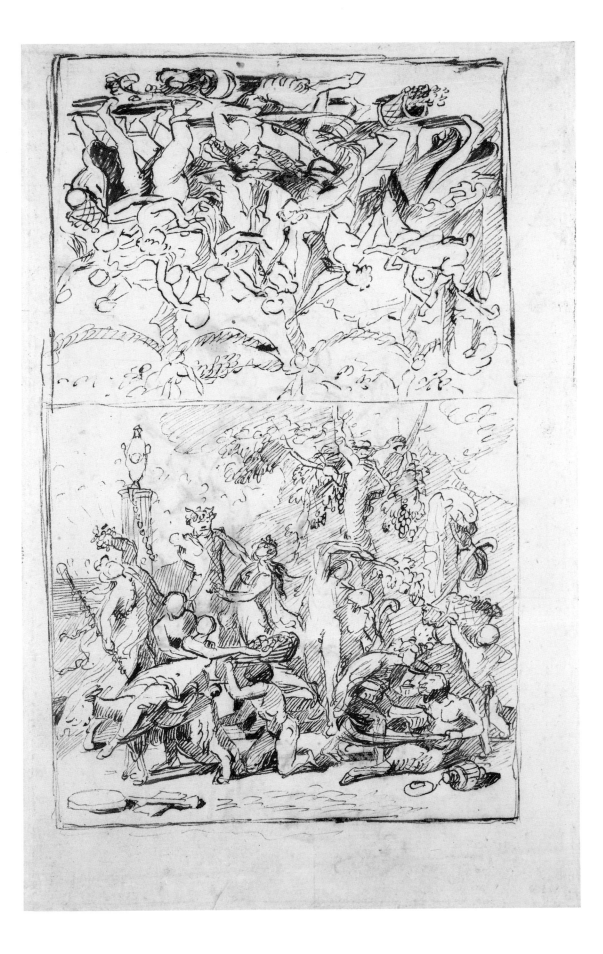

be a triumph of Priapus, whose attributes overlapped so thoroughly with Pan's, and the early sources simply refer to the painting as a *Bacchanal*.

There are several surviving preparatory drawings for the painting (e.g. fig. 33). In an elaborate analysis of the evolution of the design, Friedlaender and Blunt identified six principal motifs which recur in different combinations in the preparatory drawings (F/B, III, pp.23–26). These are: the girl garlanding the herm of Pan; the girl riding a goat, supported by a satyr and reaching for flowers from a tray held on the head of a second, kneeling satyr; two youths trying to lift a drunken satyr; a struggle between a nymph and a reclining satyr; a maenad carrying a dead deer on her shoulder; and a youth blowing a long trumpet.

To fill gaps in the composition, figures playing tambourines and children with baskets of fruit are fitted around these motifs, the whole being set before a backdrop of trees and drapery. Although the present two sketches are some way from the final design, several of the motifs occur exactly as in the painting, and it is only at the last stage of development, represented by cat. 37, that all six principal groups are found in a single composition. Another (rather early) pair of sketches for the bacchante garlanding the herm are to be found on the verso of cat. 63, a rare example of Poussin reusing a sheet of paper after many years.

This playing-card shuffling of the motifs in a confined space might suggest that Poussin was using small models on a stage to aid his composition. We have seen evidence of the use of such models in earlier projects, especially the *Rape of the Sabine women*, cats. 29 and 30, but the figures here are not drawn with the plasticity of those studies, and no group is seen from an altered angle in succeeding sketches. One of the most significant modifications is the exact mirroring of the group with the nymph on the goat's back, which is not possible without starting with a fresh model. The effect of the final picture is of a highly contrived surface pattern rather than a structure in space, and it is probable that the composition was designed entirely in two dimensions.

References: Badt 1969, p.530; Blunt 1945, no. 199; Blunt 1966, under nos. 136–37; Blunt 1967, pp.135ff; Blunt 1976, p.21; Blunt 1979a, pp.99–104; Edinburgh 1981, pp.37, 51ff, no. 22; F.A.Q.R. i, p.271; F/B, III, no. 185 (recto), no. 189 (verso); Friedlaender 1929, pp.127, 254; London 1938, no. 515; Martin 1965, p.162; Oxford 1990, no. 38; Paris 1960, no. 142; Paris 1994, no. 55; R/P, no. 83

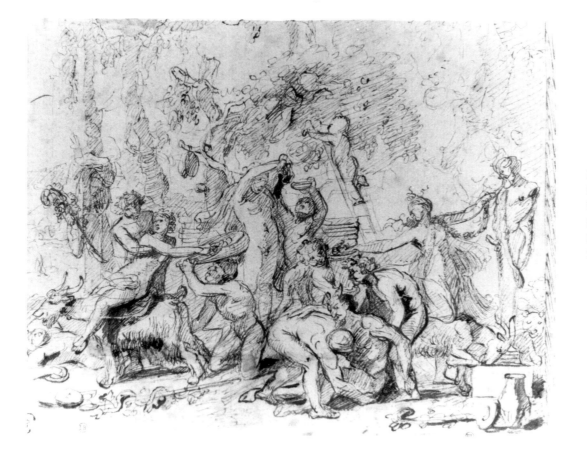

Fig. 33 Poussin, *The triumph of Pan*. Pen and brown ink. 6 ⅞″ × 8 ⅜″ (174 × 213 mm). Musée Bonnat, Bayonne, inv. 1672r

37 *The triumph of Pan* ca. 1636

Stylus lines, black chalk underdrawing, pen and brown ink, brown wash
Verso: blank
9″ × 13 ⁵⁄₁₆″ (228 × 338 mm)
No watermark
Provenance: Massimi vol., no. 22 ("Bacco Phallico")
RL 11995

In this careful study for the 1636 Richelieu *Triumph of Pan* (see cat. 36), Poussin tries out the full effect of the composition with the figures in their final positions, a type of finished preparatory drawing that was to become increasingly common in the following decade. Any dramatic tensions that were present in the earlier preparatory drawings have been suppressed, and the result is pure decoration – the contrast in purpose between this composition and the series of Sacraments that Poussin was to paint in the following years is remarkable.

The small differences of detail between drawing and painting are less significant than the overall change in the proportions of the composition. The figure group in the painting has been compressed widthways and heightened, primarily by increasing the scale of the figures at the rear, thus destroying the internal perspective of the group and rendering it even flatter than in the drawing. This effect is compounded by the extension of the background in the painting, where the screen of slender tree trunks reads as nothing more substantial than a stage backdrop.

The disturbing contrast between this blank curtain and the dense patterning of the figure group below emphasizes the last-minute nature of these adjustments. This is rather puzzling, as the paintings were commissioned for a predetermined space, and Poussin was presumably given the required dimensions from the outset, yet the preparatory drawings for the composition have no fixed proportions, as can be seen from the two sketches on the verso of cat. 36. It is as if Poussin became so carried away with the formal game of the composition that he lost sight of the requirements of the commission, and had to make a rather drastic and unsatisfactory adjustment to fit his "ideal solution" to the dimensions of the canvas.

The uniformly washed background of the drawing and the use of the vine along the top of the composition are, as has been noted, in direct emulation of Greek vase painting, though much of this effect is lost in the painting with the inclusion of a landscape. Nonetheless it does seem that Poussin was aiming for a certain archaism, and the rather stiff execution of the paintings (which remains the principal objection to the authenticity of the Kansas City painting) may be attributable to a sense of good manners – attempting to suppress all trace of seventeenth-century brushwork so that his pair of paintings would sit comfortably alongside the works of Perugino, Mantegna and Costa.

References: Blunt 1945, no. 200; Blunt 1966, under no. 136; Blunt 1967, pp.137ff; Blunt 1976, p.23; Blunt 1979a, pp.104, 117, 187; Bologna 1962, no. 182; Edinburgh 1981, no. 23; F.A.Q.R. i, p.271; F/B, III, no. 192, V, p.107; Friedlaender 1929, p.254; Oxford 1990, no. 40; Paris 1960, no. 141; Rosenberg 1991, p.211; R/P, no. 94

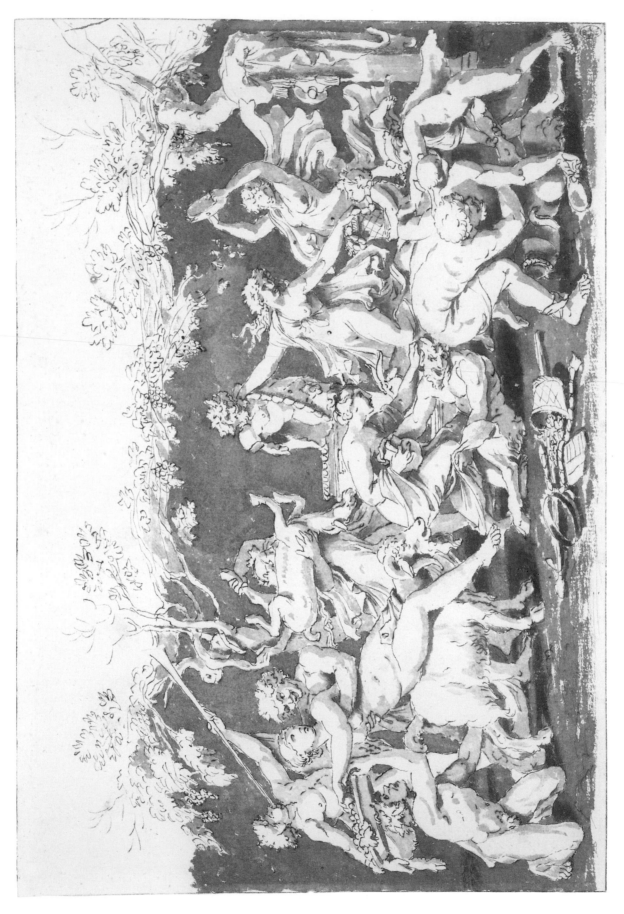

37 *The triumph of Pan*

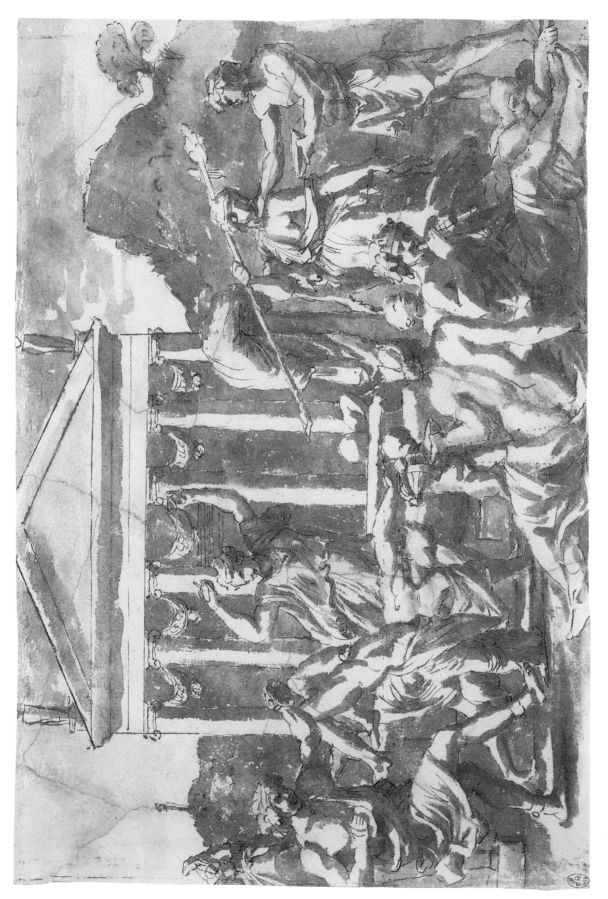

38 A ritual dance before a temple

38 A ritual dance before a temple
ca. 1636–37

Slight black chalk underdrawing, pen and brown ink, brown wash
Verso: blank
8 ³⁄₁₆″ × 12 ³⁄₈″ (208 × 314 mm), torn into fourteen pieces and repaired
No watermark
Provenance: Massimi vol., no. 19 ("Li Misteri di Priapo")
RL 11910

The Massimi catalogue identifies the subject of this drawing as the mysteries of Priapus, and several prints of the sixteenth century depict the rites of that god – one of which, after a design by Giulio Romano, was used by Poussin as the basis for his *Dance in honor of Priapus*, now in São Paulo. But apart from the ithyphallic figure at the far right, and a sketchily drawn object held by the central dancer which Blunt read as a votive phallus, there is nothing to support the identification of the subject as a Priapic ceremony rather than a generalized ritual dance before a temple.

This drawing and another at Chantilly (fig. 35; F/B, no. 195; R/P, no. 97) are related to a painting by Poussin known only through copies (fig. 34). Although the Chantilly drawing is more loosely drawn than the present sheet, it is much closer in detail to the painting, differing only in the form of the temple and the presence of a herm at the right side of the drawing. The weaknesses of the Windsor drawing are plain to see, for the design splits between the wild actions of the four revelers at the left and the rather static poses of those at the right; in the Chantilly drawing he reduced the number of figures and unified them in a closed oval composition.

The bold pen and wash of the drawings is typical of the mid-late 1630s – the Chantilly sheet in particular is close in style to the *Bacchus discovering Ariadne* (cat. 33). Scholarly consensus has placed the lost painting considerably later, the bulbous figures and carefully contrived space evident in the copies suggesting a date around 1650. Perhaps this is another example of a patron requesting a painting to the design of a pre-existing drawing (see cat. 20).

The present drawing has two unusual features. Most obviously, it has been deliberately torn up, and repaired using wheat paste, a typically seventeenth-century adhesive. As the drawing came from the collection of Cardinal Massimi, and was surely not damaged in such a way after entering his possession, it was presumably Poussin himself who frustratedly tore up a drawing with which he was unhappy. The earliest definite link between Poussin and Massimi is the collaboration over the illustrations to the 1640 edition of Barberino's

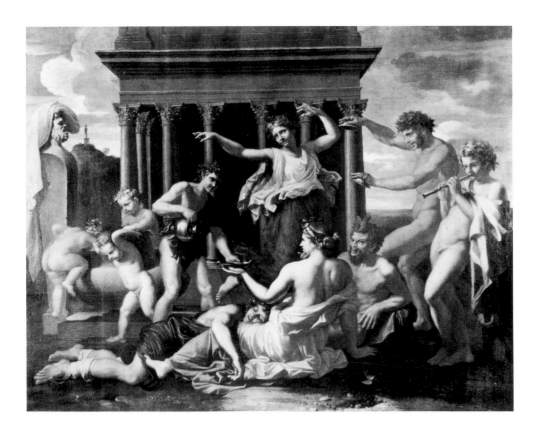

Fig. 34 Copy after Poussin, *A ritual dance before a temple*. Oil on canvas. 29 ¼″ × 40″ (74.5 × 101.5 cm). M.H. de Young Memorial Museum, San Francisco

Documenti d'Amore (see cats. 75–77); but the disputed self-portrait drawing in the British Museum states that Massimi took drawing lessons from Poussin, and as he was born in 1620, they may well have been acquainted from the mid-1630s. This would accord with the date of the present drawing, and one can imagine the fragments being retrieved by the young Massimi from the studio floor and pieced back together for his embryonic collection. Other drawings by Poussin that have been damaged in this way include the lower half of cat. 40, of a similar date, which also came from Massimi's collection.

The other oddity is the series of dotted ink lines across the lower part of the composition. Passing right across the drawing, a third of the way up, is the horizon line, emphasizing the unusually low viewpoint of the composition. Three lines radiating from a central point could be assumed to be perspecti-val, but they and a shallow diagonal across the lower right corner appear irrelevant to the construction of the picture. Similar lines are occasionally found both on Poussin's drawings and on his paintings between the mid-1630s and late 1640s, such as the set of roughly vertical stylus lines in the center of cat. 37, or the dark lines visible under the paint of the Louvre *Rape of the Sabine women*, but their use is far from systematic and in this case cannot be explained.

References: Blunt 1945, no. 198; Blunt 1960a, pp.63f; Blunt 1966, under no. 140; Blunt 1967, p.144; Blunt 1976, p.22; Chantilly 1994, under no. 16; F.A.Q.R. i, p.271; F/B, II, no. 194; Friedlaender 1929, pp.127, 253; Mahon 1962, p.119; Paris 1960, no. 161; Paris 1994, no. 61; R/P, no. 96; Thuillier 1974, under no. 167; Thuillier 1994, under no. 187; Wild 1980, I, p.50, II, under no. 48

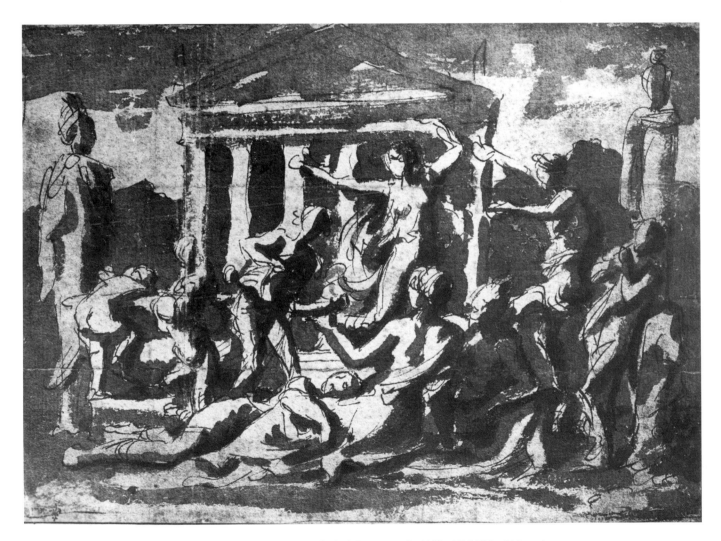

Fig. 35 Poussin, *A ritual dance before a temple*. Pen and brown ink, dark brown wash. 6 ⅛" × 8 ¼" (155 × 210 mm). Musée Condé, Chantilly, inv. 178

39 The death of Cato the Younger
ca. 1636–38

Pen and brown ink
Verso: sketches for a drunken Silenus, and a female warrior
Black chalk, and pen and brown ink
3 ¾" × 5 ⅞" (95 × 149 mm)
Watermark: saint in shield (cut)
Provenance: Massimi vol., no. 45 ("Catone Uticense")
RL 11919

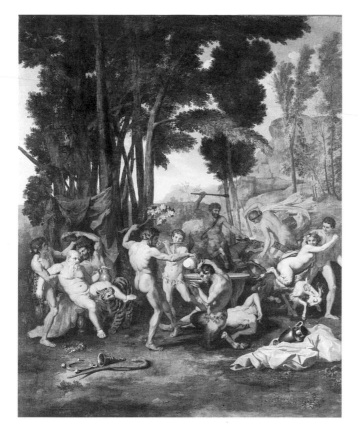

Fig. 36 Copy after Poussin, *The triumph of Silenus*. 56 ½" × 47 ¾" (143.5 × 121 cm). National Gallery, London

Cato the Younger committed suicide at Utica after the defeat by Caesar of Pompey's faction in the civil war. He is shown in his chamber, on his pillow the copy of Plato's *Phaedo* on which he had been meditating before running himself through with his sword. This exemplar of stoicism is unconnected with any other work known by Poussin, and it has been suggested that the drawing is a visual note made after reading Plutarch (*Life of Cato*, 58). Poussin's early biographers testify that his method when confronted by a new subject was to read all the available accounts of a story, forming an impression of the scene in his mind before committing it to paper, and one may reasonably assume that not all drawn compositions that have survived were preparatory for a painting.

The most prominent sketch on the verso appears to show a female warrior with her arm raised in greeting, which Prat and Rosenberg suggested (Paris 1994) might be a depiction of Erminia with the shepherds, a scene from Tasso's *Gerusalemme Liberata*. The rough black chalk sketch above the warrior can be read by turning the sheet round by ninety degrees clockwise, whereupon it shows a fat, slumped figure supported from behind by another figure. The obvious identification of this fat figure is a drunken Silenus, and it is possible that the sketch is related to one of the Bacchanals painted for Cardinal Richelieu. The original of the *Triumph of Silenus* is now lost, but the composition is known through copies (the version in the National Gallery in London, fig. 36, has occasionally been claimed as the ruined original, most recently in Paris 1994, under no. 54). The *Triumph of Pan* and the *Triumph of Bacchus* were dispatched from Rome in May 1636, and though no documentation is known and no other drawings survive, the *Silenus* seems to have followed some time afterward. The style of the *Death of Cato* suggests a date in the later 1630s, which would be consistent with the sketch on the verso being preparatory for the Richelieu painting, but it is so brief that it can tell us little about the evolution of the composition.

References: Bardon 1960, p.129; Blunt 1945, no. 206; Blunt 1976, p.27; Blunt 1979a, pp.113, 115, 185, 188; F.A.Q.R. ii, p.177; F/B, II, no. 124 (recto), V, no. 373 (verso); Friedlaender 1929, p.256; Paris 1960, no. 178; Paris 1994, no. 85; R/P, no. 139; Wild 1980, II, no. 171

39 *The death of Cato the Younger*

39 verso

40 The Agony in the Garden
ca. 1636–38

Blue paper, slight black chalk underdrawing, pen and brown ink, brown wash
Verso: blank
Upper portion 6 ⅞″ × 9 ½″ (174 × 241 mm)
Watermark: Name of Jesus in oval
Provenance: Vol. II, p.1b
Lower portion 4 ⅛″ × 9 ⅜″ (105 × 238 mm), torn into four pieces and repaired
Provenance: Massimi vol., no. 59 ("Li Discepoli nell'Horto")
RL 11997

After the Last Supper, Christ went with the disciples James, Peter and John to the Mount of Olives, to pray and meditate on the fate that awaited Him. The traditional depiction of the scene showed Christ in prayer on a rocky outcrop above the slumped figures of the sleeping disciples, as an angel (mentioned in the Gospel of St Luke) appears to Him. Poussin follows this convention, but there are two unusual features. First, Christ is shown lying prostrate rather than kneeling. There are precedents for this in a woodcut by Dürer and in the earliest representations of the scene, but in fact the Gospels of Sts Mark and Matthew both specify this pose: "And he went a little farther, and fell on his face, and prayed . . ." (Matthew 26:39). The other novelty is the presence of a second figure, without wings, beside the angel who kneels before Christ. It has been suggested that this figure might represent Ecclesia, but there is no pictorial tradition for a second figure and no written source has been adduced which satisfactorily explains the feature.

The drawing has been related to two small paintings of this subject executed by Poussin in the 1620s, in both cases on a copper support. One painting, for Cassiano dal Pozzo, was published by Standring in 1985; a second, also in a private collection, was recorded in a 1648 Barberini inventory and was presumably painted for Cassiano's employer, Cardinal Francesco Barberini. Brigstocke (in Oxford 1990) suggested a date shortly after the execution of the two paintings, around the *Death of Germanicus* in Minneapolis (1627); Rosenberg and Prat prefer to date both paintings and this drawing to around 1630 (Paris 1994). (Wild, 1967, attributed the drawing to Charles Mellin, without explanation.)

But the present study only resembles the paintings generically, in the setting and the dramatic light from Heaven; it has a solemnity quite opposed to the effect of the baroque shower of putti in the paintings. Further, no motif as consciously archaic as the prostrate Christ can be found in Poussin's œuvre in the 1620s. It suggests an interest in early pictorial sources that only took off with his work on the first set of Sacraments in the second half of the 1630s, and did not reach its full expression until the second set in the mid-1640s (see cats. 56, 57). The only substantive link between drawing and paintings is the inexplicable second figure, who assists the angel in supporting a large cross in both paintings, but this cannot be used to argue a date for the drawing. The wash has an intensity not found in Poussin's drawings before the thirties, and the figure types and rather broken handling of the pen come closest to drawings such as the *Ritual dance before a temple* (cat. 38) or *Camillus and the schoolmaster of Falerii* (cat. 41). A date around 1636–38 thus seems most probable.

Remarkably, the drawing entered the Royal Collection in two pieces – reunited with only a small strip missing around the turn of this century – the upper half from the Cassiano volume, the lower half (torn into four fragments and repaired at an early date – see cat. 38) from the Massimi volume.

References: Blunt 1945, no. 196; Blunt 1963, p.73; Blunt 1966, under no. L30; Blunt 1976, p.29; Blunt 1979, pp.44, 50; Edinburgh 1947, no. 85; F.A.Q.R. ii, p.179, iii, p.106; F/B, I, no. 64, V, p.78; Friedlaender 1929, p.257; Hamburg 1958, no. 29; Kamenskaya 1969; London 1938, no. 526; Mérot 1990, under no. 77; Oxford 1990, no. 15; Paris 1960, no. 160; Paris 1994, no. 41; R/P, no. 64; Standring 1985, p.617; Sydney 1988, no. 37; Thuillier 1974, under no. 79; Thuillier 1994, under no. 88; Wild 1967, pp.17f; Wild 1980, II, p.213

40 *The Agony in the Garden*

117

41 *Camillus and the schoolmaster of Falerii* ca. 1637

Stylus lines, graphite underdrawing, pen and brown ink, brown wash
Laid down
7 ¹⁄₁₆″ × 7 ⅛″ (179 × 180 mm)
Provenance: Massimi vol., no. 40 ("Furio Camillo")
RL 11913

The Roman General Furius Camillus was besieging the town of Falerii, when a schoolmaster offered his pupils as hostages to raise the siege. Camillus instead turned the schoolmaster over to be beaten by his pupils (Plutarch, *Life of Camillus*, 10; Livy, V, 27; Valerius Maximus, VI, 5, 1). This tale was only rarely depicted, but Poussin treated it on at least two separate occasions.

One painting, now in the Louvre (fig. 37), is large and al-most square and was painted in 1637 for Louis Phélypeaux de la Vrillière to hang alongside paintings by Guercino, Pietro da Cortona and others in the gallery of his hôtel in Paris, begun by Mansart in 1636. A second, oblong in format and much smaller but of very similar figuration, is in the Norton Simon Museum in Pasadena, California. Félibien (1725, IV, p.25) stated that Poussin had painted a smaller version of the subject "some years earlier" than that for La Vrillière, and this is surely the Pasadena painting (despite Blunt's attempt to date it, on stylistic grounds, after the Louvre version).

The present drawing is a study for the painting in the Louvre, for although there are few differences in the figuration of the two paintings, and indeed the sketchy landscape here is much closer to the Pasadena version, a constructional stylus line from lower left to upper right corners and a perspective grid extending to the lower right corner show that the drawing has not been cut down, and is preparatory for a painting square in format. The main changes in figuration between

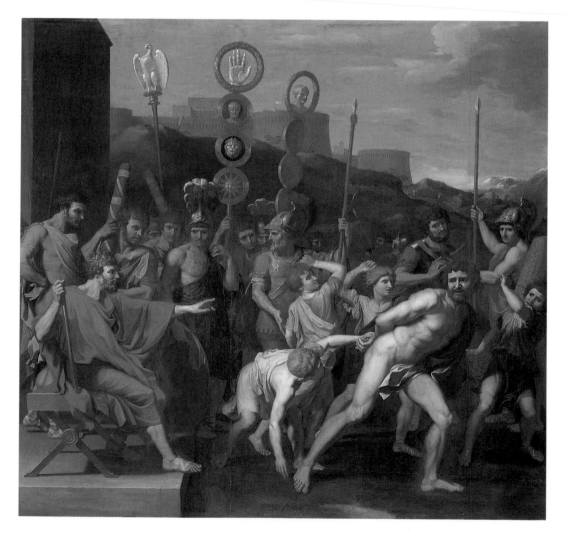

Fig. 37 Poussin, *Camillus and the schoolmaster of Falerii*. Oil on canvas. 99 ¼″ × 105 ½″ (252 × 268 cm). Louvre, Paris

drawing and painting are the increased scale of the boys beating the schoolmaster, and the introduction of three more figures at the right to contain the flow of the composition.

In another drawing for the Louvre painting, in the Fogg Art Museum in Cambridge, Massachussetts (fig. 39; F/B, no. 419; R/P, no. 126), Poussin attempted to solve the problem of the compositional gap in the center of the Windsor drawing by increasing the size of the boys. This drawing owes its unusual appearance to the method of its execution. The use of transparent overlays has shown that the figure of the schoolmaster, and the group of Camillus and the soldier behind him, follow the same contours and are the same size in both drawings. Poussin was evidently satisfied with these figures, and traced them in pen on the Fogg sheet from the Windsor drawing; the paper slipped as he moved from one side of the drawing to the other, causing a small increase in separation between the two groups. In black chalk he then sketched in the three boys on a larger scale, added two more, and increased the height of the background group, finally inking in some of the boys to try the effect of the whole composition.

In the Louvre painting, the three central boys are on the same scale with respect to the schoolmaster as in the Fogg drawing, but the two boys turning backwards have been left out. These two were first found at the right of the Pasadena version, but make little narrative sense on the Fogg sheet; as with the landscape in the Windsor drawing, Poussin must have been simply reusing motifs from his earlier version as he devised a new composition.

In addition to the two canvases, there is a carefully drawn panoramic drawing of the subject in the British Museum (fig. 38; F/B, no. A30; R/P, no. 127; the authenticity of this sheet has been questioned, but it is certainly by Poussin himself). It is not close in figuration to the paintings, and the degree of finish has led some scholars to propose that it was produced as an independent work of art; but it should be noted that the proportions are very close to those of the Pasadena painting (357×497 mm, a ratio of 1:1.39, against 100×137 cm). This might suggest that it was a rejected *modello*, produced for the patron before the painting was begun; however, it would be untypical of Poussin to reuse so few of the motifs when revising the composition. Such drawings are difficult to date on stylistic grounds alone, but it must be of the mid-1630s.

References: Badt 1969, p.246; Blunt 1945, no. 190; Blunt 1966, under no. 142; Blunt 1976, p.26; Blunt 1979, pp.44, 49; Bologna 1962, p.155; F.A.Q.R. ii, p.176; F/B, II, no. 123, V, p.94; Friedlaender 1929, pp.128, 256; Oxford 1990, under no. 48; R/P, no. 125

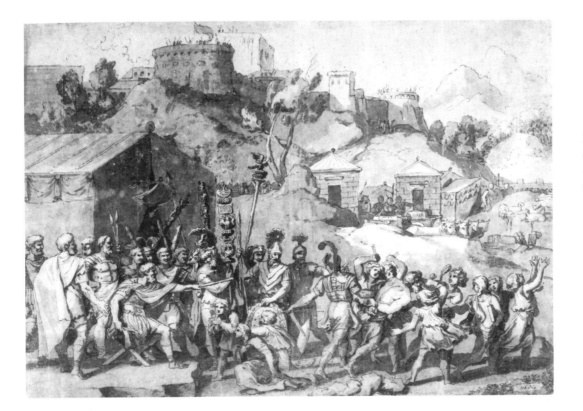

Fig. 38 Poussin, *Camillus and the schoolmaster of Falerii*. Pen and brown ink, brown wash. 14 $^1\!/_{16}$" × 19 $^9\!/_{16}$" (357×497 mm). British Museum, London, inv. 1895–9–15–922

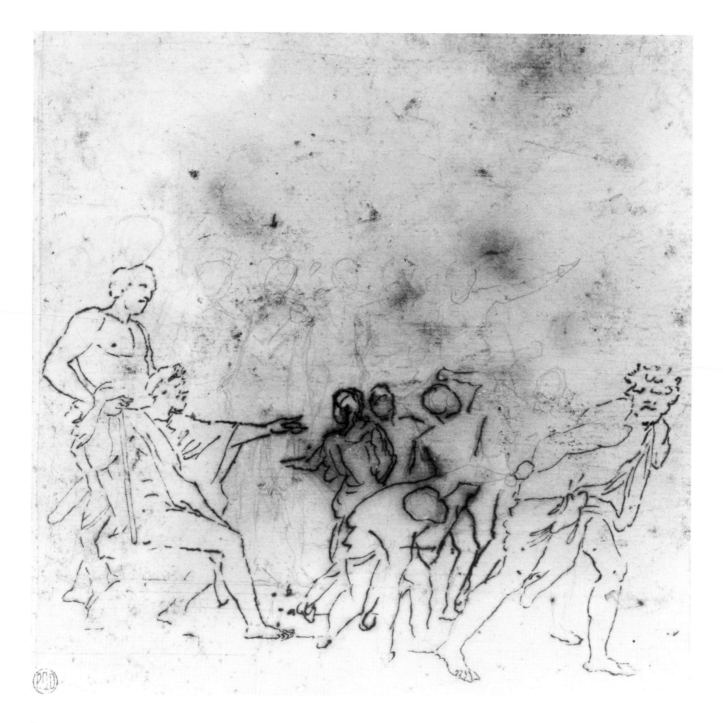

Fig. 39 Poussin, *Camillus and the schoolmaster of Falerii*. Pen and brown ink, graphite. 6 ⅞" × 7" (175 × 177 mm).
Fogg Art Museum, Cambridge, Massachusetts, inv. 1984.609

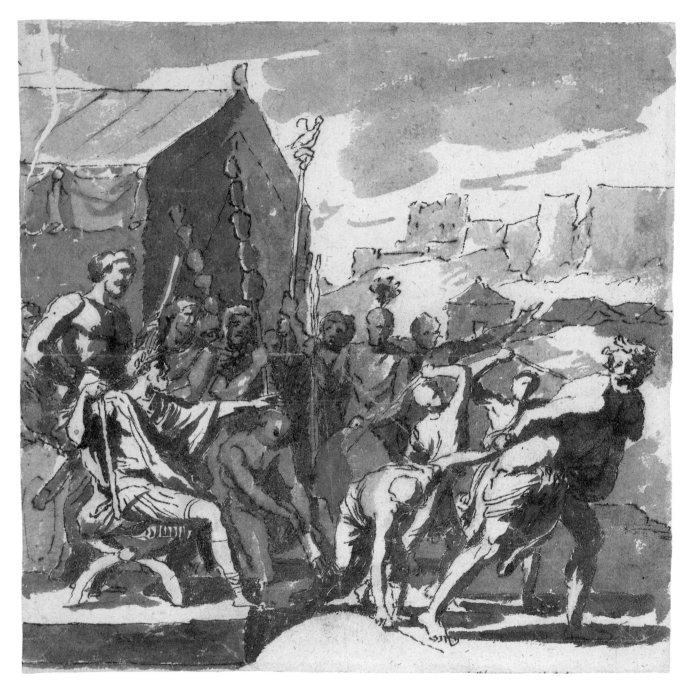

41 *Camillus and the schoolmaster of Falerii*

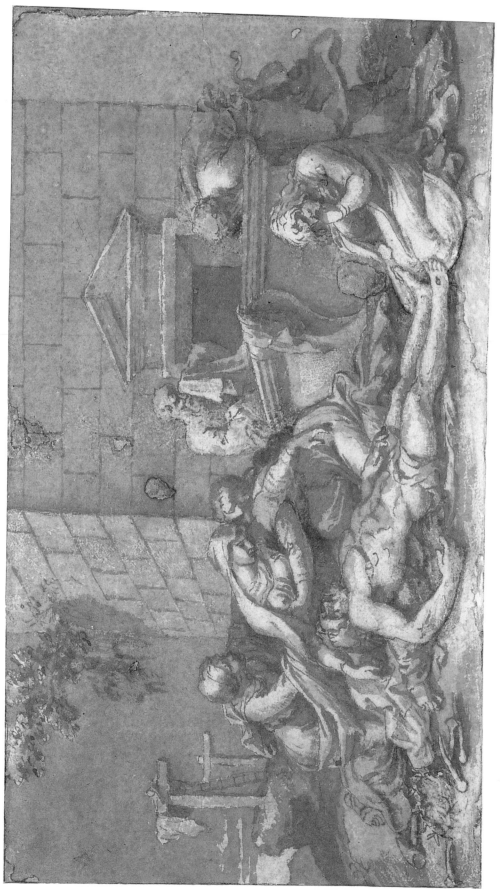

42 *The Lamentation before the tomb*

43 *The Holy Family with the infant St John*

Baptist, by the hand of Poussin (see Barroera 1979, p.70). This painting was presumably designed and executed in 1637, and indeed one of the two other studies for the present composition (cat. 44 verso) is on the reverse of a drawing datable to 1637. The subject of Rosciolo's painting corresponds to the present drawing, and the intimate composition has every appearance of being a final design for a relatively small painting. If the connection with the painting for Rosciolo is accepted, it becomes possible to group a series of related works (cats. 44–47) around 1637.

References: Badt 1969, p.230; Blunt 1945, no. 208; Blunt 1976, p.29; Blunt 1979, p.47; F.A.Q.R. ii, p.178; F/B, I, no. 41; Friedlaender 1929, p.256; London 1986, no. 71; Paris 1983, no. 203; Paris 1994, no. 102; R/P, no. 152; Salomon 1938

43 verso

44 *Hercules and Deianeira* ca. 1637

Slight black chalk underdrawing, pen and brown ink, brown wash
Verso: *The Holy Family*
Black chalk
8 ⁹/₁₆″ × 12 ⁷/₁₆″ (217 × 316 mm)
Watermark: shaft (?) on hills in shield
Provenance: Massimi vol., no. 27 ("Hercole e Deianira")
RL 11912

Fig. 40 Poussin, *Hercules and Deianeira*. Pen and brown ink.
8 ¹/₁₆″ × 6 ³/₈″ (205 × 162 mm). Louvre, Paris, inv. 32508

Hercules carries off Deianeira, whom he had won in a combat with the river-god Achelous (see cat. 17). A nymph tends the head of the river-god, while a second makes the cornucopia from his broken horn. Two putti carry Hercules's club and lion skin above him, a youthful Cupid leading the way. The episode on the right is more obscure, for it appears to show a nymph presenting the cornucopia to a maiden who is presumably Ceres, the goddess of agriculture (the cornucopia being her attribute), while a king – probably Oeneus, the father of Deianeira – walks away. This repetition of the cornucopia breaks Poussin's usual observance of the dramatic unities in his compositions, and Ceres is not mentioned in Ovid's account, but a nymph does present the cornucopia to *la Dea fertile* at the end of the Achelous's telling of the story in Anguillara's "improved" Italian translation of the *Metamorphoses* (see cat. 19).

In his biography of Poussin (1725, IV, p.26), Félibien stated that Poussin painted this subject for Jacques Stella in about 1637, and cat. 44 is almost certainly a study for that picture, now lost. Two other preparatory drawings survive, in the Louvre (fig. 40; F/B, no. 219; R/P, no. R782) and the Uffizi (F/B, no. A63; R/P, no. 101) – each of these has been catalogued as a copy at different times, but I believe both to be autograph. These correspond to the left half only of the present composition. The heavy ink line down the center of the present sheet suggests that Poussin decided to change the format of the picture and concentrate on the group with Hercules, and the Louvre drawing probably shows the composition in something like its final form.

The concentration on the effect of the wash is typical of Poussin's drawings in the second half of the 1630s. The handling of the foliage is identical to that in a study of a wooded landscape in the Louvre, recently published by Sutherland Harris, and the relationship between the landscape and the figures is very similar to that in *Ordination*, one of the earliest of the series of Sacraments painted for Cassiano dal Pozzo in the later 1630s. For the two rough black chalk sketches of a *Holy Family* on the verso of the sheet, see cat. 43.

References: Badt 1969, pp.230, 248; Blunt 1945, no. 207; Blunt 1966, under no. L63; Blunt 1976, p.25; Bristol 1956, no. 64; F.A.Q.R. i, p.273; F/B, I, no. 42 (verso), III, no. 218 (recto); Friedlaender 1914, p. 318; Friedlaender 1929, pp.127, 255; London 1949, no. 498; Oxford 1990, no. 42; Paris 1960, no. 158; R/P, no. 100; Sutherland Harris 1994; Thuillier 1974, under no. 103; Thuillier 1994, under no. 119; Wild 1980, II, no. 86

44 *Hercules and Deianeira*

44 verso *The Holy Family*

45 *Confirmation* ca. 1637

Black chalk underdrawing, pen and brown ink, brown wash
Verso: *The Holy Family*
Pen and brown ink
5 ⁷₁₆″ × 8 ⅛″ (138 × 207 mm)
No watermark
Provenance: Vol. II, p.8a
RL 11896

This is the only surviving study for *Confirmation* (fig. 41), one of the set of seven Sacraments painted for Cassiano dal Pozzo. A seated priest anoints the head of a child with the consecrated oil from a bowl held by an acolyte, while beyond, in the second stage of the ceremony, another ties a fillet around the head of a girl. In the foreground a kneeling mother urges her child forward. The principal group of figures is close to the final composition, but in the painting Poussin developed the pictorial devices that give the scene its gravity. There the figures are reduced in scale, and the architecture plays a greater role than the perfunctory row of columns and niches in the drawing (Blunt pointed out in 1967 that the building as painted is very close in detail to the church of Sant'Atanasio dei Greci, which stood opposite Poussin's house in Rome). The strong foreground lighting against the dark recess

beyond and the compression and movement backwards of the group on the left focus attention on the central act of anointing, heightening the contrast between the informality of normal human emotions and the solemnity of the ritual.

The dates of execution of the first series of Sacraments are not known in any detail. On the verso of cat. 63, the combination of studies in a uniform style and ink for *Extreme Unction* and for the Richelieu *Triumph of Pan* suggests that the planning, at least, of the series had begun by early 1636, but the last painting, *Baptism*, was not completed until 1642. The treatment of wash and the figure types of the present drawing are identical with those of the *Holy Family* (cat. 43), and indeed on the verso is another study for that composition. If the *Holy Family* can be associated with the lost painting for Rosciolo, and if one assumes that the two sides of the present sheet were executed at about the same time, it follows that Poussin was working on the design of *Confirmation* during 1637 – a rare point of reference in the chronology of the Sacraments.

References: Badt 1969, pp.215f, 230; Blunt 1945, no. 205; Blunt 1966, under no. 106; Blunt 1967, pp.189–95; Bologna 1962, under no. 69; Edinburgh 1981, no. 36; F.A.Q.R. iii, p.109; F/B, I, no. 40 (verso), no. 85 (recto); Newcastle 1952, no. 10; Oxford 1990, no. 45; Paris 1960, no. 166; Paris 1994, under nos. 66, 102; R/P, no. 107

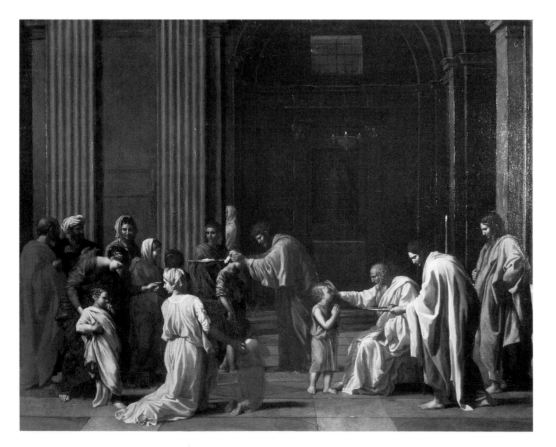

Fig. 41 Poussin, *Confirmation*. Oil on canvas. 37 ½″ × 47 ¾″ (95.5 × 121 cm). Belvoir Castle, Leicestershire

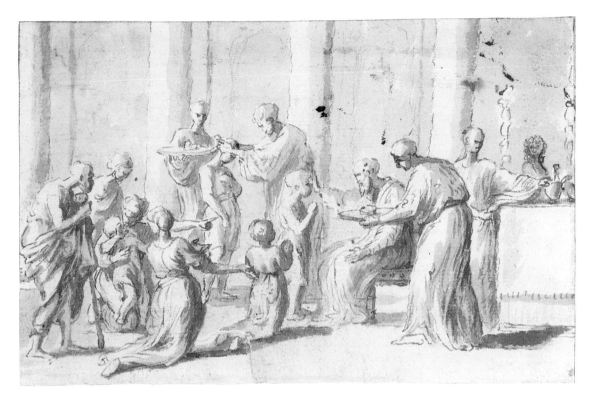

45 *Confirmation*

45 verso *The Holy Family*

46 *Moses and the daughters of Jethro*
ca. 1637

Slight graphite underdrawing, pen and brown ink, brown wash
Verso: sketch for the same
Pen and brown ink, rubbed over with graphite
5 13⁄$_{16}$″ × 8 ³⁄₁₆″ (148 × 208 mm)
Watermark: small fragment of kneeling saint in shield
Provenance: Massimi vol., no. 48 ("Le figlie di Iethro")
RL 11890

47 *Moses and the daughters of Jethro*
ca. 1637

Graphite underdrawing, pen and brown ink, brown wash
Verso: *The combat of the Horatii and the Curiatii*
Pen and brown ink, brown wash
7 ½″ × 12 ⅜″ (190 × 314 mm)
No watermark
Provenance: Vol. II, p.2
RL 11889

Having fled to Midian after slaying an Egyptian, Moses came upon the seven daughters of Jethro, who were being prevented by shepherds from watering their flock. Moses drove the shepherds from the well, was received into Jethro's house, and later married one of the daughters (Exodus 2:16–22).

Cats. 46 and 47 recto form a group with other drawings in the Rhode Island Museum of Design (fig. 43; F/B, no. 385; R/P, no. 300) and at Karlsruhe (fig. 42; F/B, no. 10; R/P, no. R457). First to be drawn was the verso of cat. 46: not only do the girls stand in an awkward straight line, but the paper has been blackened with graphite which would have impeded any further sketching, and, as will become clear, this graphite must have been added shortly after the execution of the drawing on the recto.

Our first sight of the whole composition is on the Karlsruhe sheet, with the girls less stiffly grouped, the well at the center, and a rather unseemly tangle on the right. By now Poussin was happy with the poses of the girl recoiling from the attacking shepherd, the kneeling girl, and the two seen from behind, and he studied them in more detail on the recto of cat. 46, changing the attitudes of the other three. Meanwhile, he had developed a more dignified pose for Moses striding over two sprawling shepherds, and studied these figures in isolation on the careful Rhode Island sheet.

Next Poussin integrated these two studies into a single composition. The use of transparent overlays has confirmed that in cat. 47 recto the recoiling girl, the kneeling girl, and the two with their backs turned are the same size and follow the same contours as the corresponding figures on cat. 46 recto, and the group of Moses and the two shepherds likewise corresponds exactly to fig. 40. Careful examination of the underdrawing of cat. 47 recto shows that these figures are outlined with a hard, unbroken graphite line, whereas all the others have a relatively free underdrawing. The verso of cat. 46 has been rubbed over with graphite, which confirms that Poussin used a transfer method in the creation of cat. 47 recto. He blackened the back of the preparatory drawings, positioned them on a second sheet, and with a stylus went round the contours of the figures that he wished to use in the final composition. (The Rhode Island drawing is laid down on an old mount, but if it were to be lifted it would no doubt also show traces of blackening.) The remainder of the composition was then sketched out in graphite, all the outlines gone over with ink, and the drawing carefully shaded with wash.

This rather mechanical procedure explains both the stilted execution of cat. 47 (which has given rise to doubts about its authenticity in the past) and the discrepancy of scale between the two halves of the drawing. But we have no idea whether the composition was refined further, for the sketches cannot be connected with any painting or documented commission.

The wash on the recto of cat. 46 is daintily applied with the tip of a fine brush, a handling that is typical of the later 1630s – compare with *Hercules and Deianeira*, cat. 44. Further, the pen sketch on the verso is identical in character with the *Holy Family* on the verso of cat. 45, and if stylistic analysis carries any weight at all, these drawings must be of the same date, that is about 1637.

A second group of drawings by Poussin (F/B, nos. 13–15; R/P, nos. 302–306) are studies for a painting of the same subject, now lost and known only through engravings, with a significantly different composition. These drawings are datable to around 1647; as so often in Poussin's career, he had revisited a subject after a lapse of some years, reusing some of the motifs but remodeling the composition in the light of his developed aesthetic sensibilities. Despite Goldstein's attempt to assemble all the drawings and the final engraved composition into an unbroken preparatory sequence – subsequently accepted by Blunt (in F/B, V) and recently reiterated by Goldfarb (Cleveland 1989) – it is not possible to connect the series of drawings discussed above with this other group, for the drawing style and compositional principles of these sheets are quite different. (Thuillier's tentative attribution to Charles Errard of all the sheets for *Moses and the daughters of Jethro* is thoroughly unconvincing.)

The vigorous sketch on the verso of cat. 47 represents an episode from pre-Imperial Roman history, recounted by Livy (I, 23f). A dispute between the Romans and the people of Alba was to be settled by mortal combat between three brothers from each side, of the families of the Horatii and Curiatii. One of the Horatii was left alive, and Rome was declared

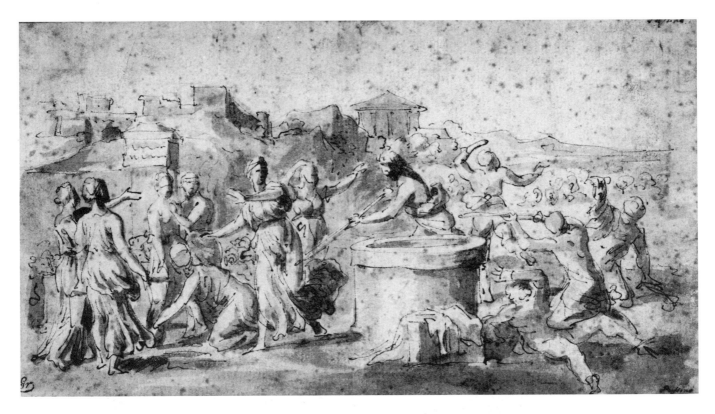

Fig. 42 Poussin, *Moses and the daughters of Jethro*. Pen and brown ink, brown wash. 5 ⅛″ × 8 ¹⁄₁₆″ (130 × 205 mm). Staatliche Kunsthalle, Karlsruhe

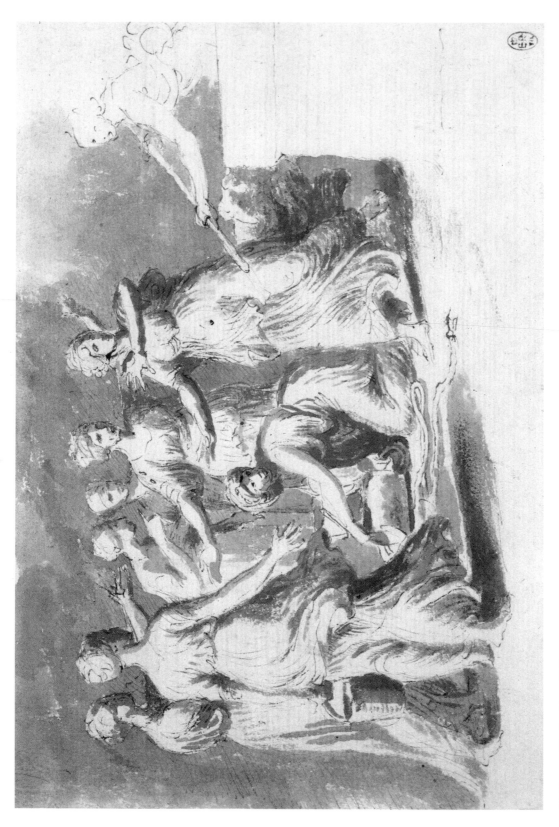

46 *Moses and the daughters of Jethro*

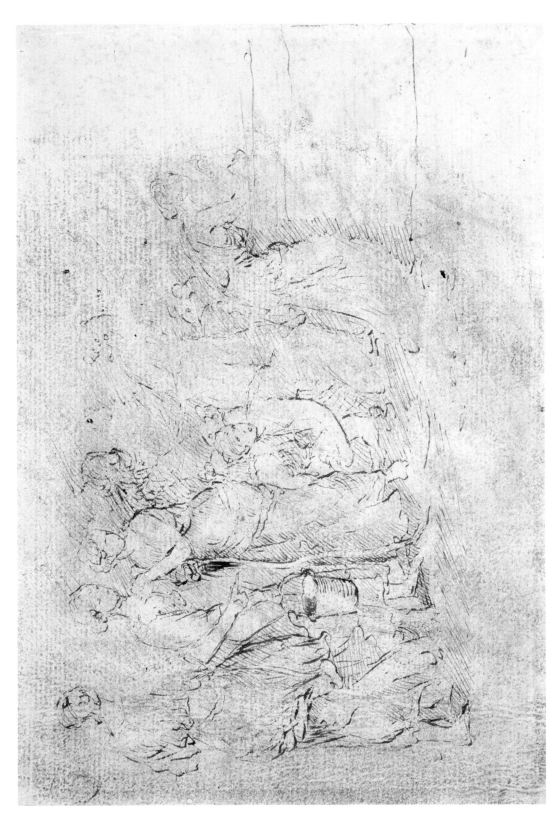

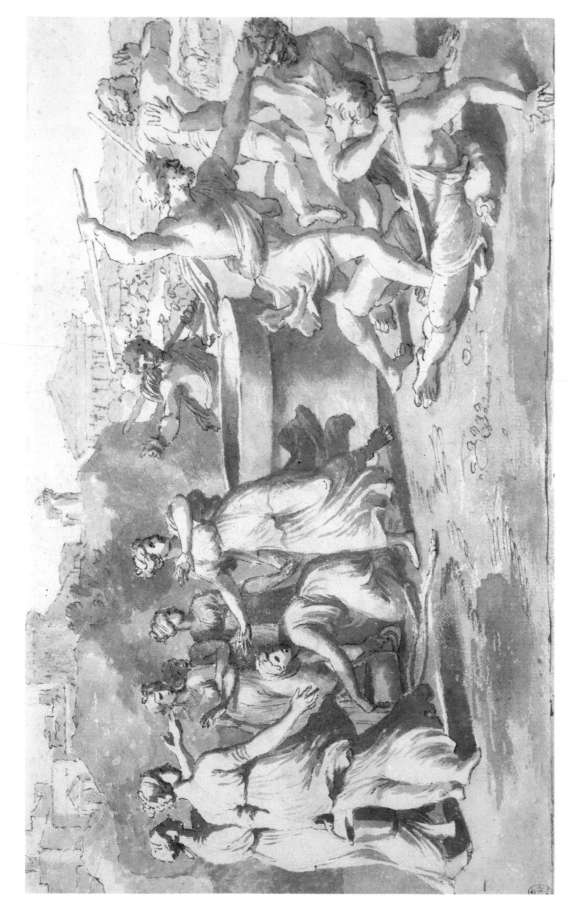

47 *Moses and the daughters of Jethro*

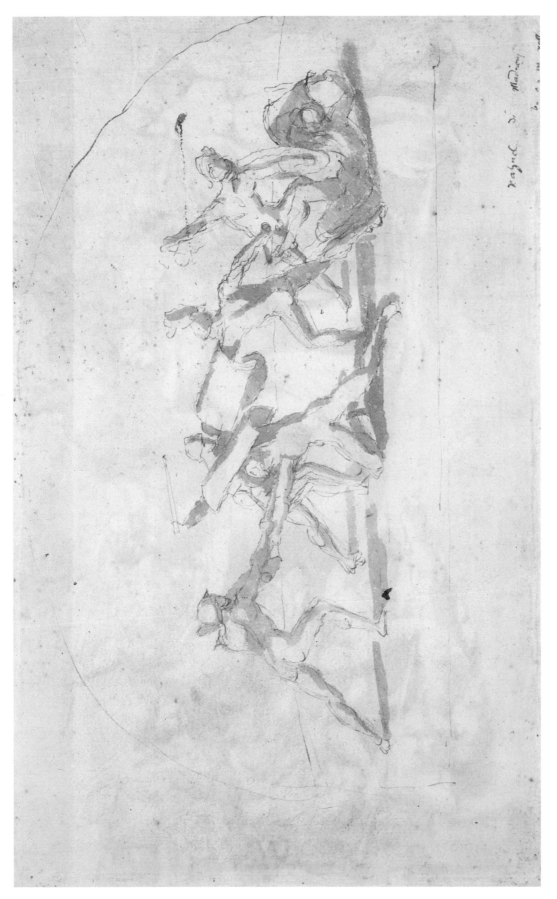

47 verso *The combat of the Horatii and the Curiatii*

victorious. Subsequently, he found his sister had been betrothed to one of the Curiatii, slew her, was tried and sentenced to death, but was reprieved by a public assembly after an appeal from their father.

No painting of this subject is known by Poussin; the rough semi-circle around the figures suggests that they were destined for a lunette, but Poussin has made no concessions to this format in the composition. The very rapid pen lines display signs of the trembling hand that was to afflict Poussin badly towards the end of his life, but which is found sporadically in drawings from the mid-1630s onwards (for example certain passages in *Hercules and Deianeira*, cat. 44). The handling of the pen and the equally energetic wash is characteristic of the mid-late 1630s, contemporary with the recto of the sheet.

The inscription at the lower right of cat. 47 verso, in Poussin's hand, appears to read *rahuel di Madiany / r. a. m rall. . .* – the last word is cut by the edge of the paper. The first line refers to the subject of the recto of the sheet ("Raguel [the alternative name of Jethro] of Midian"); I can make no sense of the second line.

References: Cat. 46: Blunt 1945, no. 209; Blunt 1966, under no. 17; Blunt 1976, p.29; Blunt 1979a, pp.52, 195; Cleveland 1989, under no. 19; F.A.Q.R. ii, p.177; F/B, I, nos. 11, 12, V, p.66; Friedlaender 1914, p.318; Friedlaender 1929, p.256; Goldstein 1969; London, 1938, no. 490; R/P, no. 137; Thuillier 1978, pp.166, 172

Cat. 47: Blunt 1945, no. 210; Blunt 1966, under no. 17; Blunt 1979a, p.195; Cleveland 1989, under no. 19; F.A.Q.R. iii, p.106; F/B, I, no. A3, V, p.66 (recto), II, 121 (verso); Friedlaender 1914, p.318; Goldstein 1969; Paris 1994, under no. 156; R/P, no. 301; Thuillier 1978, pp.166, 172; Wild 1980, II, no. 145a

Fig. 43 Poussin, *Moses driving off two shepherds*. Pen and brown ink, brown wash. 6 ½″ × 6 ⅜″ (165 × 162 mm). Museum of Art, Rhode Island School of Design, inv. 59.020

48 *The marriage of the Virgin*
ca. 1639–40

Pen and brown ink, brown wash
Verso: blank
7 ⅝″ × 11 ⅛″ (194 × 283 mm)
No watermark
Provenance: Massimi vol., no. 51 ("Sposalitio di Maria")
RL 11894

This is a study for the painting of *Marriage* from the first set of Sacraments (fig. 44). In this series of canvases, Poussin went beyond simple depictions of the seven Christian sacraments (acts conferring grace) to illustrate, in five cases, specific moments from the New Testament. *Baptism* obviously showed the Baptism of Christ, and *Communion* the Last Supper; for *Ordination* he painted Christ's charge to St Peter; for *Penance*, Christ in the house of Simon with the Magdalene anointing His feet, and for *Marriage*, the betrothal of the Virgin to St Joseph. Joseph was selected from the competing suitors by the miraculous flowering of his rod in the temple, and the presence of the Holy Dove and the flowering rod held by Joseph leave no doubt about the subject of the drawing. But other than these basic attributes Poussin keeps the scene as simple and solemn as possible, eliminating such narrative elements as the virgin companions of Mary, and Joseph's rivals discarding or breaking their rods.

Despite the apparent sketchiness of the drawing, it is very close in composition to the final design. Only the two pairs of figures standing behind the priest were to change significantly, and the facture of the present sheet suggests that these were the last to be drawn. It appears that Poussin was having difficulty striking the right balance between an excessively hierarchical structure, with wide gaps either side of the priest, and a similarly excessive homogeneous arrangement with an evenly spaced row of heads right across the canvas. His eventual compromise was to keep the two pairs of figures in these positions but moved slightly to the side and backward, reasserting the formality of the scene with strictly symmetrical architecture, barely indicated in the drawing.

The drawing is stylistically quite unlike that for the painting of *Confirmation* discussed above (cat. 45). The pen is starker, and the wash is treated in long angular strokes that reduce some of the tall, thin figures almost to geometrical shapes. In these features the drawing is close to the study for *Scipio Africanus and the pirates* (cat. 51), which probably dates from Poussin's stay in Paris, and the long outlining strokes of wash are found again in such drawings as *Hercules and Theseus fighting the Amazons* of 1641 or 1642. The date of the painting of *Marriage* cannot be determined by any external evidence, but on the basis of this preparatory sketch it must have been conceived right at the end of the 1630s or even as late as 1640. Rosenberg (in Paris 1994) proposed that *Marriage* was one of the first of the series, but the disposition of the figures, their excessively simplified facial types, and the rather hard tonality of the draperies places the painting close to the Moscow *Continence of Scipio*, paid for in July 1640.

References: Blunt 1945, no. 204; Blunt 1976, p.29; Blunt 1979a, p.194; F.A.Q.R. ii, p.178; F/B, I, no. 90; Friedlaender 1929, p.256; Paris 1994, under nos. 63, 70; R/P, no. 102; Wild 1980, II, under no. 43

Fig. 44 Poussin, *The marriage of the Virgin*. Oil on canvas. 37 ½" × 47 ¼" (95.5 × 121 cm). Belvoir Castle, Leicestershire

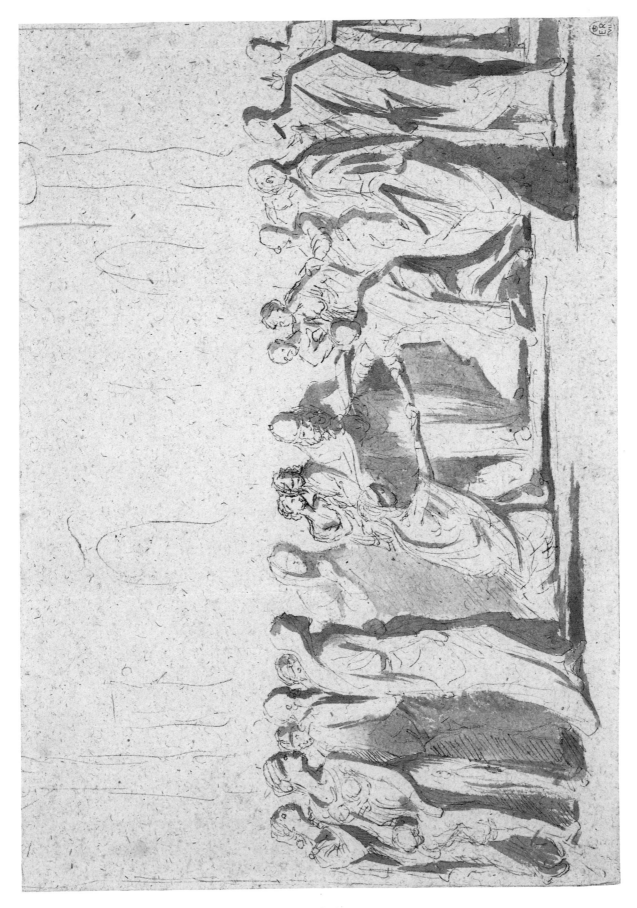

48 *The marriage of the Virgin*

49 *"Amor vincit Pan"* ca. 1636–39

Black chalk (?) underdrawing, pen and brown ink, brown wash
Verso: sketches of dead centaurs
Pen and brown ink
5" × 3 ⅞" (127 × 99 mm), upper right corner made up, and a patch inserted at upper center
No watermark
Provenance: Massimi vol., no. 11 ("Amore contro un Satiro")
RL 11915

The subject of this drawing is the same as cat. 16. Poussin's use of a pen with rather uneven ink flow makes the style of the drawing difficult to judge, but the rapidly indicated foliage and the delicate and atmospheric use of wash, applied with an almost dry brush in places, is characteristic of drawings of the later 1630s. There is an enlarged, inexact copy of this drawing in the Louvre (F/B, no. A54; R/P, no. R727), and a painted version, not by Poussin, in the Hermitage (reproduced by Thuillier).

The sketches on the verso, with the sheet turned through ninety degrees, are of the slumped bodies of centaurs. The most obvious context for such studies would be a depiction of the battle of Lapiths and Centaurs at the wedding of Pirithous and Hippodamia, described in lovingly gruesome detail by Ovid (*Metamorphoses*, XIII, 210ff), but not known to have been painted by Poussin. The right-hand half of a drawing in Bayonne (F/B, no. 240; R/P, no. 90), also of the mid-late 1630s, shows a centaur carrying off a maiden, and this may have been connected with the same project.

A roughly circular patch at the upper right of the sheet can be seen from the drawings on the verso to have been cut from a discarded part of the same sheet, in much the same manner as cat. 27. Both drawings came from the collection of Cardinal Massimi, and it is likely that this rather intricate modification was carried out under Massimi's instructions, when the drawings were trimmed to the borders of the principal subject in preparation for mounting in an album; but like cat. 27, the sheet is otherwise undamaged, and the reason for the "restoration" is unknown.

References: Bardon 1960, p.130; Blunt 1945, no. 185; Blunt, 1976, p.21; F.A.Q.R. i, p.270; F/B, III, no. 210 (recto), no. 239 (verso); Friedlaender 1929, p.253; R/P, no. 56; Thuillier 1974, under no. B38; Thuillier 1994, under no. B22

49 verso Sketches of dead centaurs

49 *"Amor vincit Pan"*

SECTION THREE

Paris 1640–1642, and the late years in Rome

Poussin left Rome in November 1640 accompanied by Paul Fréart de Chantelou and his brother Roland Fréart de Chambray, who had been sent to Italy the previous May to fetch the reluctant artist. They arrived at Fontainebleau on 14 December, and during the next week Poussin was cordially received by Sublet de Noyers, Cardinal Richelieu, and Louis XIII himself.

Although Sublet had apparently gone to some lengths to give Poussin an idea of what would be expected of him in Paris, it is clear that the Court considered him common property, and he was inundated with commissions in his first few months. At their first meeting, the king ordered Poussin to paint an altarpiece some eleven by eight feet (325 × 250 cm) of the *Institution of the Eucharist*, for the chapel of the Château of Saint-Germain-en-Laye (now in the Louvre). From Sublet came a commission for an even larger altarpiece, of the *Miracle of St Francis Xavier* for the Jesuits (also now Louvre), and from Richelieu an order for two paintings for his own palace. But the biggest task assigned to Poussin was the decoration of the Grande Galerie of the Louvre (see cat. 50), an enormous project of a kind he had never before attempted.

Poussin had habitually worked by himself in Rome. His meticulous approach to the craft of painting did not allow him to delegate to others the execution of portions of his small-scale canvases, destined to be studied closely in private houses, unlike the large decorative schemes undertaken by his contemporaries, which were usually seen from afar and rarely with much critical attention. But no single artist could cope with the volume of work that was imposed upon him in Paris, and although he expressed contempt for Parisian painters in his letters, he had little option but to recruit assistants, including the specialist stucco workers, gilders and so on necessitated by the Louvre project.

Despite his distaste for the workshop system, Poussin seems to have accommodated himself to the arrangement, for the paintings were completed at a satisfactory rate. It appears from Poussin's letters of the time that his old friend Jean Lemaire was responsible for the day-to-day running of the workshop, and of the many surviving sheets from this period, a number of the most important (including cats. A1, A5, A6, A8, A10) are in a uniform style and are probably by Lemaire. A detail from such a drawing for the Grande Galerie, cat. A6, shows the elaborate technique typical of many of these sheets, but the arcane subject cannot disguise the lack of the sense of nobility that had been evident in Poussin's own drawings of the 1630s. He must have felt that his appointment as *premier peintre du roi* had actually been accompanied by a fall in his status as an artist. In Rome, his mind had been admired by his patrons; in Paris, the emphasis was effectively on his crafts-manship, and although his name was valued as an adornment

A6 detail

to the Court, there is no sense that his employers' concept of the vocation of an artist coincided with his own.

After a hectic year, Poussin was less pressured in 1642, and his thoughts turned more strongly back to Italy. Two paintings were executed for Italian patrons (the last of the *Sacraments* for Cassiano dal Pozzo, and a small *Holy Family* for Stefano Roccatagliata, now in Detroit), and in the summer he made a presentation drawing for Cardinal Barberini (cat. 52). Life at Court was tense after the discovery of a plot against Richelieu, and the impossible scale of the Grande Galerie project must have become apparent to Poussin. In a letter to Cassiano of 25 July 1642, Poussin remarked that it was very likely that he himself would be the courier of Barberini's drawing (Jouanny 1911, p.169), for that month he had obtained Sublet's permission to travel to Rome, ostensibly to bring his wife to Paris. He left that September, but probably had little intention of returning, and with the deaths of Richelieu in December 1642 and of the king in May 1643, and the subsequent transferal of Sublet from his post as *surintendant des bâtiments*, there was little political will in Paris to force the artist to complete his contract.

Back in Rome, aged forty-eight, Poussin returned at once to his former practice of working alone on relatively small easel paintings. But a new seriousness, even severity, is found in his paintings and preparatory drawings; his experiences in Paris seem to have prompted him to re-examine his aims as an artist and to accentuate those qualities he felt were essential. Of the drawings from this period presented here, we can see in the *Holy Family in the temple* (cat. 54) an emphasis on the three-dimensional abstract features of the design, which was to become ever more profound in the series of many-figured Holy Families from the years around 1650. The study for the Massimi *Infant Moses trampling Pharaoh's crown* (cat. 55) shows to perfection the sense of discipline that runs through his work of the forties: although the painting was to be provided with a naturalistic (if austere) setting, cat. 55 is drawn as a bas-relief against a blank background, highlighting any weaknesses in the figural composition.

Also evident in cat. 55 are signs of the trembling hand that had started to afflict Poussin in the mid-thirties. He had complained about the condition (probably a consequence of the syphilis that had struck him down in 1630) in letters from Paris, but it was not to impair his drawing ability seriously until the 1650s. Nonetheless, he seems in the 1640s to have suffered a loss of confidence in his ability to draw a steady line with the pen, and the flowing lines of drawings such as those for the Richelieu *Bacchanals* (cat. 36) are no longer to be found. He countered this handicap in three ways. In some sketches where the subject allowed, he drew in a rapid, almost violent manner, where his lack of fine control would not matter

52 detail

55 detail

61 detail

(*Medea killing her children*, cat. 61). Occasionally, he used a drawing medium that was easier to control with a shaky hand, such as the reed pen, wash alone, or black chalk (*The Three Marys at the Sepulcher*, cat. 65, if the attribution is accepted; several other drawings from the period, not at Windsor, if it is not). But in the majority of cases, he retained the quill pen and used short, stabbing strokes that give a reticent look to the drawings, as seen in most of the other sheets in this section.

Poussin's biggest undertaking of the 1640s was a second set of Sacraments, painted for Paul Fréart de Chantelou between 1644 and 1648. Chantelou had initially asked for copies of the Sacraments painted the previous decade for Cassiano dal Pozzo, but Poussin was understandably reluctant to agree to this, and eventually he proposed an entirely new series of compositions. Although Poussin never saw the paintings together – they were dispatched one by one to Paris as each was finished – they hang as a series much better than Cassiano's heterogeneous canvases. It does appear that Poussin devised a full set of compositions before starting work on the project, but this does not in itself explain the coherence of the series, for occasionally (e.g. *Ordination*, cat. 58, and *Marriage*) we have two distinct sets of preparatory drawings for a painting – one group presumably from 1644, and a second showing Poussin's revised thoughts as he was about to begin work on the canvas.

The coherence of the second set of Sacraments is more readily explained by the consistency of purpose that is evident in Poussin's works from the 1640s onwards. There is no frivolity; painting is treated as an art form worthy of the most elevated themes and concepts. As the colors become more strident and the figures less naturalistic, the scenes depicted lose their temporality. The Holy Families and Annunciations attain a formal monumentality; harsh subjects such as the Death of Sapphira or the Judgement of Solomon are treated unflinchingly; landscapes are suffused with the history of civilizations and the cycles of life and death. Regrettably, little of this late development can be followed in the collection at Windsor, which has nothing of significance beyond 1650, though the drawings of around this date for *Medea killing her children*, *Christ healing the blind*, and the *Sacrifice of Polyxena* (cats. 62–64) give the flavor of the works to follow.

Poussin's final drawings are large in scale and the paintings inexact in outline, no doubt to counter his shaking hand, but the viewer is absorbed by their breadth of vision. Nothing seems contrived in these last works; he had created a parallel world through a lifetime's pursuit of the highest principles of art. Poussin died in 1665, living a simple life to the end, but revered – especially in France – as the greatest classicizing artist of his age.

50 Hercules and Theseus fighting Amazons ca. 1641–42

Circle traced with stylus, slight black chalk underdrawing, pen and brown ink, brown wash
Inscribed by the artist at lower right: *29*
Verso: sketches for a *Madonna and Child*
Pen and brown ink
5 ³⁄₁₆″ × 5 ¼″ (132 × 134 mm)
No watermark
Provenance: Vol. II, p.33a
RL 11920

As a punishment for the murder of his sons and nephews while mad, Hercules was ordered by the Delphic Oracle to serve Eurystheus, king of Tiryns, for twelve years. Eurystheus set the hero twelve superhuman tasks, the Labors of Hercules, and this drawing concerns the ninth. Admete, the daughter of Eurystheus, desired the girdle of Hippolyte, Queen of the Amazons, and Hercules was sent to secure it. At first he was welcomed by the Amazons, but the goddess Hera soured relations, and in an ensuing battle Hercules – in some accounts aided by Theseus and other Greeks – killed Hippolyte and took her girdle. Here Hercules, with lion skin and club, grasps the hair of an Amazon at the left of the circle, and if the identification of the subject (given in the late-eighteenth-century *Inventory A* of the Royal Collection) is correct, Theseus must be the helmeted figure just above Hercules.

The drawing is preparatory for Poussin's decoration of the Grande Galerie, a wide corridor four hundred yards long connecting the Louvre with the Tuileries, the biggest project forced upon him during his unhappy two years in Paris (and this despite a promise from François Sublet de Noyers in a letter to Poussin of 14 January 1639 that "you will not have to paint on ceilings nor on vaults" – Jouanny 1911, p.7). In March 1641 he was given control over the decoration of all the royal palaces in France, and began by destroying the scheme that the architect Jacques Lemercier had begun in the Louvre. But Poussin carried out very little work, and what he completed was in turn destroyed the following century.

It would be hard to conceive of an enterprise less suited to Poussin's temperament than this, requiring him to devise an extensive decorative scheme for painting on a barrel vault,

Fig. 45 Poussin, *The exploits of Hercules*. Pen and brown ink. 7 ³⁄₈″ × 11 ⅞″ (187 × 302 mm). Musée Bonnat, Bayonne, inv. N.I. 48

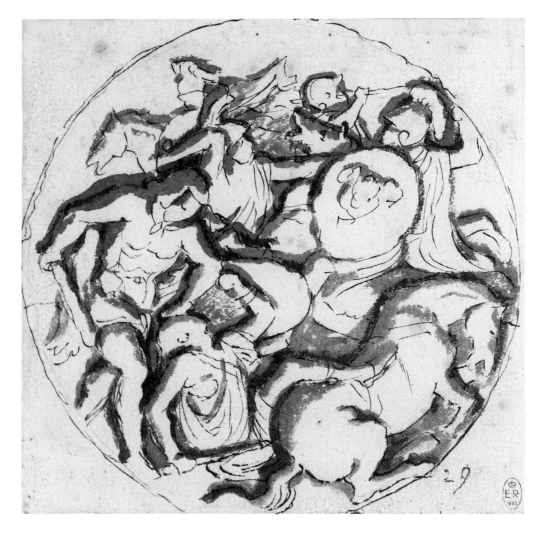

50 *Hercules and Theseus fighting Amazons*

50 verso Sketches for a *Madonna and Child*

inevitably involving the supervision of a large number of assistants, not only painters but also craftsmen. Probably the only aspect that appealed to him was the erudition required to spin out a mythological theme into dozens of episodes; quite reasonably the life of Hercules was chosen as a subject, having been treated at length by several classical authors. Nonetheless Van Helsdingen demonstrated that Poussin's main source was not an ancient work but a French translation of Natale Conti's widely used mythographic handbook *Mythologiae sive explicationis fabularum libri decem*, which went through several French editions between 1599 and 1627.

Many drawings for the project survive, mostly the carefully finished working drawings used to transfer the designs to the ceiling (fig. 46), executed by Poussin's assistants, including Jean Lemaire, who apparently took over practical responsibility for the project in 1642 and continued the work for several months after Poussin left for Rome. Of the few sheets by Poussin himself, two contain a series of rough first thoughts for the compositions, mostly annotated by Poussin with an identification of the scene and a sequence number (Bayonne, fig. 45; F/B, no. 241; R/P, no. 213; and the Louvre; F/B, no. 242; R/P, no. 212). Of the next stage, where the first sketch is worked up into a full composition, only the present drawing survives, showing the change from the essentially pictorial conception of the first sketches to the emulation of relief sculpture apparent in all the finished sheets. Poussin

abhorred the spatial illusionism that dominated Baroque decorative schemes: he wrote in a letter to Sublet that "everything I have placed on this vault should be understood as being attached to it in the manner of a relief, without pretending that there is any object which breaks through, or which lies beyond and at a greater distance than, the surface of the vault, but that everything follows its curvature and shape." (Jouanny 1911, p.144.)

In this drawing he dragged long lines of dark wash around the contours of the figures to give the effect of shadows cast by high relief on to a plain ground, but the composition is somewhat incoherent compared to the workshop fair copies, all of which have a definite "up" if not a solid horizon, and it may well be that the present design was simplified into the depiction of Hercules stuggling with a single mounted Amazon, known through studio sheets in the Hermitage and the Prado (F/B, nos. A99–A100; R/P, nos. A56–57).

The fragmentary drawings on the verso are for a composition of the Madonna and Child. In their scale, motif and the degree of abstraction of the figures, they must be connected with cat. 54.

References: Blunt 1945, no. 214; Blunt 1951; Blunt 1979a, p.153; F/B, I, no. 44 (verso), IV, no. 243 (recto); Forte 1983, p.271, no. 56; Hattori 1994; Henderson 1977; Martin 1965, pp.160–64; Mérot 1990, p.125; Paris 1994, no. 103; R/P, no. 214; Van Helsdingen 1971; Wild 1966; Wild 1980, II, under no. 125

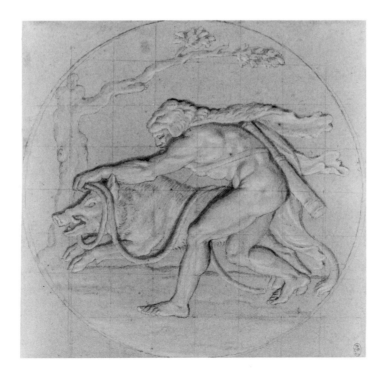

Fig. 46 Studio of Poussin (Jean Lemaire?), *Hercules and the Erymanthean boar.* Blue-green paper, graphite underdrawing, pen and brown ink, brown wash, white heightening, squared in graphite. 8 %16″ × 8 %16″ (218 × 218 mm). Cat. A6

51 *Scipio Africanus and the pirates* 1642

Pen and brown ink, brown wash
Verso: sketches for the same
Pen and brown ink
8 ⁷⁄₁₆″ × 11 ⅛″ (214 × 283 mm)
No watermark
Provenance: Massimi vol., no. 43 ("Scipione Africano")
RL 11886

52 *Scipio Africanus and the pirates* 1642

Squaring in stylus and black chalk, black chalk underdrawing, pen
and brown ink, brown wash
Verso: blank
12 ⅞″ × 18 ½″ (327 × 470 mm)
No watermark
Provenance: Vol. II, p.15
RL O698

The Roman general Scipio Africanus was in retirement at his villa at Liternum in Campania (around modern-day Naples) when pirates landed, apparently planning to attack the villa. But their intention was merely to pay homage to the general, and they were allowed to proceed to the villa unmolested by Scipio's companions (Valerius Maximus, II, 10, 2).

Both of the present sheets show three pirates gathered in homage around Scipio, their shields cast aside, as Scipio's companions look on. One sheaths his sword, a narrative key that is found sketched in isolation on the verso of cat. 51. A sheet in the Ecole des Beaux-Arts in Paris (fig. 47; F/B, no. 128; R/P, no. 222) shows the final preparatory stage, with the squaring corresponding to that of cat. 52. All the figures are in position, with the scene reversed and expanded and two more pirates rushing in from the left; the action has been moved from an open space to the portico of a large classical building. Only the details of the architecture were to be decided upon, Poussin finally substituting heavy Doric columns for the slender coupled pillars, and giving the back wall two niches and one portal.

On 27 June 1642, Poussin wrote to Cassiano dal Pozzo from Paris, thanking him for giving him the opportunity to make a drawing on the subject of Scipio (the episode is not specified) for Cardinal Francesco Barberini, and expressing his regrets that he had left a sketch of the subject in Rome (Jouanny 1911, p.166). The drawing is referred to again in another letter to Cassiano on 25 July (*ibid.*, p.169); there is never any mention of a painting of the subject, and cat. 52, large and carefully finished, is exactly what one would expect of a drawing executed as a work of art in its own right.

Nonetheless, the high degree of finish of cat. 52 has led to a persistent attribution of the sheet to an assistant of Poussin. This is both methodologically unsound and stylistically unwarranted. It is hard to imagine Poussin entrusting to an assistant the execution of a drawing for a patron as potentially important as Barberini, for one cannot correct a bungled drawing in the way that one can a painting. Poussin in his letter to Cassiano dal Pozzo stated that he would execute the drawing himself; only if the visual evidence contradicted this first-hand testimony could one dismiss the drawing as by Poussin, and this it fails to do.

Of the sheets from the Paris period which are by assistants, a number stand out for their uniform and relatively high quality, including many of the finished drawings for the Grande Galerie (cats. A5 and A6), the models for engraving (cats. A8–A10), and the large *modello* for the *Institution of the Sacrament* (cat. A1); these are almost certainly by Poussin's principal assistant in his Parisian years, Jean Lemaire. But the style of those sheets, with unbroken contours and prosaic wash, is completely unlike that of cat. 52, where the outlines,

though controlled, have the spark of life, the abbreviations are those of Poussin, and the wash is treated with the sensitivity and intelligence that we would expect after witnessing the evolution of Poussin's drawings during the 1630s. The style of the statues in the niches is exactly that of cat. 51, and Blunt's suggestion (1945) that the statues, and the ships and figures in the distance, might be the work of Poussin himself and the remainder by an assistant is not borne out by the facture of the drawing, as stressed by Popham. In short, cat. 52 is a very fine drawing, and it is difficult to argue that it is not by Poussin himself.

It has also been suggested (e.g. F/B, II) that cat. 51 is the sketch left by Poussin in Rome when he departed for Paris, as mentioned in the letter of 27 June 1642. But the central motif of Scipio and the three pirates in cat. 52 is a mirror of the corresponding group in cat. 51, and if Poussin was capable of remembering the structure of such an intricate group so exactly more than eighteen months after he first drew it, he would hardly have needed his earlier sketches. This repeated group alone must indicate that cat. 51 was drawn in Paris during Poussin's preparations for the finished drawing in mid-1642.

Cat. 52 came from the collection of Cassiano dal Pozzo, to whom Poussin's letters mentioning the drawing were written, and who was the secretary of Cardinal Barberini. The letter of 25 July 1642 makes it clear that Cassiano was the intermediary in Poussin's dealings with the powerful and busy Barberini, and we have no way of knowing whether the drawing ever reached Barberini's collection. Even if it did, Barberini fled Rome after the death of his protector Urban VIII in 1644, and it may be that Cassiano took the opportunity then to secure the sheet for his own collection.

There is another version of cat. 52 in the museum in Orléans (fig. 48; F/B, no. A175; R/P, no. A190). Although its poor condition makes a judgement of quality difficult, it is much cruder in many of its details, particularly in the faces and hands, and is unlikely to be a repetition by Poussin himself. It has been cut down somewhat but is on an identical scale to cat. 52, and was therefore probably made by a copyist using some transfer technique while the original was in Cassiano's collection.

References: Cat. 51: Blunt 1945, no. 211; Blunt 1976, p.27; F.A.Q.R. ii, p.178; F/B, II, nos. 126, 127; Friedlaender 1929, p.256; Oxford 1990, no. 44; Paris 1960, no. 171; Paris 1994, under no. 106; R/P, no. 221

Cat. 52: Blunt 1945, no. 251; Blunt 1979a, pp.117, 156f, 197; F.A.Q.R. iii, p.110; F/B, II, no. A32, V, p.95; Friedlaender 1914, p.318; Paris 1960, no. 173; Paris 1994, under no. 106; Popham 1946, p.284; R/P, no. A89; Wild 1980, II, no. 108

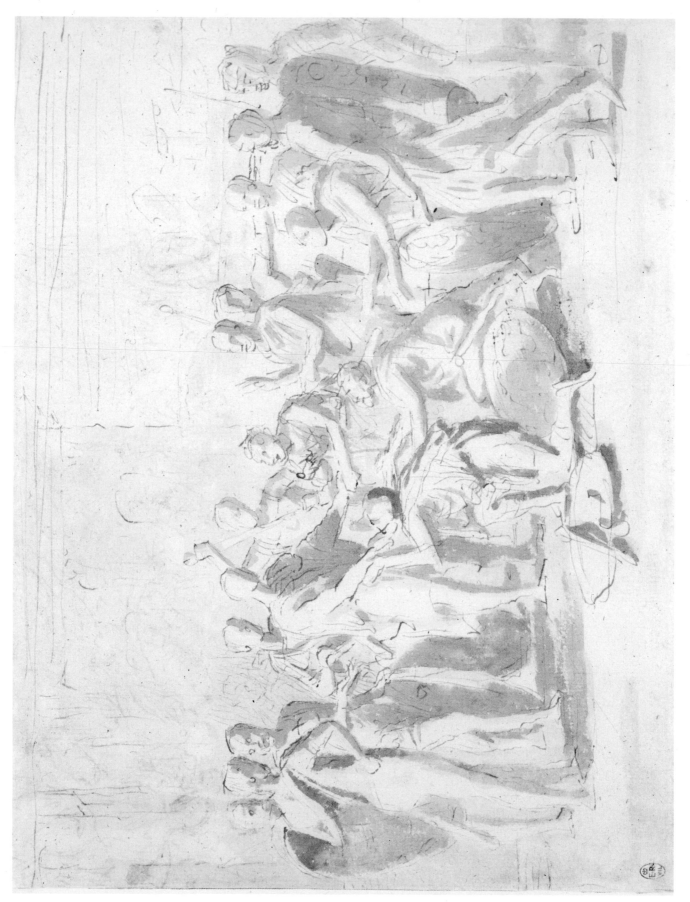

51 *Scipio Africanus and the pirates*

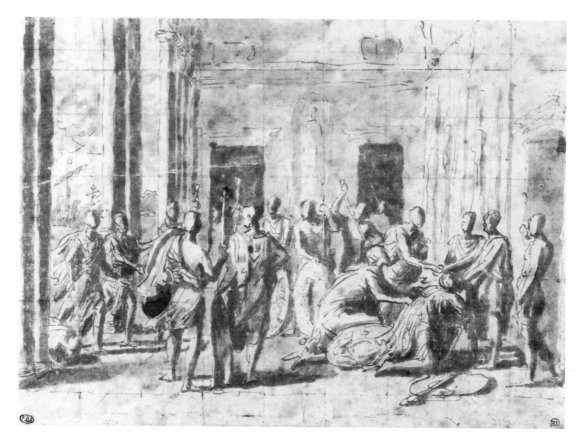

Fig. 47 Poussin, *Scipio Africanus and the pirates*. Pen and brown ink, brown wash, squared in black chalk. 5 ⅝″ × 7 ¾″ (143 × 197 mm). Ecole des Beaux-Arts, Paris, inv. 1422

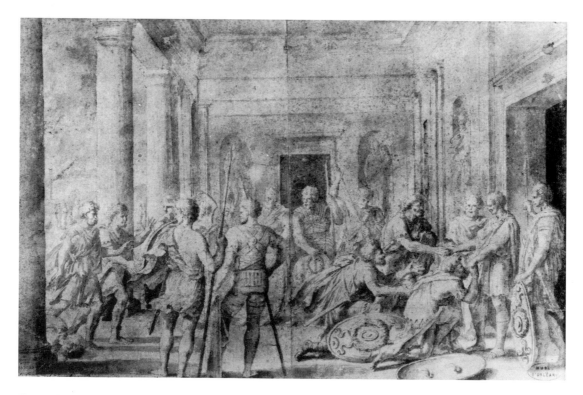

Fig. 48 Copy after Poussin, *Scipio Africanus and the pirates*. Pen and brown ink, brown wash. 11 ¹³⁄₁₆″ × 17 ¹¹⁄₁₆″ (300 x 450 mm). Musée des Beaux-Arts, Orléans, inv. 1040N

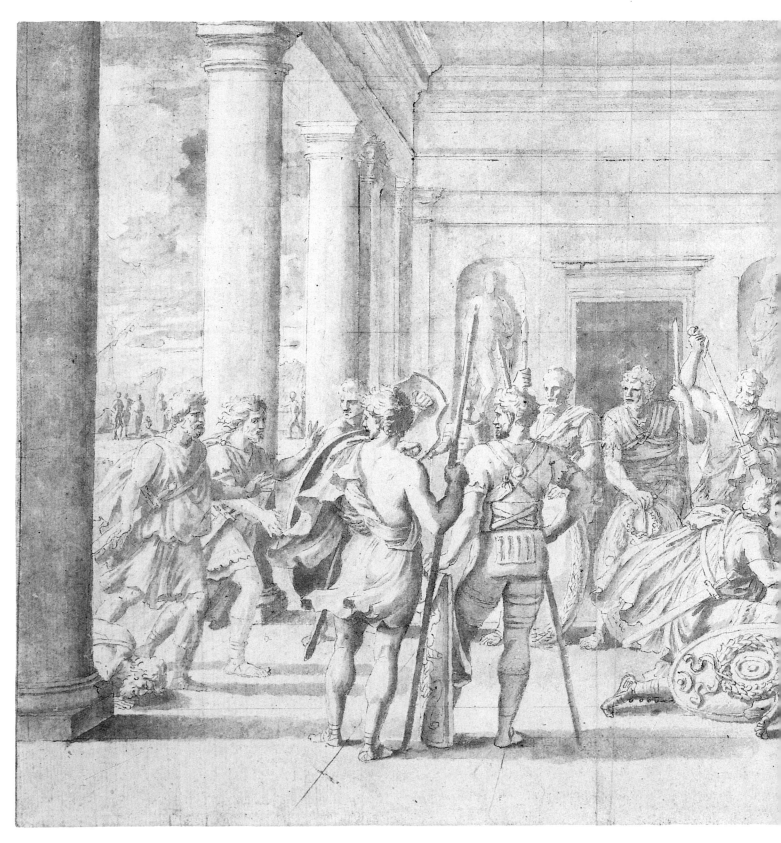

52 *Scipio Africanus and the pirates*

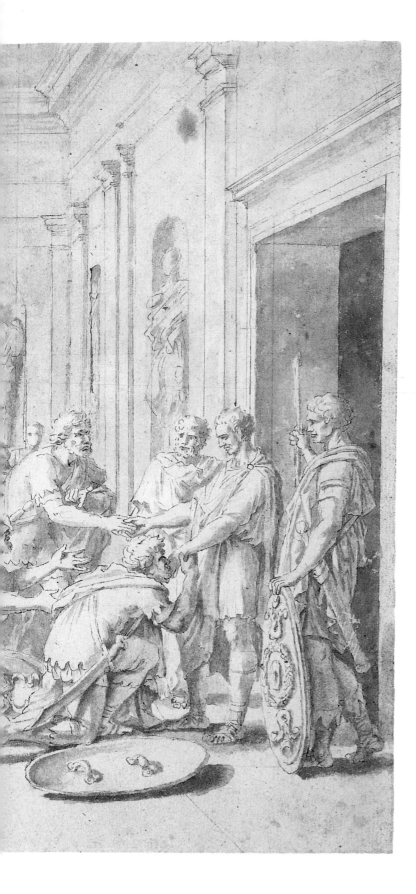

53 The body of Darius returned to his mother ca. 1644–45

Blue paper, slight black chalk underdrawing, pen and brown ink, pale brown wash
Verso: blank
10 ¼″ × 16 ⅛″ (260 × 410 mm)
Watermark: fleur-de-lis in circle, surmounted by cross flanked by letters C G
Provenance: Massimi vol., no. 65 ("La Clemenza d'Alesso. Magno")
RL 11989

The subject of this drawing is identified in the Massimi catalogue. Alexander the Great defeated the Persian king Darius in three battles, at the Granicus, Issus, and Guagamela. After the final battle, Darius was seized by his subordinate Bessus, governor of Bactria, who had him put to death the following year as Alexander overtook the fleeing Persians. Alexander laid his cloak over his great enemy, had his body embalmed and returned to his mother, and having captured Bessus, executed him in macabre fashion (Plutarch, *Life of Alexander*, 43).

Until its recent acceptance by Rosenberg and Prat, this drawing had been unanimously dismissed as by a follower of Poussin. Blunt suggested an attribution to Pierre Lemaire, and Thuillier saw parallels with the late work of Charles Errard. But the drawing must come from the circle of Poussin; it is not drawn like a copy; and the foreground figures, rather statuesque, with large pointy hands and heads outlined by short curving strokes, are those of Poussin in the mid-1640s – in fact the pen-work of the figures is virtually identical to the final study for *Confirmation* (cat. 57) of 1644–45. One should not be put off by the rather unattractive effect of the light wash against the pristine blue paper, as the drawing is clearly unfinished; its final appearance would presumably have been something like a pale cousin of *Confirmation*. The background figures are typical of Poussin's loosest sketching style, and the architecture is drawn in the same manner as that in the *Holy Family in the temple* (cat. 54). Even the odd looping pen-work in the sky finds a parallel in the backdrop of the earlier study for *Marriage* (cat. 49).

The sheet is not connected with any other drawing or painting, and its purpose can only be surmised. It is too large and elaborate to have been a mere "visual note" by Poussin, and it may have been the final preparatory stage for an undocumented painting that was lost or never executed – as was possibly the case with the studies for *Moses and the daughters of Jethro* (cats. 46 and 47) and *Medea killing her children* (cats. 61 and 62).

References: Blunt 1945, no. 258; Blunt 1976, p.30; Blunt 1979a, pp.156f; F.A.Q.R. ii, p.180; F/B, II, no. A29; Friedlaender 1929, p.257; R/P, no. 226; Thuillier 1978, p.172; Wild 1980, II, no. R22a

54 The Holy Family in the temple ca. 1641–43

Blue paper, black chalk underdrawing, pen and brown ink, brown wash, squared in black chalk
Verso: blank
8 ¼″ × 6 ⁷⁄₁₆″ (210 × 163 mm)
No watermark
Provenance: Massimi vol., no. 54 ("La Vergine, S. Elisabetta, e S. Gioseppe")
RL 11988

This drawing of the Madonna and Child with St Joseph, the infant Baptist and his mother St Elizabeth, is preparatory for a painting known in several versions, of which the finest appears to be that at Chantilly (fig. 49). A fragment of another drawing for the same composition is in the Los Angeles County Museum of Art (F/B, no. 393a; R/P, no. R560).

The authorship of the painting and of both drawings has been questioned in recent years, and Rosenberg and Prat rejected all three from Poussin's corpus, proposing that the two drawings are by different artists. But the Chantilly painting is of high enough quality and close enough in handling to Poussin's paintings of around 1640 to have been accepted as autograph by scholars as eminent as Blunt (who later expressed reservations) and Mahon. The Massimi provenance of the present drawing is no guarantee of its authenticity, but the scale of the figures, their depiction in the nude and the degree of abstraction are comparable with certain drawings of the forties such as the *St Matthew and the angel* on the verso of cat. 59. The Los Angeles sketch, while not particularly attractive, is certainly consistent in its handling of wash with drawings of the same period. And, most tellingly, the sketches on the verso of cat. 50 are surely connected with the same composition, for the scale, the pen style, and the types of abstract, egg-headed, drop-shouldered Madonna and heavy, uncomfortably posed Child are identical to those on cat. 54. It seems very bold to reject this cumulative evidence without proposing some more convincing alternative.

The verso of cat. 50 provides an important point of reference for the dating of the project. As these sketches are on the verso of a drawing which must have been executed around 1641, it is reasonable to suppose that Poussin was mulling over the composition during his years in Paris. But the painting is not mentioned in his many letters from that period, and it is thus unlikely (though not impossible) that any work was carried out then. The painting now at Chantilly came from the Palazzo Rospigliosi, and if it is the original it was probably commissioned from Poussin by Cardinal Giulio Rospigliosi (later Pope Clement IX). Rospigliosi had employed Poussin in the later 1630s, but he was absent from Rome between 1644

and 1653. It therefore seems most probable that the composition was worked out sometime after 1641, and that the painting was executed between Poussin's return to Rome and the departure of Rospigliosi.

The drawing is squared for transfer and corresponds more or less with the disposition of the figures in the painting, but there are obvious differences between drawing and painting in the architectural background and in the portrayal of the figures here as nudes. The formulation of compositions with the figures unclothed was a commonplace of art theory, but Poussin (like many artists) only rarely followed such a procedure. The conception of the figures is strongly sculptural, with simplified limbs and one foot of the Madonna raised on a block. This robustness tends to support Posner's observation that Poussin adapted his composition from Caravaggio's *Madonna di Loreto* (Sant'Agostino, Rome), suggesting that his range of interest in other artists' work extended beyond the obvious classicist prototypes.

References: Blunt 1945, no. 213; Blunt 1966, under no. 52; Blunt 1971, p.215; Blunt 1974, p.761; Blunt 1976, p.29; Blunt 1979a, pp.110, 114; Chantilly 1994, under no. 8; Edinburgh 1947, no. 88; F.A.Q.R. ii, p.179; F/B, I, no. 43, V, pp.72f; Friedlaender 1914, p.319; Friedlaender 1929, pp.127, 257; Leicester 1952, no. 47; London 1938, no. 518; Mahon 1962, pp.110f; Muchall-Viebrook 1925, pp.101f; Oxford 1990, no. 50; Paris 1960, no. 190; Posner 1965; Rosenberg 1991, pp.211f; R/P, no. R1321; Thuillier 1974, under no. B41; Thuillier 1994, under no. B24; Wild 1958, pp.17f; Wild 1967, p.43; Wild 1980, II, under no. R52

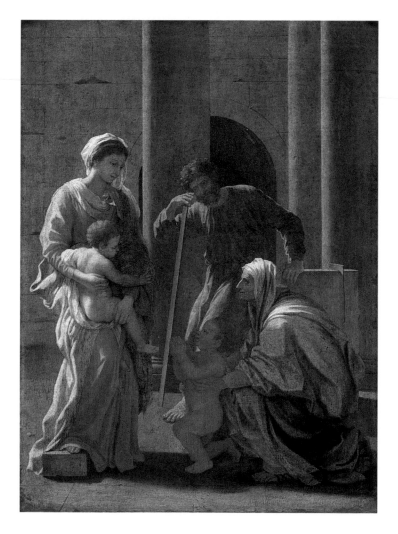

Fig. 49 Poussin (?), *The Holy Family in the temple*. Oil on canvas. 26 ½" × 19 ¼" (67 × 49 cm). Musée Condé, Chantilly

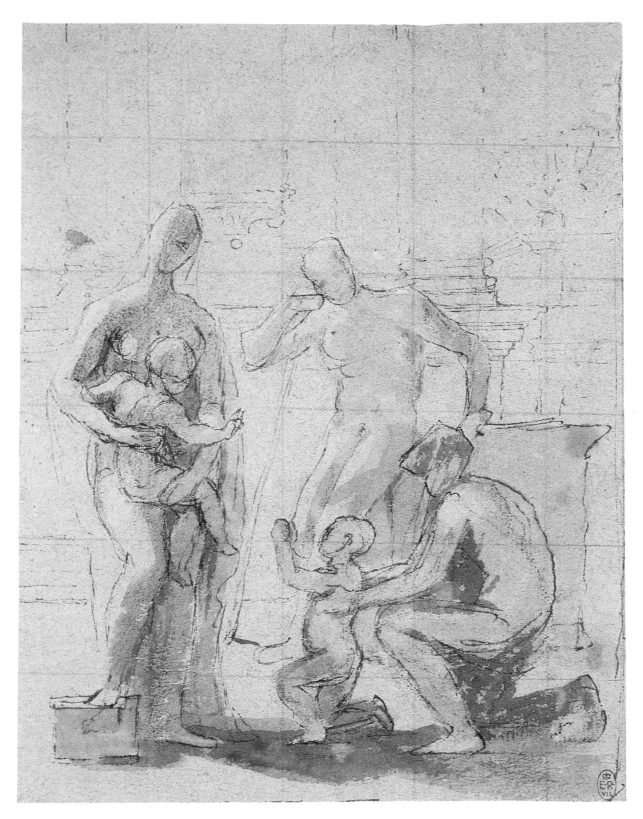

54 *The Holy Family in the temple*

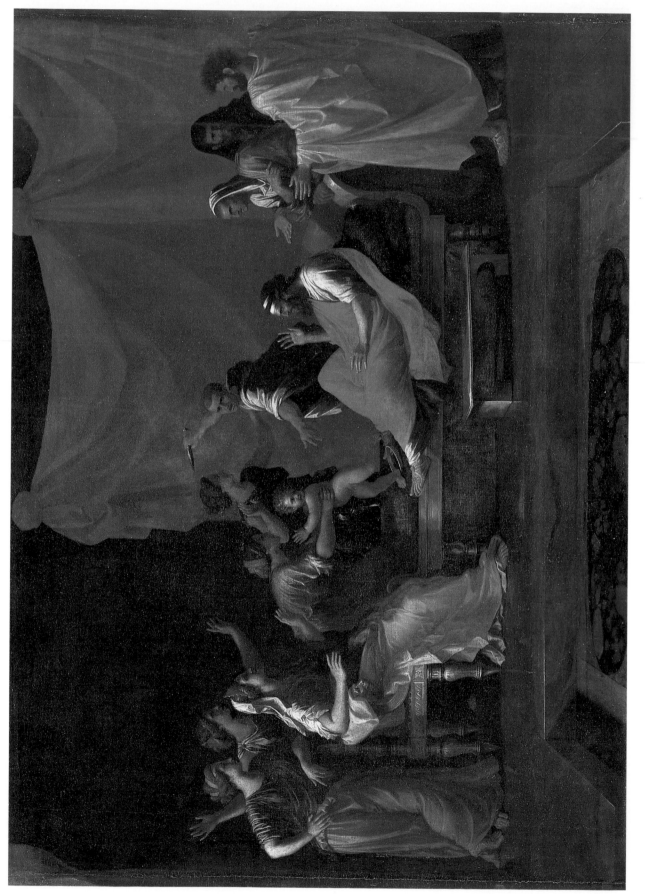

Fig. 50 Poussin, *The infant Moses trampling Pharaoh's crown*. Oil on canvas. 36 ¼″ × 50 ½″ (92 × 128 cm). Louvre, Paris

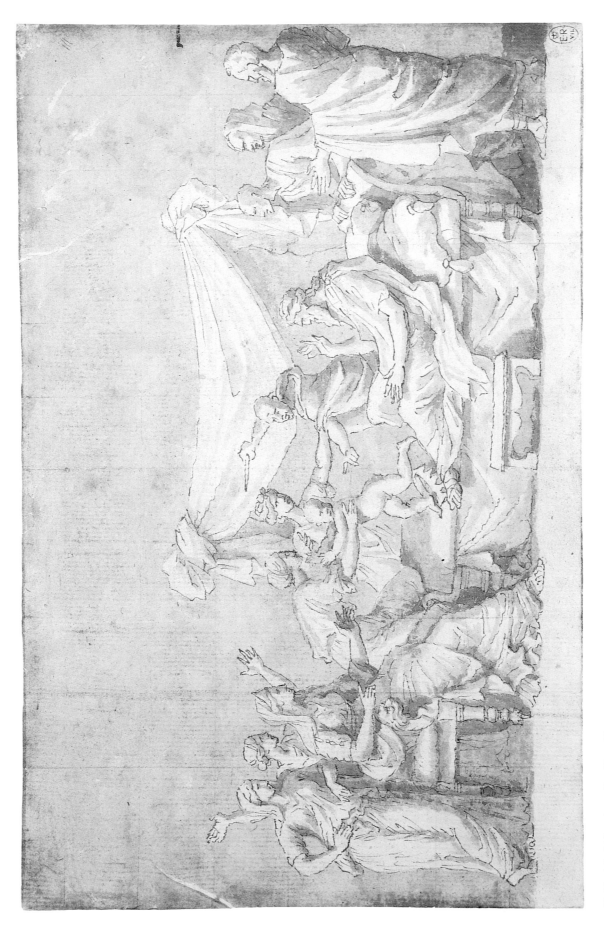

55 The infant Moses trampling Pharaoh's crown

163

55 *The infant Moses trampling Pharaoh's crown* ca. 1644–45

Slight black chalk underdrawing, pen and brown ink, pale brown
wash, lightly squared in black chalk
Verso: blank
6 $\frac{5}{16}$" × 9 $\frac{15}{16}$" (161 × 252 mm)
Watermark: indecipherable
Provenance: Vol. II, p.5b
RL 11885

Moses was adopted by Pharaoh's daughter, who had found him in the bulrushes. At court, Pharaoh in jest placed his crown on the head of the infant, who threw it down and trampled on it – a sign that he would one day overcome Pharaoh. This episode is not recounted in the Old Testament, being derived instead from the Roman antiquary Flavius Josephus (*Antiquitates*, II, 9, 7).

Poussin painted two versions of this unusual subject, now in the Louvre and at Woburn Abbey. This drawing is close in its figuration to the Louvre painting (fig. 50) and is squared for transfer, but some final adjustments were to be made: the line of heads is more varied in height in the painting, and the background and foreground are elaborated, negating the deliberate relief effect given here by the uniformly washed ground and the denial of any perspectival space.

Although this drawing was catalogued by Friedlaender (F/B, I) as autograph, it was described by Blunt in the 1945 catalogue of the Windsor collection as a studio work, an opinion which he later recanted. There is indeed no reason to doubt that it is an original drawing by Poussin, in the rather formal style he used throughout the 1640s in the latter stages of developing his compositions. The affliction of the *main tremblante* is in places pronounced, in others quite absent, and his lack of confidence in the steadiness of his line may have caused him to make the short, stabbing strokes with which the figures are outlined.

The Louvre painting was executed for Camillo Massimi, who as a youth had received drawing lessons from Poussin. It was pointed out by Mahon (in Bologna 1962) that the effect of light in the Louvre painting places it close to the canvases of *Extreme Unction* (1644) and *Confirmation* (1645), from the second set of Sacraments. This connection was satisfyingly confirmed by the discovery of a sheet in the Gabinetto Nazionale in Rome (F/B, nos. 384, 415; R/P, no. 290), which has on its recto studies for the left-hand woman in *Moses trampling Pharaoh's crown* and the priest in its pendant painting, *Aaron's rod changed into a serpent* (also Louvre), and on its verso, in a uniform style, studies for *Extreme Unction*. A date around 1644–45 for the pair of paintings thus seems safe; this

coincides with the rapid advancement of the young Massimi's career after the election of Giovanni Battista Pamphilj as Pope Innocent X in 1644, and the two Louvre pictures must have been among Massimi's first major commissions. The Woburn Abbey version was painted for Jean Pointel, who was in Rome between April 1645 and July 1646; but Poussin presumably met Pointel in Paris, referring to him as a friend in a letter of March 1644 (Jouanny 1911, p.258), and that painting may well have been commissioned and begun before Pointel's arrival in Rome.

References: Blunt 1945, no. 262; Blunt 1966, under no. 15; Blunt 1971, p.216; Blunt 1979a, p.118; Bologna 1962, under no. 73; F.A.Q.R. iii, p.108; F/B, I, no. 9, V, p.65; Friedlaender 1929, p.257; R/P, no. 297

56 *Confirmation* ca. 1644–45

Pen and brown ink, brown wash
Verso: head of a woman
Pen and brown ink
7 ⅛″ × 10 ³⁄₁₆″ (181 × 258 mm)
Watermark: Cardinal's hat with Barberini arms
Provenance: Vol. II, p.7
RL 11897

57 *Confirmation* ca. 1644–45

Slight black chalk underdrawing, pen and brown ink, rich brown
wash, lightly squared in black chalk
Verso: blank
7 ⁵⁄₁₆″ × 11 ⁵⁄₁₆″ (186 × 287 mm)
No watermark
Provenance: Massimi vol., no. 63 ("La Cresima")
RL 11898

These two sheets are preparatory for the painting of *Confirmation* from the second set of Sacraments (fig. 54), which we know from Poussin's surviving letters was begun by 30 April 1645 and finished by 10 December the same year. They represent the first and last stages of development of the composition as known to us, and with three intermediate studies in the Louvre they show better than any other composition the evolution of the scene and the accumulation of significant detail.

The repetition of many motifs and the absence of any major pentimenti in the preparatory sketches suggest that Poussin was making use of small models on a stage to work out the composition. The basic elements remain the same throughout, and it is unnecessary to list every detail of Poussin's choreography, but some features may be pointed out. The first sketch, cat. 56, is similar to the painting of *Confirmation* from the first set of Sacraments (fig. 41) in both the informal grouping of the figures and their relationship to the architecture. Indeed it is apparent from the irrational spatial arrangement of the architecture – the pier on the left appears much nearer than that on the right – that Poussin had given it no real thought at this stage, merely sketching in a couple of sixteenth-century pillars to give the scene some context; the Louvre sheets do not concern themselves with the background at all.

The next three drawings gradually clarify and formalize the structure of the composition (F/B, nos. 87–89; R/P, nos. 249–251). In fig. 51, the acolyte serving the main priest is brought on to the near side, to simplify the middle ground. Fig. 52 introduces the two kneeling children awaiting confirmation and compresses the figures, an unhappy development that was to be corrected in fig. 53, where the nearest acolyte now kneels and the waiting children are separated from the group of bystanders.

Cat. 57 was inexplicably described as a studio work by both Friedlaender (F/B, I) and Blunt (1945); it has since been unanimously accepted as one of Poussin's most brilliant drawings of the 1640s, and here the design crystallizes into rigorous symmetry. The acolyte lighting a candle at the left – first studied in recently discovered sketches on the verso of fig. 52 – mirrors the youth with the branch at the right, holding in the composition at either side. A faint horizon line can be seen passing through the heads of the standing figures, and the central vanishing point acts as a focus, not only for the architecture, but also for the inverted V of the confirmands. The light source of two antique hanging lamps is also centralized, and the pools of shadow around the statically posed figures give an atmosphere of deeply felt seriousness – though this dramatic device, highly effective in the painting of *Eucharist*, had to be abandoned for *Confirmation* where it would have obscured the face of the main confirmand.

As well as developing the composition in the preparatory studies, Poussin also gradually introduced arcane references to the rites of the early Christian Church, as discussed fully by Blunt (1967). The Renaissance church setting of the first version gives way to a dark chamber, which from the pair of sarcophagi partly hidden by columns in the background of cat. 57 is no doubt intended to be the Roman catacombs. The date of the ceremony, Easter Eve, is indicated by the lighting of a Paschal candle on the left, while on the right a youth sprinkles the celebrants with hyssop. The huge bowl in the center background alludes to the baptism which often took place on the same day as confirmation in the early Church, its size suggesting total immersion of those baptized, and the varied ages of the confirmands emphasizes the routine baptism and confirmation of adults.

The woman's head on the verso of cat. 56, obtrusively showing through the thin paper, is presumably a sketch from the life, and is not connected with any known project.

References: Cat. 56: Badt 1969, p.224; Blunt 1945, no. 215; Blunt 1966, under no. 113; Blunt 1967, pp.193f; Blunt 1979a, p.113; Edinburgh 1981, no. 42; F.A.Q.R. iii, p.108; F/B, I, no. 86 (recto), V, no. 376 (verso); London 1986, no. 74; Oxford 1990, no. 46; Paris 1960, no. 205; Paris 1994, under no. 115; R/P, no. 108

Cat. 57: Blunt 1945, no. 261; Blunt 1966, under no. 113; Blunt 1967, pp.189–95; Blunt 1971, p.216; Blunt 1976, p.30; Blunt 1979a, pp.96, 113; Bologna 1962, p.195; Edinburgh 1981, no. 46; F.A.Q.R. ii, p.180; F/B, I, no. A20, V, p.89; Friedlaender 1929, p.257; Hattori 1994; Oxford 1990, no. 47; Paris 1960, no. 209; Paris 1994, no. 118; R/P, no. 252; Thompson 1980, pp.25f; Wild 1980, I, p.115

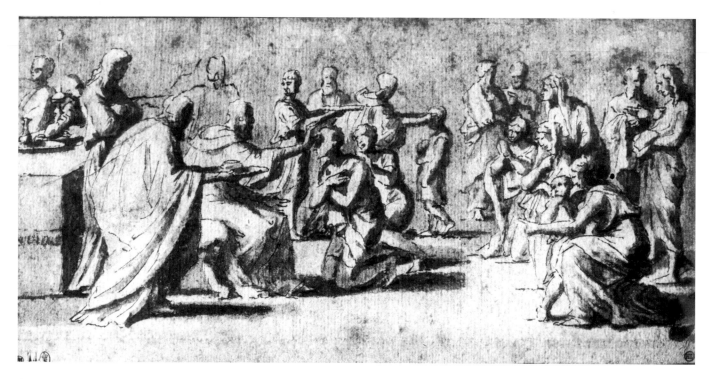

Fig. 51 Poussin, *Confirmation*. Pen and brown ink, brown wash. 4 ⅞" × 9 ¹¹⁄₁₆" (124 × 246 mm). Louvre, Paris, inv. M.I.995

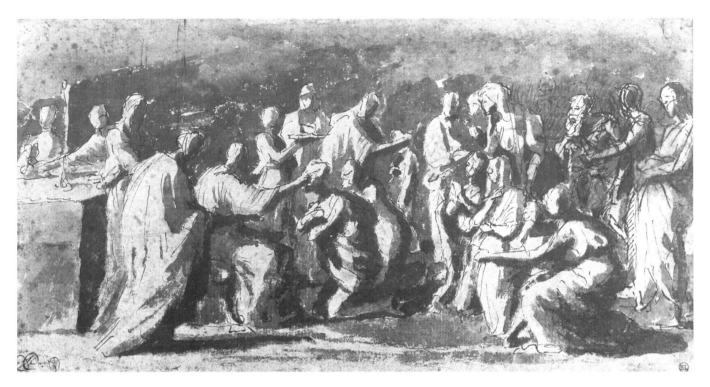

Fig. 52 Poussin, *Confirmation*. Pen and brown ink, brown wash. 5 ⅛″ × 10″ (131 × 254 mm). Louvre, Paris, inv. M.I.994

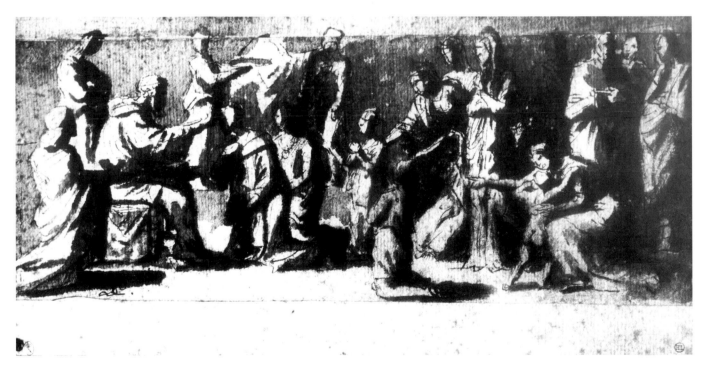

Fig. 53 Poussin, *Confirmation*. Pen and brown ink, brown wash. 5 ⅜″ × 8 ⅜″ (137 × 213 mm). Louvre, Paris, inv. M.I.993

56 Confirmation

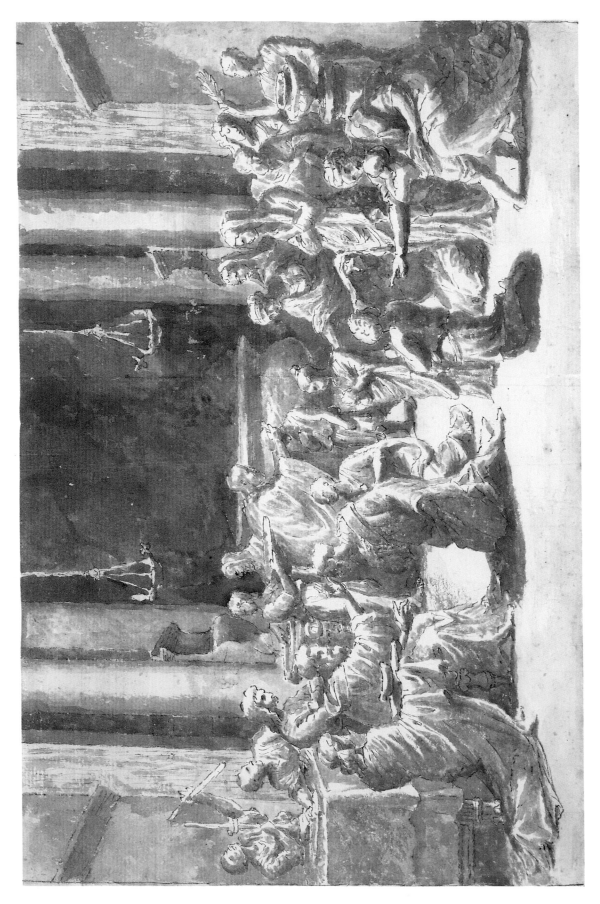

57 *Confirmation*

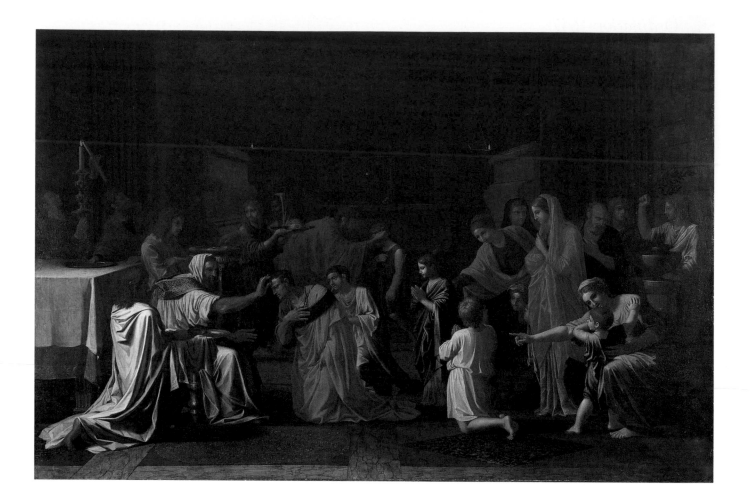

Fig. 54 Poussin, *Confirmation*. Oil on canvas. 46" × 70" (117 × 178 cm). Duke of Sutherland Collection, on loan to the National Gallery of Scotland

56 verso (detail)

58 *Ordination* 1647

Lightly squared in black chalk, slight black chalk underdrawing, pen and brown ink, brown wash
Verso: blank
7 ¾″ × 12 ¹³⁄₁₆″ (196 × 326 mm)
Watermark: bird with letter C, in circle
Provenance: Massimi vol., no. 60 ("Il sacramento del'Ordine")
RL 11899

This sheet depicts Christ's charge to St Peter, "And I say also unto thee, That thou art Peter, and upon this rock I will build my church; and the gates of hell shall not prevail against it. And I will give unto thee the keys of the kingdom of heaven." (Matthew 16:18–19.) Christ's metaphorical pronouncement was the first indication that St Peter would be the founding head of the Church, and was thus taken as the prototype for the admission into holy orders.

The drawing is a study for *Ordination* from the second set of Sacraments (fig. 56), and is very close in figuration to the painting but entirely different in the landscape, which Poussin altered radically while working on the painting. The drawing is squared and represents the last phase of the composition's development; nonetheless, Friedlaender (F/B, I) and Blunt (1945) catalogued the drawing as the product of an assistant, a judgement later both recanted and restated by Blunt, who finally suggested Pierre Lemaire as the author. It is in fact

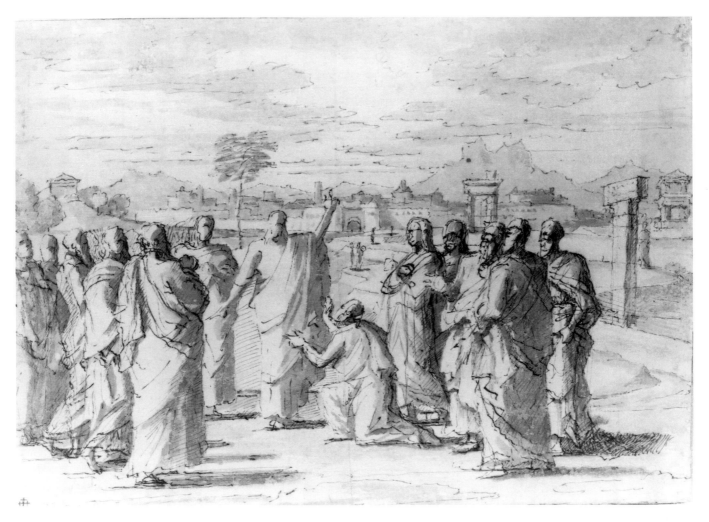

Fig. 55. Poussin, *Ordination*. Pen and brown ink, brown wash. 7 ⅜″ × 10 ¹⁄₁₆″ (187 × 255 mm). The Pierpont Morgan Library, New York, inv. III, 70

Fig. 56 Poussin, *Ordination*. Oil on canvas. 46″ × 70″ (117 × 178 cm). Duke of Sutherland Collection, on loan to the National Gallery of Scotland

58 *Ordination*

173

highly probable that this is an autograph drawing, its stiffness explained by the function of the drawing at the end of the creative process. The hard, scratchy pen-line is identical to that in several other preparatory drawings for the second Sacraments, including another preparatory drawing for *Ordination* in the Pierpont Morgan Library (fig. 55; F/B, no. 98; R/P, no. 264), which shows the figure group with essentially the same structure but shifted towards the left (assuming that that drawing has not been cut down), and again a markedly different landscape.

We know from Poussin's letters that the painting of *Ordination* was begun before 3 June 1647 and despatched by 19 August of the same year. The second series of Sacraments were not designed and executed in a steady procession: Poussin began work on the series unenthusiastically, finishing only one painting each year from 1644 to 1646, and it is likely that compositions he had worked out in 1644 were reconsidered when each painting was begun. Two other drawings for *Ordination* with Christ at the far right probably date from 1644 (both Louvre; F/B, nos. 95, 96; R/P, nos. 261, 262); in conception they are not unlike the *Ordination* of the first series, itself based on Raphael's tapestry design of the subject. But when Poussin came to execute the painting three years later, he remodeled and centralized the composition.

The black chalk squaring of the present sheet appears to have fulfilled a double function: it was not added after the drawing to act only as an aid for the transfer of the design, but before, to lay out the composition as well. Each of the full-length disciples, five on the left and four on the right, stands with his head and weight-bearing foot on one of the vertical lines. The steady procession of forms across the drawing is broken by the head and momentous left hand of Christ, which fall exactly half-way between these lines, either side of the axis of the whole composition (perhaps explaining the awkward articulation of His shoulder). Cat. 58 shows how the symmetry and regularity of the design were contrived; it is a tribute to Poussin's subtle sense of interval that the painting does not appear stiflingly mechanical.

References: Blunt 1945, no. 260; Blunt 1976, p.30; Blunt 1979a, p.159; F.A.Q.R. ii, p.180; F/B, I, no. A21, V, p.89; Friedlaender 1929, p.257; Paris 1960, no. 200; Paris 1994, no. 129; R/P, no. 265; Thompson 1980, p.9

59 verso *St Matthew and the angel*

59 *Moses striking the rock* ca. 1646

Slight black chalk underdrawing, pen and brown ink, brown wash
Verso: *St Matthew and the angel*
Slight black chalk underdrawing, pen and brown ink
5 ⁹⁄₁₆″ × 14 ¼″ (142 × 362 mm)
No watermark
Provenance: Vol. II, p.3
RL 11887

On their wanderings in the wilderness, the Israelites were stricken with thirst. God told Moses to strike a certain rock with his rod, from which water flowed (Exodus 17:1–7; Numbers 20:1–13).

Poussin appears to have painted this subject on three occasions. Two canvases survive, one of around 1633–35, in the collection of the Duke of Sutherland, the other of 1649, in the Hermitage; a third is lost, but was described by Bellori and is known from engravings. This drawing does not correspond with any of these versions, for although several of the motifs recur in one or other of the paintings (the figures raising their hands aloft, the men reaching forward with jugs, the women with babes-in-arms), the long format and the grouping of the Israelites into two dense masses either side of Moses and Aaron are unique. Bellori (1672, p.421) stated that Poussin was constantly designing new ideas with many figures for the subject, because of the opportunity it offered for the depiction of human emotions, and it is thus probable that the drawing was not preparatory for any painting.

The rather severe composition is characteristic of works of the mid-1640s onwards – Poussin's growing affinity for symmetry can be observed in the second series of Sacraments (see cats. 57 and 58). Indeed the figure types and the handling of pen and wash here are also found in several studies for the Sacraments, particularly *Baptism* (F/B, nos. 78–83; R/P, nos. 253–259), and a date contemporary with these, around 1646, seems likely.

The vigorous sketch on the verso represents the angel dictating the Gospel to St Matthew, a popular subject in the seventeenth century, though it is not connected with any known painting by Poussin. It was catalogued by Friedlaender (F/B, I) as by a follower, but Blunt (F/B, V) acknowledged that it must be an original: its presence on the back of an undoubtedly authentic drawing provides evidence that only the most striking stylistic discrepancy could rebut. Although the scale of the figures is unusual, they are very close in their bold outlines and degree of abstraction to a study for the *Death of Hippolytus* on the verso of a sheet in the Pierpont Morgan Library (F/B, no. 443; R/P, no. 323), the recto of which (again by comparison with studies for the *Baptism*, especially F/B, no. 78; R/P, no. 253) is datable to ca. 1646. The figures were drawn in the nude before the drapery was sketched in, an uncommon practice for Poussin but also found in the study for the *Holy Family*, cat. 54.

References: Blunt 1945, no. 218; Blunt 1979a, p.117; F.A.Q.R. iii, p.107; F/B, I, no. 28 (recto), I, no. B18, V, p.84 (verso); Paris 1960, no. 220; Paris 1994, under no. 186; R/P, no. 273

60　The Ecstasy of the Magdalene
ca. 1647

Slight black chalk underdrawing, pen and brown ink, brown wash
Verso: blank
10 ⅛″ × 7 ⁵⁄₁₆″ (257 × 185 mm)
Watermark: star on mounts, in circle
Provenance: Vol. II, p.10
RL 11908

The legend of St Mary Magdalene was elaborated in France in the early Middle Ages to include a journey to Provence, where she was reputed to have lived as a hermit. Propagated by such tracts as Jacobus de Voragine's *Golden Legend*, the episodes of her voyage, her preaching to and baptism of the locals, and her last communion were all represented by artists, but scenes of her life in the wilderness were the most popular. Paintings of the penitent Magdalene, weeping or meditating on a skull, were common in the seventeenth century; the present drawing, rather less melancholy, shows her as she was lifted to Heaven by angels, seven times a day, to be shown the world beyond. On the rocks below stand a skull, a cross, and a jar of ointment, the Magdalene's attribute that alludes to her anointing of Christ's feet when He was at supper in the house of Simon.

The drawing was catalogued as a "studio" work by both Friedlaender and Blunt (who attributed it to Pierre Lemaire, as did Wild); Thuillier suggested an attribution to Charles Errard. But though dry in execution, it is of high quality and is stylistically identical to the drawing for *Ordination* (cat. 58), which is surely autograph and datable to 1647. (Rosenberg and Prat also recently accepted the drawing, in Paris 1994, but dated it much too early, around 1627–28.) No other work of this subject by Poussin is known, though the figure group is closely related in conception to two paintings of the *Ecstasy of St Paul* (Ringling Museum, Sarasota, and Louvre), of 1643 and 1649–50 respectively, and in particular to the *Assumption of the Virgin* (Louvre), also painted in 1649–50. In 1710 the Farnese bought *un batalia di mano di Nicolò Pusino et una Madalena figura intiera* (see Blunt 1966, no. L41), the latter of which is conceivably connected with this drawing; but the motif of figures borne by angels was clearly in Poussin's mind in the 1640s, and, like cats. 59 and 64, it is quite possible that the drawing was independent of any commission.

References: Blunt 1945, no. 259; Blunt 1979a, p.156; F.A.Q.R. iii, p.110; F/B, I, no. A18; Paris 1994, no. 42; R/P, no. 66; Thuillier 1978, p.172; Wild 1980, II, under no. R22

60 *The Ecstasy of the Magdalene*

61 *Medea killing her children*
ca. 1649–50

Pen and brown ink
Verso: fragment of a *Holy Family*, and various calculations
Pen and brown ink
6 ¼″ × 6 ⁹⁄₁₆″ (159 × 167 mm)
No watermark
Provenance: Massimi vol., no. 26 ("La Crudelta di Medea")
RL 11892

62 *Medea killing her children*
ca. 1649–50

Slight black chalk underdrawing, pen and brown ink, pale brown wash
Verso: the numbers 24 and 14 in a seventeenth-century hand (Poussin's?)
Pen and brown ink
10 ¹⁄₁₆″ × 7 ¹³⁄₁₆″ (255 × 199 mm)
No watermark
Provenance: Vol. II, p.25
RL 11893

Jason and the Argonauts landed in Colchis to gain the Golden Fleece. Medea, the daughter of King Aeëtes, fell in love with Jason, helped him by magic to his goal, and fled her homeland to return to Greece with him. Later, when Jason deserted her, she took her revenge by murdering, among others, their two sons. Ovid barely touched on this episode (*Metamorphoses*, VII, 396); the best-known full account of the story was Euripides's play. These drawings show Medea about to stab the younger son, as their nurse recoils over the body of the first, and Jason throws himself towards the scene. The woman beside Jason is presumably intended to be Creusa, his new bride, a rare narrative slip by Poussin, as Medea killed her and her father King Creon before slaying her own children.

No painting of this subject by Poussin is known, though Bellori describes a composition corresponding to cat. 62, without specifying whether he is referring to a painting or a drawing. Several of his accounts seem to be of drawings (see cats. 19 and 20), and in the absence of any documented painting it is reasonable to suppose that cat. 62 was the work seen by Bellori. When Marinella, the compiler of the Massimi catalogue, wrote the entry for cat. 61 he copied his description of the scene from Bellori, including the extraordinary event of the statue of Athena shielding its face from the scene, even though cat. 61 has no such detail.

The verso of cat. 61 includes a fragmentary study for a *Holy Family*, one of a series of many-figured drawings and paintings of the subject executed by Poussin in the years around 1650. The little of the composition that has survived is essentially that of the *Holy Family with six putti* (jointly J. Paul Getty Museum, Malibu, and Norton Simon Museum, Pasadena) of 1651, with an angel here in place of Joseph, and the drawing must be close in date to this painting; but the complex evolution of Poussin's ideas in these compositions makes it unwise to describe the sketch as a direct study for that or any other painting. The purpose of the extravagant calculations (for instance 46,019 multiplied by 456) which fill the other half of the verso is unknown.

Cat. 61 is characteristic of the vigorously expressive drawings of the late 1640s, often executed in rapid pen and ink only. Cat. 62 has until recently been described as a copy or a "studio" work (it is accepted by Rosenberg and Prat, who date both sheets to 1643–45), but the figures are quite typical of Poussin's drawings during the forties as he finalised a design (see cats. 55, 57, 58), and the background displays all the master's mannerisms. Another sketch for the composition, in a private collection (R/P, no. 280), shows Jason and Creusa simply standing to the left of Medea and raising their hands in horror, a weak device which is remedied by placing a physical barrier between the helpless Jason and the murder. The only figure to remain unaltered in all three drawings is Medea herself, an echo of the more naturally posed executioner in the 1649 *Judgement of Solomon* (Louvre).

References: Cat. 61: Blunt 1945, no. 217; Blunt 1976, p.25; Blunt 1979a, pp.65, 188; Blunt 1979b, pp.122–24, 143; F.A.Q.R. i, p.272; F/B, I, no. 56 (verso), III, no. 223 (recto); Friedlaender 1929, pp.127, 254; Oxford 1990, no. 54; Paris 1994, no. 142; R/P, no. 281; Thuillier 1969, p.130; Thuillier 1974, under no. B44; Thuillier 1994, under no. 168; Wild 1980, II, under no. 156

Cat. 62: Bardon 1960, p.129; Bellori 1672, p.449; Blunt 1945, no. 264; Blunt 1979a, p.159; F/B, III, no. A64; Friedlaender 1914, p.318; Friedlaender 1929, p.127; Paris 1994, no. 143; R/P, no. 282; Thuillier 1969, p.130; Thuillier 1974, under no. B44; Thuillier 1994, under no. 168; Wild 1980, II, no. 156

61 verso

61 *Medea killing her children*

62 *Medea killing her children*

63 *Christ healing the blind* ca. 1650

Graphite underdrawing, pen and brown ink
Verso: Studies for the *Triumph of Pan* and *Extreme Unction* (ca. 1636)
Pen and brown ink
5 ¹⁵⁄₁₆″ × 8 ¹¹⁄₁₆″ (151 × 220 mm)
No watermark
Provenance: Vol. II, p.8b
RL 11902

The drawing on the recto is a study for *Christ healing the blind* in the Louvre (fig. 59), painted in 1650. Although it has the appearance of a definitive composition, it is actually quite some distance from the final design – only the figures of the mother and child at the left and the disciple restraining the second blind man are found in the painting; the group of three standing figures on the right is retained, but with the place of Christ taken by a disciple.

Three other autograph studies for the painting survive. A sketch in Bayonne (fig. 60; F/B, no. 63; R/P, no. 345), although much rougher, is actually closer to the painting in some respects than cat. 63, especially in the figure of Christ. Two sheets of life drawings for the composition are discussed below. There are also two copies at Windsor after drawings for the project, one very feeble (fig. 57), the other more robust (fig. 58); the latter was attributed to Poussin himself by Rosenberg and Prat (R/P, no. 69), but, even disregarding the clumsiness of the pen-work, the way that both these elaborate drawings stop dead at the edges of the dense groups of figures indicates that they are partial copies of more extensive compositions.

The surviving drawings demonstrate that Poussin did not work inexorably towards the final design, steadily refining elements of the composition, but instead tried out a range of possible alternatives: whether to have Christ facing to left or right, whether to arrange the disciples as a dramatic huddle or a dignified assembly, whether to have the second blind man standing or kneeling. In fact the Bayonne sketch shows only a single blind man, suggesting that the precise subject had not been fixed (though Wild's objection that the crutches of the first man in the present drawing indicate that the episode is

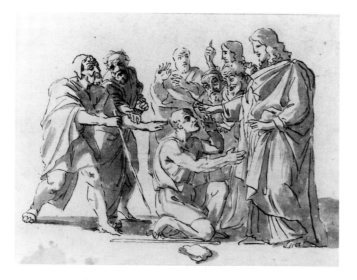

Fig. 57 Copy after Poussin, *Christ healing the blind*. Pen and brown ink, brown wash. 5 ⅝″ × 7 ⁵⁄₁₆″ (144 × 186 mm). Cat. C11

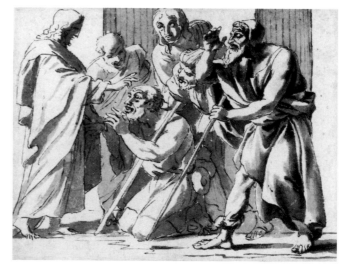

Fig. 58 Copy after Poussin, *Christ healing the blind*. Pen and brown ink, brown wash. 5 ⁵⁄₁₆″ × 6 ¾″ (135 × 171 mm). Cat. C12

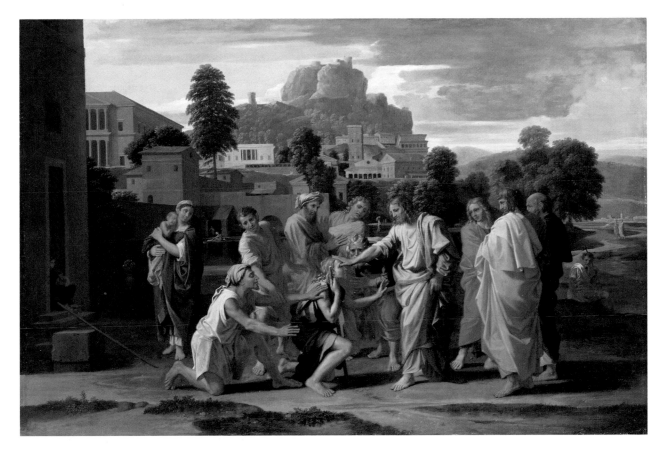

Fig. 59 Poussin, *Christ healing the blind*. Oil on canvas. 47" × 69 ¼" (119 × 176 cm). Louvre, Paris

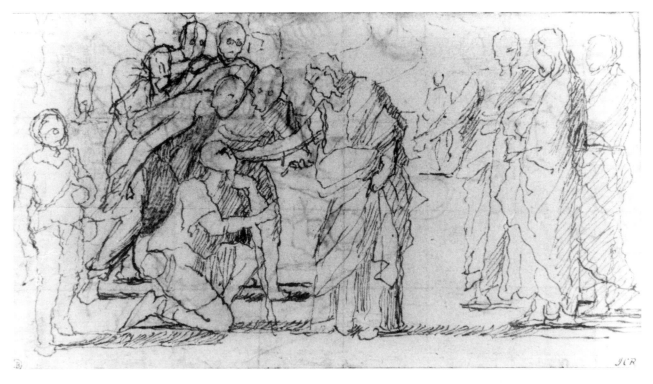

Fig. 60 Poussin, *Christ healing the blind*. Pen and brown ink. 4 ⁵⁄₁₆" × 7 ¾" (110 × 196 mm). Musée Bonnat, Bayonne, inv. 1678

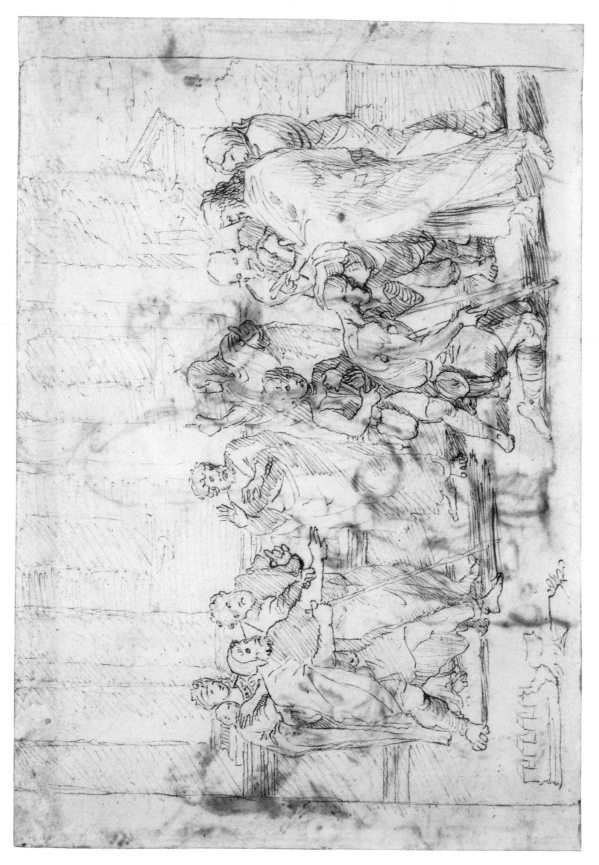

63 *Christ healing the blind*

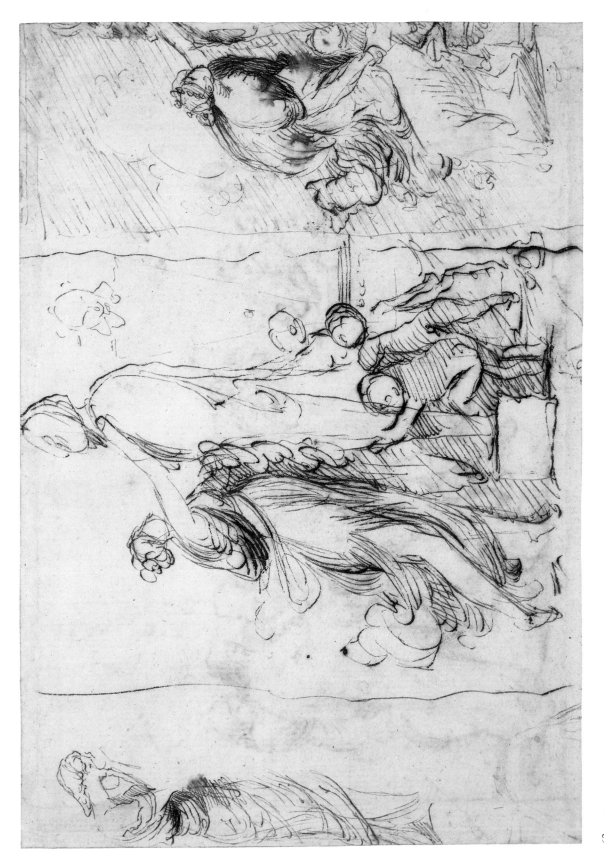

63 verso

187

the healing of the cripple, rather than the blind, is countered by the emphasis on the man making contact with Christ by touching His robes, and by the presence of the young guide and the second blind man). The Gospels refer to two miracles involving the healing of the blind, in John (9:1–7) where Christ cures a single man at Capernaum, and in Matthew (20:29–34) where two are healed outside Jericho.

Assuming that Poussin followed the Biblical text accurately, the painting, with two blind men, can only be the Jericho episode, and it was described as such by Bellori (1672, pp.452f) and Félibien (1725, IV, p.61). The alternative identification of the scene was suggested at a meeting of the French Academy in 1667, after a lecture by Bourdon which featured a lengthy analysis of the painting. Highly praised in the lecture was the depiction of the various psychological responses to the event, which are shown rather more strongly in the preparatory drawings than in the painting; one particularly effective motif here which did not survive into the painting is the young guide of the first blind man, looking on with alarm as he sees his livelihood disappearing. This concentration on the expression of individual emotion is found too in Poussin's model for the composition, Raphael's design for the tapestry of the *Blinding of Elymas* (fig. 61). Poussin's interest in Raphael's tapestry series around this time is shown further by the equally obvious derivation of his *Death of Sapphira* from the *Death of Ananias*, and by a number of sheets of head studies (mostly known from copies) which include expressive heads taken from various of the tapestry designs.

The drawings on the verso of the sheet date from much earlier in Poussin's career. The two larger sketches, showing a nymph garlanding a herm, are early studies for the Richelieu *Triumph of Pan* (see cats. 36 and 37), delivered in May 1636. The slighter sketch to the left is for the woman behind the candle-bearer in *Extreme Unction*, one of the set of Sacraments painted for Cassiano dal Pozzo (see cats. 45 and 49). The fact that recto and verso are of such different dates should caution against assuming that all the sketches on the present verso are of the same date, but the style and ink are identical in each case and it appears that they were executed in quick succession. If correct, this gives an important *terminus ante quem* for the conception of the Sacraments series, which is not known through documents, for it demonstrates that Poussin was already studying individual figures by late 1635 or early 1636, though the style of the paintings suggests that they were painted a little later; it may be that his friend Cassiano allowed him to postpone the execution of the Sacraments when he received a commission from a patron as important as Cardinal Richelieu.

References: Badt 1969, pp.237f; Blunt 1945, no. 219; Blunt 1966, p.74 and under nos. 74, 109, 136; Blunt 1979, pp.23, 41; Edinburgh 1981, no. 21; F.A.Q.R. iii, p.109; F/B, I, no. 62 (recto), III, no. 188, V, p.90 (verso); Friedlaender 1914, p.319; Mahon 1962, p.107; Paris 1983, no. 204; Paris 1994, no. 58, under no. 64; R/P, no. 87; Wild 1980, II, no. 162

Fig. 61 Agostino Veneziano after Raphael, *The blinding of Elymas*. Engraving

64 *The sacrifice of Polyxena (?)* ca. 1650

Buff paper, red chalk underdrawing, pen and brown ink, brown wash
Verso: studies of a nude man
Black chalk
6 ¹³⁄₁₆″ × 13 ⅞″ (173 × 353 mm)
No watermark
Provenance: Massimi vol., no. 31 ("Sacrificio di Pollisena")
RL 11906

This drawing could represent one of two scenes from ancient history with a very similar iconography. Agamemnon had incurred the wrath of Artemis, who becalmed the Greek fleet ready to sail for Troy; only the sacrifice of his daughter Iphigeneia would appease her. At the last minute Artemis relented and substituted a deer for Iphigeneia (Ovid, *Metamorphoses*, XII, 25ff). In the later episode, the ghost of Achilles appeared to the other Greeks after the taking of Troy, demanding that Polyxena, daughter of the defeated King Priam, be sacrificed on his tomb. She went to her fate heroically, and the watching crowd shed the tears that she held back (*Metamorphoses*, XIII, 439ff).

Neither episode satisfactorily explains all the features of the present drawing. The drawing is identified as the *Sacrifice of Polyxena* in the Massimi catalogue, where Marinella refers to the obscure legend that the manner of Achilles's death was the cause of his malice towards Polyxena beyond the grave. He had fallen in love with Polyxena, and was offered her hand to

Fig. 62 Domenichino, *The sacrifice of Iphigeneia*. Fresco. Palazzo Giustiniani-Odescalchi, Bassano Romano

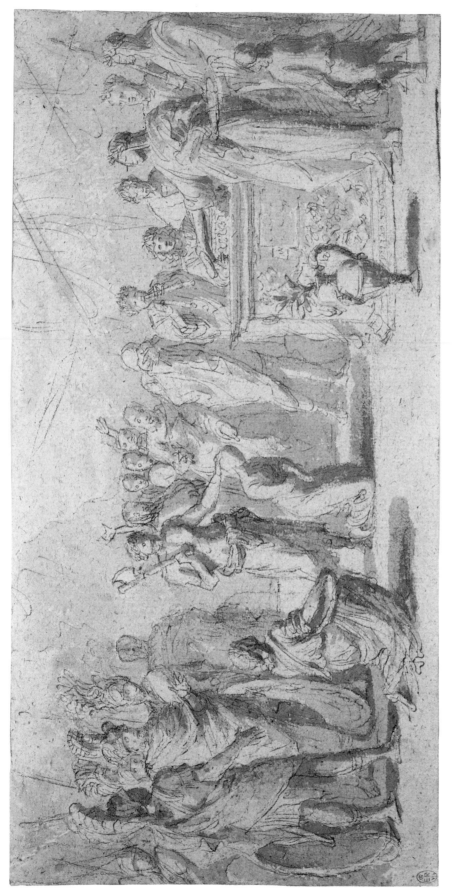

64 *The sacrifice of Polyxena (?)*

65 *The Three Marys at the Sepulcher*
ca. 1650–55

Black chalk
Verso: two calculations
Pen and ink
4 ³⁄₁₆″ × 5 ½″ (107 × 140 mm)
No watermark
Provenance: Sacchi album I
RL 4877a

The first to learn of the Resurrection were the women who visited the Holy Sepulcher the following morning to anoint the body. In a stone vault an angel sits on the edge of the empty tomb, pointing upwards with his right hand to indicate the Resurrection, and away with his left to instruct the women to spread the news. (All four Gospels mention the episode but do not agree on the number or identity of the women; traditionally three were depicted and identified as Mary Magdalene, Mary the wife of Cleophas, and Mary the mother of James.) Beyond, at the opening of the vault, stand two men who may be the soldiers set to guard the tomb.

The attribution of the present drawing to Poussin is here only provisionally accepted. It did not come from the collections of either Cardinal Massimi or Cassiano dal Pozzo, but was found by Blunt among the group of drawings by Andrea Sacchi at Windsor, and its earlier history is unknown. Blunt related it to a group of studies by Poussin in loose black chalk alone, characterized by a concentration on blocking out the composition at the expense of narrative detail; the thick lines betray the trembling hand that afflicted Poussin from the 1630s onwards, and it is possible that he used the more stable medium of black chalk when the attacks became too strong for him to control a capricious pen-nib.

Only the outlines of the composition can be discerned in this small sketch. The detail is clarified in a painting in a private collection (fig. 64), which differs mainly in the transposition of two of the women and the silhouetting of the angel against the opening to the vault, but this painting is not by Poussin. No document indicates that he ever executed a painting of this subject which the author of fig. 64 might have copied, and it is unlikely that such a painting would have escaped mention in a letter or biography at this late stage in his career. Therefore if the composition was indeed devised by Poussin, the painter of fig. 64 probably worked from a drawing, rather than from an original canvas by Poussin – though it is hard to believe that he could have elaborated his composition from the present rough sketch (as suggested by Blunt, in proposing Antoine Bouzonnet-Stella as the painter), and more legible drawings must have existed.

The intricacy of this scenario is of course a major argument against accepting it, and the pair of calculations on the recently uncovered verso of the sheet are not in Poussin's hand. Thuillier suggested an attribution of both drawing and painting – and indeed most of Blunt's group of black chalk drawings – to Charles Alphonse Dufresnoy (who was in Rome between 1634 and 1653), a suggestion that was cautiously accepted by Rosenberg and Prat. But until the graphic œuvres of such artists in Poussin's late circle are more firmly established, an attribution of the drawing to Poussin himself seems as plausible as any alternative.

References: Blunt 1945, no. 221; Blunt 1979, pp.91, 174f; F/B, V, no. 402, p.77; R/P, no. R1291; Thuillier 1983, pp.44–45, 51

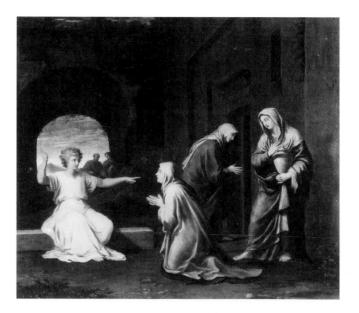

Fig. 64 Copy after Poussin (?), *The Three Marys at the sepulcher.* Oil on canvas. Present whereabouts unknown

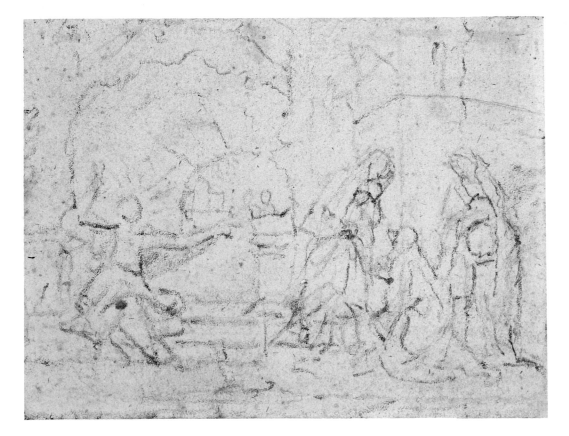

65 *The Three Marys at the sepulcher*

APPENDIX A

Drawings attributed to Poussin not in the exhibition

66 *Peasant women sewing*
Blue paper, pen and brown ink
Laid down
7 ³⁄₁₆″ × 9 ¹¹⁄₁₆″ (183 × 246 mm)
Provenance: Massimi vol., no. 68 ("Le Fanciulle Rusticane")
RL O36

Although this awkward drawing is highly unusual in Poussin's œuvre in appearing to show a pure genre scene, it appears to be autograph and may have been related in his mind to a composition of the *Virgin and her companions* (cf. cat. R6). The handling of the pen is very similar to drawings as early as *Pallas and the Muses* (cat. 14), and it must have been executed during Poussin's first years in Rome or even before he left Paris.

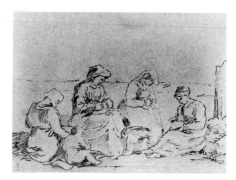

References: Blunt 1945, no. 179; Blunt 1976, p.31; Blunt 1979, pp.27f; F.A.Q.R. ii, p.180; F/B, V, no. 370; London, 1938, no. 520; Paris 1960, no. 130; Paris 1994, under no. 89; R/P, no. 41; Wild 1967, p.43

67 *The infancy of Bacchus*
Slight black chalk underdrawing, pen and gray-brown ink, gray-brown wash
Verso: fragment of an unidentified composition
Black chalk
5 ³⁄₁₆″ × 3 ⁵⁄₈″ (131 × 92 mm)
No watermark
Provenance: Massimi vol., no. 12 ("Satiro con un bambino in braccio")
RL 11981

Bacchus was born from the thigh of his father Jupiter and was brought up by nymphs and satyrs. A drawing in the Fondazione Horne in Florence (see cat. 17) shows the same group with a panther and goat to the right, confirming the identity of the child as Bacchus. The authenticity of both sheets was questioned by Blunt (in F/B, V), but they must be originals of the mid-late 1620s.

The recently uncovered verso, in weak black chalk, bears a fragment of a composition with two figures gazing

upwards before an archway. This cannot be connected with any other known work by Poussin.

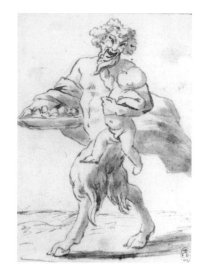

References: Blunt 1945, no. 177; Blunt 1976, p.21; F.A.Q.R. i, p.270; F/B, III, no. 231, V, pp.106, 111; Friedlaender 1929, p.253; R/P, no. 51

68 *A nymph seated beneath a tree*
Pen and brown ink
Verso: a column of figures and an inscription *Molto magei*, not in Poussin's hand
Pen and brown ink
6 ¼″ × 4 ⁷⁄₁₆″ (158 × 112 mm)
No watermark
Provenance unknown (but probably Vol. II, pp.39–43)
RL 11922

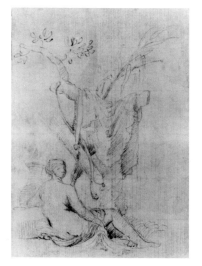

The bow and arrows suggest that the figure is one of Diana's nymphs, but this drawing of the mid-1630s cannot be connected with any other work.

References: Blunt 1945, no. 188; F/B, III, no. 233; R/P, no. 143

69 *Two figures from the antique*
Pen and brown ink
Laid down
6 ⁹⁄₁₆″ × 4 ½″ (167 × 114 mm)
Provenance: Massimi vol., no. 46 ("Statue Antiche")
RL 11916

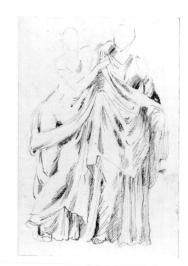

This pair of figures is to be found on a circular marble base now in the Villa Albani, Rome, though it is unclear whether Poussin copied directly from the object or from an intermediary drawing. Three sheets at Windsor from Cassiano's Paper Museum (RL 8034, 8524, 8738) show the same pair, all with different "reconstructions" of the damaged upper hands. Early to mid-1630s.

References: Blunt 1945, no. 197; Blunt 1971, p.215; F.A.Q.R. ii, p.177; F/B, V, no. 301; Friedlaender 1929, p.256; Friedlaender 1966, p.20; Prosperi Valenti Rodinò 1994, p.158; R/P, no. 176

70 Study for *Armida carrying off Rinaldo*
Pen and brown ink
Verso: fragment of a composition
Black chalk
4″ × 5 ¹¹⁄₁₆″ (102 × 145 mm)
No watermark
Provenance: Massimi vol., no. 9 ("Galathea alla riva del fiume Aci")
RL 11923

Despite the title given in the Massimi catalogue, this is an early study for the foreground group of putti, nymphs and a river-god in a painting of *Armida carrying off Rinaldo*, executed by Poussin for Jacques Stella around 1637 but now lost. A drawing in the Louvre (F/B, no. 142; R/P, no. 58) repeats these figures and adds the group of Armida carrying Rinaldo to a waiting chariot; the composition reached a definitive stage in a finished drawing known through a copy at Windsor (cat. C9), where the foreground group has been radically altered. The lost drawing recorded in cat. C9 was possibly a *modello* for Stella's approval, but the

composition as painted – known through copies and engravings – was altered substantially, so much so that Thuillier (1994, nos. 98 and 118) believes the drawings are not connected with the painting for Stella. But they are stylistically consistent with a date of around 1637, and in the absence of any compelling evidence that Poussin treated this subject on two separate occasions it seems most likely that they are all preparatory for the Stella painting.

Nothing can be made of the fragmentary composition lightly sketched on the verso.

References: Blunt 1945, no. 201; Blunt 1966, under no. 204; Blunt 1976, p.21; F.A.Q.R. i, p.269; F/B, II, no. 143; Friedlaender 1929, p.253; R/P, no. 59; Thuillier 1994, under no. 118

71 *Seated woman*
Pen and brown ink
Verso: blank
4 ½″ × 3 ¹⁄₁₆″ (114 × 77 mm)
No watermark
Provenance unknown (but probably Vol. II, pp.39–43)
RL 11924

Apparently a rare genre study from the life, perhaps a leaf from a sketchbook. Hard to date, but probably of the 1630s.

References: Blunt 1945, no. 202; Blunt 1979, pp. 95f, 193; F/B, V, no. 374; Mérot 1990, p.189; Paris 1994, no. 89; R/P, no. 70

72 *Satyrs dancing on a wine skin*
Graphite underdrawing, pen and brown ink, brown wash
Inscribed at lower right: *111*
Laid down
9 ¾″ × 12 ½″ (248 × 318 mm), arched
Provenance: Vol. II, p.34
RL 11992

Dismissed as a studio work in Blunt 1945 and F/B, III, this is an autograph Poussin of an unusually high degree of finish. It is based on an ancient gem, and illustrates a passage from Virgil's *Georgics* which describes a game of dancing on an inflated skin made slippery with oil. The drawing bears an inscribed number of a type found on most sheets from Cassiano's Paper Museum, and it is probable that it was made for Cassiano, in the mid-thirties; its provenance from Vol. II is strong evidence that this volume was assembled by Cassiano.

References: Blunt 1945, no. 227; Blunt 1960c, p.402; Blunt 1967, p.141; Blunt 1971, p.215; Blunt 1979, pp.117f; F/B, III, no. A68, V, p.116; Panofsky 1959, p.43; R/P, no. 208

73 *Two philosophers*
Slight graphite underdrawing, pen and brown ink, brown wash
Verso: blank
5 ¹⁄₁₆″ × 4 ⁵⁄₁₆″ (129 × 110 mm), lower right corner shaped, other three corners cut
No watermark
Provenance: probably Massimi vol., no. 57 ("Eraclito e Democrito"), but see under cat. 74
RL O38

Although dismissed as a "studio" work in Blunt 1945 and F/B, II, this has since been recognized as an autograph Poussin, probably of the thirties. It is difficult to say what function sheets such as this might have served.

References: Blunt 1945, no. 228; Blunt 1971, p.215; F/B, II, no. B22, V, p.98; R/P, no. 67

74 *Group of figures* (for an *Assumption of the Virgin*?)
Red chalk underdrawing, the principal two figures finished in pen and brown ink and brown wash
Verso: two standing figures, three-quarter length
Red chalk, the principal figure gone over in pen and brown ink
5 ⁵⁄₁₆″ × 5 ¹¹⁄₁₆″ (135 × 145 mm)
No watermark
Provenance: probably Vol. II, p.28 (but see below)
RL O39

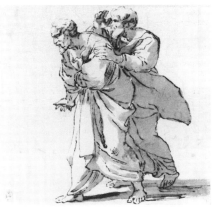

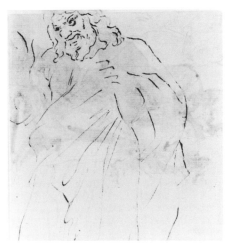

There has been much confusion about the respective provenance of cats. 73 and 74. The description of no. 57 in the Massimi catalogue identifies the figures as the philosophers Heraclitus and Democritus, and could in most details apply to either drawing; but it states that one figure holds his left hand against his chest above his cloak, which is a feature of cat. 73 alone. Inventory A lists at Vol. II, p.28, *Studies for Apostles, in an Assumption of the V:M:. Two Heads on the back*, which can only refer to cat. 74. But the drawing described (with measurements) by Woodward in F.A.Q.R. as Massimi 57 is clearly cat. 74. It seems impossible to reconcile this evidence; perhaps Woodward mixed up his notes, but this would be most untypical. Date: mid-late thirties.

References: Blunt 1945, no. 229; Blunt 1971, p.215; Blunt 1976, p.29; F.A.Q.R. ii, p.179; F/B, V, nos. 410, 411; R/P, no. 68

75 *Charity*

Pen and brown ink, with a sketched pattern in graphite (?)
Verso: *Time saving Truth from Envy and Discord*
Pen and brown ink
4 ⅝″ × 5 ¹⁵⁄₁₆″ (118 × 151 mm)
No watermark
Provenance: Massimi vol., no. 67 ("La Carità")
RL 11921

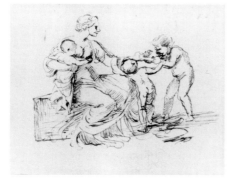

The recto of this sheet is not directly connected with any painting, but the pose of the woman was used as the basis of the figure of *Industria* in an engraving inscribed *C. Massimi fec.* in the 1640 *Documenti d'Amore* (see cats. 76–77). On the verso is a preparatory drawing for a painting executed for Cardinal Giulio Rospigliosi, now lost but known through copies and engravings. This rather ponderous allegory had a well-established pictorial tradition, from which Poussin departed little, and the rapid sketch is thus already close to the final composition. Both recto and verso point to a date around 1638–40.

References: Blunt 1945, no. 203; Blunt 1966, under no. 123; Blunt 1976, pp.30f; Davies/Blunt 1962, p.217; F.A.Q.R. ii, p.180; F/B, II, nos. 150–51; Freedberg 1994, p.66; Paris 1994, no. 88; R/P, no. 138; Wild 1980, II, under nos. 82, 92

76 *Cupid on horseback*

Slight graphite underdrawing, pen and brown ink, brown wash
Laid down
6 ¹⁄₁₆″ × 5 ¹³⁄₁₆″ (154 × 147 mm)
Watermark visible in raking light: cross on hills in circle
Provenance: Massimi vol., no. 7 ("Amore in piedi sopra un Cavallo corridore")
RL 11967

77 *Cupid on horseback*

Graphite underdrawing, pen and brown ink, brown wash
Laid down
4 ⅝″ × 4 ⅝″ (117 × 118 mm)
Provenance: Massimi vol., no. 8 ("Segue l'istesso Emblema")
RL 11968

These two drawings were preparatory for an engraving in the 1640 edition of Francesco Barberino's fourteenth-century *Documenti d'Amore*, and are based on an illustration in a manuscript of that poem. The engraving is inscribed *C. Massimi fec.*, but these drawings are perfectly consistent with Poussin's style in the late thirties (*pace* R/P). It is known that Poussin gave drawing lessons to Massimi –

probably in the 1630s, when he was in his teens – and it thus appears that Poussin helped Massimi with what the inscription claimed was his own design. Vitzthum published a much weaker drawing in the Uffizi for the same engraving, showing an infant Cupid on a foreshortened rearing horse; this is probably Massimi's initial design for the engraving, which Poussin "corrected" by providing a drawing for the Cupid and horse more in keeping with the period of the poem.

References: Blunt 1945, nos. 212, 212a; Blunt 1971, p.215; Blunt 1976, pp.20f; Davies/Blunt 1962, pp.216f; F.A.Q.R. i, p.269; F/B, II, nos. 153, A41, V, p.101; Freedberg 1994, p.66; Friedlaender 1929, p.253; R/P, nos. R1314, R1315; Vitzthum 1962; Wild 1980, II, no. 91

78 *Sarcophagus relief: The Seven against Thebes*

Graphite underdrawing, pen and brown ink, brown wash
Inscribed at lower right: *267*
Laid down
3 ¾″ × 19 ½″ (96 × 496 mm), on two sheets of paper
Provenance: Vol. II, p.35
RL 11880

This drawing is a copy after a sarcophagus in the Villa Pamphili, Rome. Another drawing of the same relief in the British Museum (Franks vol. I, no. 30) is significantly different in its details, and it is not possible to conclude that either drawing was copied from the other. It was catalogued by Blunt in 1945 as by the "studio" of Poussin, but later he came to accept it as autograph. Rosenberg and Prat now reject the sheet, but it is so close in handling to drawings of ca. 1644–45 (e.g. cats. 55 and 57) that it must be an original of about this date.

Like cat. 72, this drawing bears a Cassiano dal Pozzo number and comes from Vol. II. The fact that Cassiano did not mount it with the mass of similar copies after reliefs in his *Bassi Rilievi Antichi* volumes (also now at Windsor) suggests that he regarded the drawing as distinct from the Paper Museum – implying first that the drawing is indeed by

Poussin, and secondly that Poussin did not routinely provide drawings for the Paper Museum.

References: Blunt 1945, no. 263; Blunt 1971, p.216; Blunt 1979, pp.128, 196; F/B, V, no. 302a; R/P, no. R1300; Vermeule 1978, p.374

Drawings by Poussin's Studio in Paris 1640–1642

A1 *The Institution of the Eucharist*

Buff paper, stylus and graphite outlines, pen and brown ink, brown wash, black chalk
Laid down
21 ⅞" × 15 ¹³⁄₁₆" (556 × 402 mm)
Provenance: Vol. II, p.9
RL 11876

A large and carefully finished drawing, agreeing in all details, for the large altarpiece of 1641 for a chapel in the château of St-Germain-en-Laye, now in the Louvre. Probably by Jean Lemaire, Poussin's principal assistant in Paris.

References: Blunt 1945, no. 247; Blunt 1966, under no. 78; Blunt 1979, p.157; F/B, I, p.49; R/P, no. A87

A2 *Moses and the Burning Bush*

Black chalk compass lines and slight underdrawing, pen and brown ink, pale brown wash
Laid down
Oval, 10 ¹⁄₁₆" × 8 ⁹⁄₁₆" (256 × 218 mm)
Provenance: Massimi vol., no. 49 ("Mose nel rovo")
RL 11907

For the painting executed in 1641 for Richelieu (Copenhagen). Feeble, and perhaps a copy of a preparatory drawing rather than a true studio work.

References: Blunt 1945, no. 246; Blunt 1966, under no. 18; Blunt 1976, p.29; Blunt 1979, p.157; F.A.Q.R. ii, p.178; F/B, I, no. A4; Friedlaender 1929, p.256; R/P, no. A88

A3 *The infant Hercules killing the serpents sent by Juno*

Cream paper, graphite underdrawing, pen and brown ink, pale brown wash, discolored white heightening, squared in graphite
Laid down
6 ⅜" × 17" (162 × 432 mm)
Provenance: Vol. II, p.36
RL 11970

References: Blunt 1945, no. 252; F/B, IV, no. A75; R/P, no. A5

A4 *Hermes, Apollo and Iris*

Cream paper, graphite underdrawing, pen and brown ink, pale brown wash, discolored white heightening, squared in graphite
Laid down
Circular, diameter 10 ¹⁵⁄₁₆" (278 mm)
Provenance: Vol. II, p.32
RL 11969

References: Blunt 1945, no. 253; F/B, IV, no. A72; R/P, no. A2

A5 *Hercules killing the centaurs*

Green-blue paper, graphite underdrawing, pen and brown ink, pale brown wash, black chalk, white heightening, squared in graphite
Inscribed at lower center: *n. Poussin*
Laid down
Circular, diameter 10 ⁵⁄₁₆" (262 mm)
Provenance: Vol. II, p.30
RL 11973

References: Blunt 1945, no. 254; F/B, IV, no. A92; R/P, no. A42

A6 *Hercules and the Erymanthean boar*

Reproduced on pp.145,151
Green-blue paper, graphite underdrawing, pen and brown ink, pale brown wash, black chalk, white heightening, squared in graphite
Laid down
8 ⁹⁄₁₆" × 8 ⁹⁄₁₆" (218 × 218 mm)
Provenance: Vol. II, p.31
RL 11972

References: Blunt 1945, no. 255; F/B, IV, no. A93; R/P, no. A43

A7 *Hercules supporting the world*

Graphite underdrawing, pen and brown ink, gray-brown wash
Laid down
9 ⁵⁄₁₆" × 7 ⅛" (236 × 181 mm)
Provenance: Vol. II, p.33b
RL 11971

References: Blunt 1945, no. 256; F/B, IV, no. A110; R/P, no. A72

Cats. A3–A7 are workshop drawings for the decoration of the Grande Galerie of the Louvre (see cat. 50). A5 and A6 are probably by Jean Lemaire; A3 and A4 are in a different technique and thus hard to judge, but may also be by Lemaire.

A8 *Virgil crowned by Apollo*

Green-blue paper, graphite outlines, pen and brown ink, brown and gray washes
Laid down
14 ¹³⁄₁₆" × 9 ⁷⁄₁₆" (377 × 240 mm)
Provenance: Vol. II, p.11
RL 11948

Poussin designed the frontispiece, engraved by Claude Mellan, for an edition of Virgil published by the newly founded Imprimerie Royale in 1641. The meticulous graphite outlines here are presumably traced from an original by Poussin, but the handling of pen and wash is too stilted to be by him, and the drawing must be a studio replica, probably by Lemaire. On 10 April 1641 Poussin sent drawings of the design to Sublet and to Chantelou (Jouanny 1911, pp.53, 55); the present sheet comes from the collection of Cassiano dal Pozzo and may well be a third version.

References: Bellori 1672, p.430; Blunt 1945, no. 248; Blunt 1979, p.157; F.A.Q.R. iii, p.110; F/B, II, no. A42; R/P, no. A84; Wild 1980, II, no. 97

A9 *A Muse placing a satyr mask on Horace*

Graphite outlines, black chalk
Inscribed at lower center: *N. poussin faciebat.*
Laid down
14 ¹¹⁄₁₆" × 9 ¹⁄₁₆" (373 × 230 mm)
Provenance: Vol. II, p.12
RL 11949

Another design for a frontispiece to be engraved by Mellan, for an edition of Horace published by the Imprimerie Royale in 1642; Poussin referred to a drawing of the design in a letter of 20 March 1642 (Jouanny 1911, p.121). The black chalk is of high quality and unlike any of the other studio works from the Paris years, but as the underlying graphite outlines are of the same character as those of cat. A8, the drawing is presumably a studio work, probably by Lemaire, over a tracing from the original.

References: Bellori 1672, p.430; Blunt 1945, no. 249; Blunt 1979, p.197; F.A.Q.R. iii, p.110; F/B, II, no. A43, V, p.101; Kamenskaya 1967, pp.392f; R/P, no. A85; Wild 1980, II, no. 104

A10 *Nymphs presenting lemons to a river-god*

Blue-green paper, graphite outlines, pen and brown ink, brown wash, discolored white heightening
Inscribed at lower right: *nico. Poussin. Inu*
Laid down
12″ × 8 5/16″ (305 × 212 mm)
Provenance: Vol. II, p.23
RL 11950

A studio replica of a design by Poussin for an illustration, engraved by Cornelius Bloemart, in G.B. Ferrari's *Hesperides sive de Malorum aureorum cultura et usa,* published in Rome in 1646. Two further versions of this design, including a probable original, are in the Louvre (F/B, nos. 431, A44; R/P, nos. 225, R740; a sheet in the Hermitage seems to be a copy rather than a true studio work). Thuillier (1960, p.78) argued that the design must date from before Poussin's journey to Paris, but the technical and stylistic similarities to cats. A1, A5, A6 and A8 suggest that cat. A10 is by a member of Poussin's Parisian studio, almost certainly Jean Lemaire. The *Hesperides* was often mentioned in Poussin's letters of the first half of 1642, and this drawing was presumably produced then.

References: Blunt 1945, no. 250; F/B, II, no. A45, V, p.102; Kamenskaya 1967, pp.393f; Paris 1994, under no. 105; R/P, no. R1312 and under no. 225; Wild 1980, II, no. 93

Copies after Poussin

C1 *God the Father supported by cherubs*

Pen and brown ink
Verso: a reclining figure and architectural elements (?)
Red chalk
Oval, 7 1/4″ × 4 5/16″ (184 × 109 mm)
Watermark: six-pointed star in a circle
Provenance: Massimi vol., no. 2 ("Il Padre Eterno sostenuto dalli Angeli")
RL O750

The facile handling argues against this drawing being an original, although it comes from the Massimi volume and is stylistically very close to Poussin's work of the mid-late 1620s. The way in which the elaborate pen-work stops abruptly at the edges of the figure group strongly suggests that it is a copy, perhaps of a preparatory drawing by Poussin for an *Annunciation, Creation of the world, Moses and the Burning Bush* or *Rebuke of Adam and Eve* (see Domenichino's contemporary renderings of this scene). The fragmentary verso is impossible to decipher with certainty.

References: Blunt 1945, no. 184; Blunt 1976, p.19; F.A.Q.R. i, p.268; F/B, I, p.3, V, nos. 380 (verso), 383 (recto); Friedlaender 1929, p.253; Oberhuber 1988, no. D154; R/P, no. R1290; Wild 1980, I, p.195

C2 *St Catherine disputing with the Elders (?)*

Pen and brown ink
Verso: the head of a satyr, and various inscriptions
Red chalk, and pen and ink
5 7/8″ × 9 3/4″ (149 × 247 mm)
No watermark
Provenance: see below
RL O46

This drawing was catalogued by Popham as anonymous Italian, before 1540, but it is stylistically identical to cat. C1 and is probably a copy by the same hand of a lost drawing by Poussin from the 1620s. As it stands the composition makes little narrative sense, and the original was probably itself a partial copy by Poussin of an earlier model. This could well be the otherwise unidentified drawing listed in Inventory A as *A sketch of two Groupes, which have no relation to each other as an Historical subject,* in Vol. II, p.16.

References: Popham 1949, no. 1195; R/P, no. R1288

C3 *Venus and Mars*

Graphite underdrawing, pen and brown ink, brown wash
Laid down
8 5/8″ × 10 11/16″ (211 × 272 mm)
Provenance: Massimi vol., no. 47 ("Venere e Marte")
RL 11975

Catalogued tentatively by Blunt (1945) as by Poussin, this lifeless drawing is a painstaking copy of an original that came on to the art market in 1948 (now in the Louvre; F/B, no. 206; R/P, no. 35), a study for the painting of the late 1620s in the Museum of Fine Arts, Boston, though with many differences.

References: Blunt 1945, no. 175; Blunt 1971, p.215; Blunt 1966, under no. 183; Blunt 1976, p.27; Blunt 1979, pp.180f; F.A.Q.R. i, p.177; F/B, III, no. A50; Friedlaender 1929, p.256; Friedlaender 1942, p.24; R/P, no. R1317

C4 *Abraham driving out Hagar and Ishmael*

Graphite underdrawing, pen and brown ink, brown wash
Inscribed at lower right: *4*
Laid down
7 5/16″ × 10 1/16″ (185 × 256 mm)
Provenance: Vol. II, p.4
RL 11982

This feeble drawing was cautiously dismissed by Friedlaender, but subsequently accepted by Blunt, and recently by Rosenberg and Prat, as by Poussin. Wild suggested Mellin as the author. The scribbly underdrawing and nervously superficial outlines are not those of Poussin, and the drawing is probably a copy of a lost original of the late 1620s, perhaps by the same hand as the *Venus and Mars* (cat. C3).

References: Blunt 1945, no. 171; Blunt 1979, p.194; F/B, I, no. B3, V, pp.63f; R/P, no. 20; Wild 1967, p.36

C5 *Perseus and Andromeda: The origin of coral*

Reproduced on p.51
Black chalk underdrawing, pen and brown ink, brown wash
Verso: blank
13 13/16″ × 20 1/4″ (351 × 515 mm)
Watermark: kneeling saint in shield
Provenance: presumably Vol. II, p.19 or p.20
RL 11879

See cats. 19 and 20.

References: Bellori 1672, p.443; Blunt 1945, no. 225; Cropper 1988, p.962; F/B, III, no. A66, V, p.113; Oberhuber 1988, no. D191; Oxford 1990, no. 19; R/P, no. R1299; other references as for cat. 19

C6 *The realm of Flora*

Reproduced on p.59
Black chalk underdrawing, pen and brown ink, brown wash
Laid down
13 3/4″ × 18 3/4″ (349 × 476 mm)
Provenance: presumably Vol. II, p.19 or p.20
RL 11878

See cats. 19 and 20.

References: Bellori 1672, pp.441f; Blunt 1945, no. 223; Blunt 1966, under no. 155; Blunt 1967, p.118; Cropper 1988, p.962; F/B, III, no. A58; Oberhuber 1988, no. D189; R/P, no. R1298; other references as for cat. 20

C7 *Venus and Adonis hunting: The coloring of the rose*

Black chalk underdrawing, pen and brown ink, brown wash
Laid down
13 3/4″ × 19 13/16″ (350 × 503 mm)
Provenance: Vol. II, p.18
RL 11877

See cats. 19 and 20. The drawing depicts Venus pricking her foot on the thorn of a rose while out hunting; her blood dyed the rose red.

References: Bellori 1672, p.443; Blunt 1945, no. 224; Blunt 1966, under nos. 163, L73; Blunt 1967, p.118; Cropper 1988, p.962; F/B, III, no. A51; Friedlaender 1929, p.255; Oberhuber 1988, no. D192; R/P, no. R1297; Spear 1965; Thuillier 1969, p.105; Wild 1980, II, under no. 36

C8 Designs for plates to Leonardo's *Trattato*

Two reproduced on p.89
Pen and brown ink, blue-gray wash
Laid down
Heights from 4 3/8″ (111 mm) to 6 1/4″ (159 mm); widths from 2″ (51 mm) to 8 3/16″ (208 mm)
Provenance unknown
RL 11951–11966

These sixteen drawings are copies of designs provided by Poussin to be engraved as illustrations to an edition of Leonardo da Vinci's *Trattato della pittura* (see cat. 31). The figures are identical in size to the originals in the Biblioteca Ambrosiana in Milan, and must have been produced by some transfer method. The Windsor series is the only one of the several surviving sets of copies independent of a manuscript.

References: Blunt 1945, nos. 230–45; Blunt 1971, p.216; Blunt 1979, pp.18, 159, 192; F/B, IV, pp.26–33; R/P, no. R1313 and under no. 129; Steinitz 1953

C9 *Rinaldo and Armida*
Black chalk underdrawing, pen and brown ink, brown wash
Laid down
9 ¹³⁄₁₆″ × 14 ⁷⁄₁₆″ (250 × 367 mm)
Provenance: Massimi vol., no. 71 ("Rinaldo et Armida")
RL 11976

See cat. 70. What was almost certainly this sheet was described by Bellori, without stating whether he was discussing a drawing or a painting (see cat. 20). Rosenberg and Prat tentatively suggested that this copy might have been retouched by Poussin, but there is no evidence that two hands were responsible for the drawing.

References: Bellori 1672, p.447; Blunt 1945, no. 226; Blunt 1966, under no. 204; Blunt 1976, p.31; Blunt 1979, p.156; F.A.Q.R. ii, pp.180f; F/B, II, no. A39; Friedlaender 1929, p.258; Mérot 1990, under no. 194; R/P, no. R1318; Thuillier 1969, pp.114f; Thuillier 1974, under no. 97; Thuillier 1994, under no. 98; Wild 1980, II, under no. 77

C10 *Alpheus and Arethusa*
Slight black chalk underdrawing, pen and brown ink, brown wash
Laid down
12″ × 8 ¾″ (305 × 222 mm)
Provenance: Massimi vol., no. 25 ("Alfeo et Aretusa")
RL 11977

The river-god Alpheus fell in love with the nymph Arethusa as she bathed in his waters. He pursued her, but she was rescued by Diana who enveloped her in a cloud and transformed her into a stream (Ovid, *Metamorphoses*, V, 572ff). This labored drawing was thought by Friedlaender (1929) first to be one of the Marino drawings, then (in F/B) to be a copy of a drawing of the late 1620s; but the figure types, swinging draperies and saucer eyes have much in common with drawings such as *Medea* (cat. 62) and, if the copy is faithful, the original was more probably a work of the years around 1650.

References: Bardon 1960, p.130; Blunt 1945, no. 265; Blunt 1976, p.25; Blunt 1979, p.159; Costello 1955, pp.296, 307; F.A.Q.R. i, p.272; F/B, III, no. A55; Friedlaender 1929, p.254; R/P, nos. R1319 and under R948

C11 *Christ healing the blind*
Reproduced on p.184
Slight black chalk (?) underdrawing, pen and brown ink, pale brown wash
Laid down
5 ¹¹⁄₁₆″ × 7 ⁵⁄₁₆″ (144 × 186 mm)
Provenance: Vol. II, p.5a
RL 11900

A feeble partial copy of a lost drawing by Poussin for the 1650 *Christ healing the blind*: see cats. 63–64.

C12 *Christ healing the blind*
Reproduced on p.184
Pen and brown ink, brown wash
Laid down
5 ⁵⁄₁₆″ × 6 ¾″ (135 × 171 mm)
Provenance: Massimi vol., no. 58 ("Il Cieco illuminato")
RL 11901

This drawing is close to cats. 73–74 and was accepted as authentic in R/P. But the painstaking, unbroken outlines and rubbery modeling suggest rather that it is a good copy of a lost study for *Christ healing the blind*: see cats. 63–64.

References: Badt 1969, p.238; Blunt 1945, no. 267; Blunt 1966, under no. 74; Blunt 1976, p.29; F.A.Q.R. ii, p.179; F/B, I, no. A11; Friedlaender 1929, p.257; R/P, no. 69

C13 *Portrait of Poussin*
Red chalk, lightly squared
Laid down
8 ⅞″ × 10 ⁹⁄₁₆″ (225 × 268 mm)
Provenance: Massimi vol., no. 1 ("Ritratto di Nicolo Pussino")
RL 11993

A workmanlike copy of the Louvre self-portrait, no doubt made specifically as a frontispiece for the Massimi volume.

References: Blunt 1945, no. 279; Blunt 1966, under no. 2; Blunt 1976, pp.19f; F.A.Q.R. i, p.268; Friedlaender 1929, p. 253; R/P, no. R1323

C14 *Landscape with a woman washing her feet*
Pen and brown ink, gray wash, stained by damp
Laid down
10 ½″ × 16 ⁹⁄₁₆″ (266 × 420 mm)
Provenance unknown
RL 5723

A weak copy after the painting in Ottawa.

References: Blunt 1945, no. 281; Blunt 1966, under no. 212; F/B, IV, p.54; R/P, no. R1292

C15 *Two heads*
Graphite
Laid down
3 ⁹⁄₁₆″ × 5 ⁹⁄₁₆″ (90 × 141 mm)
Provenance unknown (Vol. II, p.27/29?)
RL 11930

C16 *Two heads*
Graphite
Laid down
3 ⅛″ × 5 ¼″ (79 × 133 mm)
Provenance unknown (Vol. II, p.27/29?)
RL 11932

Copies of four heads in Poussin's *Christ and the woman taken in adultery* (Louvre), possibly from preparatory drawings for that painting.

References: Blunt 1945, nos. 282, 283; F/B, V, p.78; R/P, nos. R1309, R1311; Wild 1980, II, under no. 177

C17 *Studies of heads*
Graphite
Laid down
3 ⁷⁄₁₆″ × 8 ¹⁄₁₆″ (87 × 205 mm)
Provenance: Massimi vol., no. 56 ("Ritratti di Filosofi, Oratori, e Poeti")
RL 11931

These heads may be copies from studies by Poussin, but no particularly close correspondences can be found. Marinella's title for this sheet in the Massimi catalogue seems to be an over-interpretation. The handling of the graphite is rather amateurish, and it is not impossible that the drawing is by Massimi himself.

References: Blunt 1945, no. 284; Blunt 1976, p.29; F.A.Q.R. ii, p.179; F/B, V, p.62; Friedlaender 1929, p.257; R/P, no. 1310

Drawings not by Poussin or his Studio

R1 *Landscape*
Buff paper, pen and brown ink, brown wash
Inscribed at lower left: *G.P.*
Verso: blank
10 ³⁄₁₆″ × 14 ⅝″ (258 × 372 mm)
Watermark: anchor flanked by letters M L, in circle, surmounted by star
Provenance unknown
RL 6140

Hesitantly attributed to Poussin by Blunt (1945), the old attribution to Gaspard Dughet was reaffirmed by Shearman in F/B, IV.

References: Blunt 1944, p.155; Blunt 1945, no. 222; Chiarini 1965, p.73; F/B, IV, no. G42, V, p.124; London 1949, no. 399; R/P, no. R1293

R2 *Italian farm buildings*
Black chalk underdrawing, pen and brown ink
Laid down
10 ⁹⁄₁₆″ × 12 ¼″ (268 × 311 mm)
Provenance unknown
RL 6141

Blunt suggested that this unusual drawing was the work of a French imitator of Poussin working in Italy in the late 1640s or early 1650s.

References: Blunt 1945, no. 274; F/B, IV, no. B41; London 1949, no. 521; R/P, no. R1294

R3 *The* Arcus Argentariorum
Black chalk underdrawing, pen and brown ink, rich brown wash
Verso: sketch of two figures
Red chalk
14 ⅛″ × 10 ¹³⁄₁₆″ (359 × 275 mm)
No watermark
Provenance: Cassiano dal Pozzo (not Vol. II)
RL 8237

From one of the Cassiano dal Pozzo *Bassi Rilievi Antichi* volumes at Windsor. The drawing was first attributed to Poussin by Blunt, who noted that the two large outline figures on the verso are in the pose of Crocus and Smilax in Poussin's composition of the

Realm of Flora (see cats. 20 and C6). This attribution has recently been disputed by Turner, who rightly stated that the faint red chalk drawing on the verso is unconvincing as a preparatory study for the *Realm of Flora*; he proposed instead Pietro Testa as the author of both sides of the sheet, suggesting that the verso is a copy after Poussin.

The drawing on the recto is in fact strikingly similar in style to cat. R4, by Domenichino, and Poussin was stated to have drawn in Domenichino's studio in the 1620s, which might be a starting point in explaining the figures on the verso; but to suggest that Domenichino provided drawings for Cassiano's Paper Museum would be to open a scholarly can of worms, and I make the observation without offering any conclusions.

References: Blunt 1967, pp.280, 283; Blunt 1971, French no. 20; Blunt 1979, pp.141f, 148; F/B, V, nos. 292 (recto), 441 (verso); Turner 1992, p.143; London 1993, pp.31f, no. 80; R/P, no. R1295; Vermeule 1978, p.373; Wild 1980, I, p.191

R4 Studies for a decorated ceiling (recto/verso)

Red chalk underdrawing, pen and brown ink, rich brown wash
10 ½″ × 7 ¹⁵⁄₁₆″ (266 × 201 mm)
No watermark
Provenance: now in an eighteenth-century album entitled *Architectural Ornaments*. Formerly in the Domenichino albums?
RL 10934

This double-sided sheet of studies by Domenichino, for the decoration of the vault of Sant'Andrea della Valle in Rome, was claimed instead by Oberhuber to be a copy by Poussin of drawings by Domenichino, thus showing how close Poussin's drawing style was to that of Domenichino in the mid-1620s. This is unarguable.

References: Blunt 1971, no. 160; Cropper 1988, p.961; Oberhuber 1988, pp.108f, no. D109; R/P, no. R1296

R5 *Roman relief*

Pen and brown-black ink, gray wash
Inscribed at lower right: *164*
Laid down (R/P claim erroneously that there is a drawing in black chalk visible on the verso)
8 ¹⁄₁₆″ × 18 ¹⁄₁₆″ (205 × 458 mm)
Provenance: Cassiano dal Pozzo (but apparently not Vol. II)
RL 11881

After a relief formerly in the Villa Medici and now in the Uffizi. The inscribed number indicates that it came from Cassiano's Paper Museum, the bulk of which is now also at Windsor. Not by Poussin nor in his style, it is a mystery how this drawing ever came to be associated with his name.

References: Blunt 1945, no. 271; R/P, no. R1301

R6 *The Virgin and her companions*

Stylus lines, slight black chalk underdrawing, pen and brown ink, rich brown wash
Verso: the beginnings of an underdrawing for the head and right arm of the Virgin
Black chalk
6 ¾″ × 10 ¼″ (171 × 260 mm)
No watermark
Provenance unknown
RL 11883

Having dismissed this drawing in 1945 as a free version of Guido Reni's painting of the subject, by an Italian imitator of Poussin, Blunt (in F/B, V) subsequently accepted the drawing as autograph. While the technique is familiar from Poussin's drawings, the style is not his. R/P plausibly suggest an attribution to Reni himself.

References: Blunt 1945, no. 272; Cropper 1975, p.284; F/B, V, no. 404; Friedlaender 1929, pp.127, 257 (confusing this sheet with cat. 66); R/P, no. R1302; Wild 1980, I, p.196

R7 *Coriolanus*

Graphite underdrawing, pen and brown ink, brown wash
Laid down
6 ⅜″ × 9 ⅜″ (162 × 238 mm)
Provenance: Vol. III, p.2
RL 11891

Blunt suggested that the drawing might be a copy after a lost study for the painting at Les Andelys, and even that the underdrawing might be by Poussin himself. The composition is clearly based on Poussin's painting, but the style is quite unlike his and seems to be that of an artist close to Mola.

References: Blunt 1945, no. 280; F/B, II, no. A31; Blunt 1966, under no. 147; R/P, no. R1303; Wild 1980, II, under no. 152

R8 *Heads of children*

Pen and brown ink
Laid down
3 ⅝″ × 5 ⅞″ (92 × 150 mm)
Provenance: Massimi vol., no. 55 ("Ritratti")
RL 11928

The Massimi catalogue states that these are portraits of the children of Carlo Antonio dal Pozzo, Cassiano's brother, but they can hardly be considered portraits at all; they seem to be almost caricatures of Poussin's expressive heads from the latter part of his career, by an imitator of his pen style.

References: Blunt 1945, no. 277; Blunt 1976, p.29; F.A.Q.R. ii, p.179; F/B, V, p.62; Friedlaender 1929, p.257; R/P, no. R1307

R9 *Two heads and a foot*

Black chalk
Laid down
3 ¾″ × 5 ¹⁄₁₆″ (95 × 128 mm)
Provenance: Vol. II, p.22
RL 11929

By a contemporary of Poussin, but otherwise unconnected with him.

References: Blunt 1945, no. 276; F/B, V, p.62; R/P, no. R1308

R10 *Scene at an altar to Priapus*

Slight black chalk (?) underdrawing, pen and brown ink, yellow-brown wash
Laid down
8″ × 10 ⅞″ (203 × 276 mm)
Provenance: Massimi vol., no.15 ("Sacrificio di Priapo")
RL 11974

This drawing purports to depict a fragment of a relief, but is probably an imaginative pastiche. In places it is close to Poussin's manner, but it has many weaknesses and, despite Blunt's final acceptance of the sheet as autograph, it must be the work of an efficient imitator.

References: Blunt 1945, no. 268; Blunt 1967, p.141; Blunt 1976, p.22; Cropper 1988, p.961; F.A.Q.R. i, p.270; F/B, V, no. B57; Friedlaender 1929, p.253; R/P, no. R1316

R11 *A bishop with an acolyte*

Pen and brown ink, yellow-brown wash
Laid down
5 ¹¹⁄₁₆″ × 6 ⅝″ (145 × 168 mm), shaped right side, cut upper left corner
Provenance unknown
RL 11978

Blunt accepted this drawing in F/B, V. Certain details bear a passing resemblance to Poussin's drawings, but the handling is not his and the overall effect is feeble.

References: Blunt 1945, no. 269; F/B, I, no. B6, V, p.69; R/P, no. R1320

R12 *The martyrdom of St Erasmus*

Pen and brown ink, brown and reddish wash, white heightening, squared in red chalk
Laid down
12 ⅝″ × 7 ⅞″ (320 × 200 mm)
Provenance: Vol. II, p.24
RL 11991

Unrelated to Poussin's altarpiece for St Peter's. Blunt (1971) attributed the sheet to Pietro da Cortona, while recording Vitzthum's much more convincing suggestion of Giacinto Gimignani, subsequently accepted by Fischer and Merz.

References: Blunt 1945, no. 275; Blunt 1967, p.86; Blunt 1971, no. 351; F/B, I, p.39; Fischer 1973, no. Z128; Merz 1991, p.340; R/P, no. R1322

R13 *The death of Cato the Younger*

Blue paper, pen and red-brown ink, gray-brown wash, discolored white heightening
Verso: slight sketches of heads
Pen and brown ink
7 ⁹⁄₁₆″ × 11 ⁷⁄₁₆″ (192 × 291 mm), extensively damaged and patched at lower right
No watermark visible
Provenance: Vol. III, p.1
RL 11994

Although the poor condition of this sheet makes a judgement of quality difficult, this seems to be the work of a later, perhaps French, follower of Poussin.

References: Blunt 1945, no. 278; F/B, II, no. B21, V, p.94; R/P, no. R1324

R14 *Landscape with classical buildings*

Graphite underdrawing, pen and brown ink, brown wash
Laid down
9 $^{11}/_{16}$" × 14 $^{7}/_{16}$" (246 × 367 mm)
Provenance unknown
RL 11996

Only generically related to the works of Poussin. Attributed by Shearman (in F/B, IV) to Jan Frans van Bloemen (Orizonte).

References: Blunt 1945, no. 273; F/B, IV, p.59; R/P, no. R1325

R15 *The Creation of the Sun and Moon*

Pale blue paper, pen and brown ink, brown wash, discolored white heightening
Laid down
7 $^{1}/_{16}$" × 7 $^{15}/_{16}$" (180 × 201 mm)
Provenance: Vol. II, p.1a
RL 11998

An unexceptional copy after one of the Loggie scenes in the Vatican by Raphael and his studio. Probably done from an engraving by a Roman follower of Poussin.

References: Blunt 1945, no. 270; F.A.Q.R. iii, p.106; R/P, no. R1326

APPENDIX B

Watermarks

Nearly all the sheets by Poussin at Windsor have now been freed from their old mounts. With the notable exception of the Nivelle watermark (see Clayton 1991), they can tell us little – none can help to date a drawing more precisely than other considerations, and as many of the sheets in other major collections are pasted down, comparisons within Poussin's graphic œuvre are limited. But for future reference it was thought desirable to record the watermarks here.

16

1, 3, 4, 9, 12, 13

25

27

40

56

34

44

58

39

53

60

APPENDIX C

Concordances

1. With RL numbers

O36	66
O37	23
O38	73
O39	74
O46	C2
O698	52
O748	42
O749	26
O750	C1
4877a	65
5723	C14
6140	R1
6141	R2
8237	R3
10934	R4
11876	A1
11877	C7
11878	C6
11879	C5
11880	78
11881	R5
11882	24
11883	55
11884	22
11885	55
11886	51
11887	59
11888	34
11889	47
11890	46
11891	R7
11892	61
11893	62
11894	48
11895	35
11896	45
11897	56
11898	57
11899	58
11900	C11
11901	C12
11902	63
11903	29
11904	30
11905	36
11906	64
11907	A2
11908	60
11909	31
11910	38
11911	33
11912	44
11913	41
11914	28
11915	49
11916	69
11917	43
11919	39
11920	50

11921	75
11922	68
11923	70
11924	71
11925	32
11928	R8
11929	R9
11930	C15
11931	C17
11932	C16
11933	1
11934	8
11935	5
11936	10
11937	4
11938	9
11939	7
11940	6
11941	3
11942	12
11943	13
11944	11
11945	15
11946	14
11947	2
11948	A8
11949	A9
11950	A10
11951–66	C8
11967	76
11968	77
11969	A4
11970	A3
11971	A7
11972	A6
11973	A5
11974	R10
11975	C3
11976	C9
11977	C10
11978	R11
11979	25
11980	16
11981	67
11982	C4
11983	20
11984	19
11985	18
11986	17
11987	27
11988	54
11989	53
11990	21
11991	R12
11992	72
11993	C13
11994	R13
11995	37
11996	R14
11997	40
11998	R15

2. With Blunt 1945

154	1
155	2
156	3
157	4
158	5
159	6
160	7
161	8
162	9
163	15
164	14
165	10
166	12
166	12
167	13
168	11
169	20
170	19
171	C4
172	21
173	17
174	25
175	C3
176	16
177	67
178	18
179	66
180	22
181	24
182	23
183	26
183a	42
184	C1
185	49
186	27
187	28
188	68
189	31
190	41
191	29
192	30
193	34
194	33
195	32
196	40
197	69
198	38
199	36
200	37
201	70
202	71
203	75
204	48
205	45
206	39
207	44
208	43
209	46
210	47
211	51
212	76
212a	77
213	54
214	50
215	56
216	35
217	61
218	59
219	63
220	64
221	65
222	R1
223	C6
224	C7
225	C5
226	C9
227	72
228	73
229	74
230–245	C8
246	A2

247	A1
248	A8
249	A9
250	A10
251	52
252	A3
253	A4
254	A5
255	A6
256	A7
258	53
259	60
260	58
261	57
262	55
263	78
264	62
265	C10
266	C11
267	C12
268	R10
269	R11
270	R15
271	R5
272	R6
273	R14
274	R2
275	R12
276	R9
277	R8
278	R13
279	C13
280	R7
281	C14
282	C15
283	C16
284	C17

3. With Friedlaender/ Blunt

9	55	
11, 12	46	
22	22	
28	59	
30	23	
40	45	
41	43	
42	44	
43	54	
44	50	
56	61	
62	63	
64	40	
85	45	
86	56	
90	48	
107	64	
108, 109	31	
110	11	
111	13	
112	12	
113	10	
116	30	
117	29	
121	47	
122	34	
123	41	
124	39	
126–7	50	
132	35	
143	70	

147, 148	24	
150, 151	75	
153	76	
154	1	
155	9	
156	5	
157	3	
158	7	
159	2	
160	6	
161	4	
162	8	
163	14	
164	15	
181	34	
182	33	
183	21	
185	36	
188	63	
189	36	
192	37	
194	38	
196	25	
200	18	
209	16	
210	49	
211	27	
214	20	
218	44	
220	17	
223	61	
224	19	
227	28	
231	67	
233	68	
239	49	
243	50	
275	32	
292	R3	
301	69	
302a	78	
370	66	
373	39	
374	71	
376	56	
380, 383		C1
387	22	
400	42	
402	65	
403	26	
404	R6	
410, 411		74
441	R3	
A3	47	
A4	A2	
A11	C12	
A12	C11	
A18	60	
A20	57	
A21	58	
A29	53	
A31	R7	
A32	52	
A39	C9	
A41	77	
A42	A8	
A43	A9	
A45	A10	
A50	C3	
A51	C7	
A55	C10	
A58	C6	
A64	62	

A66	C5	149	34	
A68	72	150	33	
A72	A4	152	43	
A75	A3	176	69	
A92	A5	208	72	
A93	A6	214	50	
A110	A7	221	51	
B3	C4	226	53	
B6	R11	252	57	
B18	59	265	58	
B21	R13	271	42	
B22	73	272	64	
B41	R2	273	59	
B57	R10	281	61	
G42	R1	282	62	
		297	55	
		301	47	

4. With Rosenberg/Prat

2	2	A2	A4
4	3	A5	A3
5	9	A42	A5
6	15	A43	A6
7	14	A72	A7
8	4	A84	A8
9	1	A85	A9
10	5	A87	A1
11	8	A88	A2
12	6	A89	52
13	7	R1287	23
14	13	R1288	C2
15	11	R1289	26
16	12	R1290	C1
17	10	R1291	65
20	C4	R1292	C14
22	24	R1293	R1
24	22	R1294	R2
30	20	R1295	R3
36	19	R1296	R4
41	66	R1297	C7
42	18	R1298	C6
50	27	R1299	C5
51	67	R1300	78
54	17	R1301	R5
55	16	R1302	R6
56	49	R1303	R7
57	25	R1304	C11
59	70	R1307	R8
61	21	R1308	R9
63	28	R1310	C17
64	40	R1311	C16
67	73	R1312	A10
68	74	R1313	C8
69	C12	R1314	76
70	71	R1315	77
76	31	R1316	R10
79	30	R1317	C3
80	29	R1318	C9
83	36	R1319	C10
87	63	R1320	R11
94	37	R1321	54
96	38	R1322	R12
100	44	R1323	C12
102	48	R1324	R13
107	45	R1325	R14
108	56	R1326	R15
122	35		
125	41		
128	32		
137	46	**5. With the contents of the Massimi vol.**	
138	75		
139	39	1	C13
143	68	2	C1
		3	2
		4	3

5	17
6	16
7	76
8	77
9	70
10	28
11	49
12	67
13	27
14	9
15	R10
16	18
17	15
18	21
19	38
20	25
21	36
22	37
23	19
24	14
25	C10
26	61
27	44
28	4
29	1
30	5
31	64
32	8
33	6
34	7
35	20
36	*Hercole* – recorded as missing in Inventory A
37	29
38	13
39	11
40	41
41	31
42	12
43	51
44	10
45	39
46	69
47	C3
48	46
49	A2
50	23
51	48
52	blank
53	43
54	54
55	R8
56	C17
57	73 (but see entry for cat. 74)
58	C12
59	40
60	58
61	26
62	blank
63	57
64	blank
65	53
66	32
67	75
68	66
69	blank
70	blank
71	C9
72	blank
73	24

6. With the contents of Vol. II

1a	R15
1b	40 (part)
2	47
3	59
4	C4
5a	C11
5b	55
6	*The Adoration of the Shepherds* From the detailed description in F.A.Q.R. iii, p.108, this can be identified as Popham 1949, no. 1184 (RL O364), by an unidentified North Italian of the sixteenth century and quite unrelated to the works of Poussin
7	56
8a	45
8b	63
9	A1
10	60
11	A8
12	A9
13	22
14	34
15	52
16	C2 (q.v.)
17	33
18	C7
19, 20	No drawing listed in Inventory A, but presumably these pages contained C5 and C6
21	*Two drap'd Figures and two Heads*
22	R9
23	A10
24	R12
25	62
26	*Three small Sketches for different compositions*
27	*Two Heads* (C15/C16?)
28	74 (q.v.)
29	*Heads caricatura* (C15/C16?)
30	A5
31	A6
32	A4
33a	50
33b	A7
34	72
35	78
36	A3
37	*Various Deities &c.*
38	*Vulcan forging the Arms of Achilles or Aeneas*

13 more Drawings on 5 pages, not described (perhaps including 30, 35, 68, 71)

Bibliography

References have only been given to catalogues of Poussin's work and other substantive remarks in the literature; mere mentions in passing are not recorded. Full bibliographies for Poussin have been give elsewhere, most recently in R/P, and the following list therefore includes only those works referred to in the catalogue entries.

Actes 1960 *Actes du Colloque International Nicolas Poussin*, 2 vols, ed. A. Chastel, Paris 1960

Badt 1969 K. Badt, *Die Kunst des Nicolas Poussin*, 2 vols, Cologne 1969

Bardon 1960 H. Bardon, "Poussin et la littérature latine", in *Actes* 1960, I, pp.123–32

Barroera 1979 L. Barroera, "Nuove acquisizioni per la cronologia di Poussin", *Bollettino d'Arte* LXIV (4), 1979, pp.69–74

Bellori 1672 G.P. Bellori, *Le Vite de Pittori, Scultori et Architetti Moderni,* Rome 1672

Bialostocki 1960 J. Bialostocki, "Poussin et le *Traité de la peinture* de Léonard", *Actes* 1960, pp.133–39

Birmingham 1992 *Nicolas Poussin: Tancred & Erminia*, exh. cat. by R. Verdi, Birmingham, Museum & Art Gallery, 1992

Blunt 1944 A. Blunt, "The Heroic and the Ideal Landscape in the Work of Nicolas Poussin", *Journal of the Warburg and Courtauld Institutes* VII, 1944, pp.154–68

Blunt 1945 A. Blunt, *The French Drawings in the Collection of His Majesty The King at Windsor Castle,* London 1945

Blunt 1951 A. Blunt, "Poussin Studies VI: Poussin's decoration of the Long Gallery in the Louvre", *Burlington Magazine* XCIII, 1951, pp.369–76

Blunt 1958 A. Blunt, "Poussin Studies VII: Poussin in Neapolitan and Sicilian Collections", *Burlington Magazine* C, 1958, pp.76–86

Blunt 1959 A. Blunt, "Poussin Studies VIII: A series of anchorite subjects commissioned by Philip IV from Poussin, Claude and others", *Burlington Magazine* CI, 1959, pp.389f

Blunt 1960a A. Blunt, "Poussin et les cérémonies religieuses antiques", *Revue des Arts* X, 1960, pp.56–66

Blunt 1960b A. Blunt, "La première période romaine de Poussin", in *Actes* 1960, I, pp.163–73

Blunt 1960c A. Blunt, "Poussin Studies XI: Some Addenda to the Poussin Number", *Burlington Magazine* CII, 1960, pp.396–403

Blunt 1961 A. Blunt, "A Mythological Painting by Poussin", *Burlington Magazine* CIII, 1961, p.437

Blunt 1965 A. Blunt, "Poussin and His Roman Patrons", in *Walter Friedlaender zum 90. Geburtstag,* Berlin 1965, pp.58–70

Blunt 1966 A. Blunt, *The Paintings of Nicolas Poussin: A Critical Catalogue,* London 1966

Blunt 1967 A. Blunt, *Nicolas Poussin,* 2 vols, London & New York 1967

Blunt 1971 A. Blunt, "Supplements to the Catalogues of Italian and French Drawings", in F. Schilling, *The German Drawings in the Collection of Her Majesty The Queen at Windsor Castle,* London & New York 1971

Blunt 1973 A. Blunt, "Poussin's *Death of Germanicus* Lent to Paris", *Burlington Magazine* CXV, 1973, pp.533f

Blunt 1974 A. Blunt, "The Complete Poussin", *Burlington Magazine* CXVI, 1974, pp.760–63

Blunt 1976 A. Blunt, "The Massimi Collection of Poussin Drawings in the Royal Library at Windsor Castle", *Master Drawings* XIV, 1976, pp.3–31

Blunt 1979a A. Blunt, *The Drawings of Poussin,* New Haven & London 1979

Blunt 1979b A. Blunt, "Further Newly Identified Drawings by Poussin and his Followers", *Master Drawings* XVII, 1979, pp.119–46

Bologna 1962 *L'ideale classico del Seicento in Italia e la pittura di paesaggio,* exh. cat., Bologna, Palazzo del'Archiginnasio, 1962

Borenius 1928 T. Borenius, "An exhibition of Poussin and Claude Drawings", *Old Master Drawings* III, 1928, pp.17–19

Boyer/Volf 1988 J.C. Boyer & I. Volf, "Rome à Paris: les tableaux du maréchal de Créqui (1638)", *Revue de l'Art* LXXIX, 1988, pp.22–41

Bristol 1956 *French XVIIth Century Drawings,* exh. cat., Bristol, Museum & Art Gallery, 1956

Chantilly 1994 *Nicolas Poussin: La collection du musée Condé à Chantilly*, exh. cat. by P. Rosenberg & L.-A. Prat, Chantilly, Musée Condé, 1994

Chiarini 1965 M. Chiarini, review of F/B, IV, in *Paragone* XVI, 1965, pp.66–73

Clayton 1991 M. Clayton, "A Nivelle Watermark on Poussin's Marino Drawings", *Burlington Magazine* CXXXIII, 1991, p.245

Cleveland 1989 *From Fontainebleau to the Louvre: French Drawing of the Seventeenth Century*, exh. cat. by H.T. Goldfarb, Cleveland Museum of Art, 1989

Costello 1947 J. Costello, "The Rape of the Sabine Women by Nicolas Poussin", *Bulletin of the Metropolitan Museum of Art* V, 1947, pp.195–204

Costello 1950 J. Costello, "The Twelve Pictures 'Ordered by Velasquez' and the Trial of Valguarnera", *Journal of the Warburg and Courtauld Institutes* XIII, 1950, pp.237–84

Costello 1955 J. Costello, "Poussin's Drawings for Marino and the New Classicism. I: Ovid's *Metamorphoses*", *Journal of the Warburg and Courtauld Institutes* XVIII, 1955, pp.296–317

Cropper 1988 E. Cropper, review of Oberhuber 1988, in *Burlington Magazine* CXXX, 1988, pp.958–62

Davies/Blunt 1962 M. Davies & A. Blunt, "Some corrections and additions to M. Wildenstein's *Graveurs de Poussin au XVIIe siècle*", *Gazette des Beaux-Arts* LX, 1962(II), pp.205–22

Edinburgh 1947 *The King's Pictures,* exh. cat., Edinburgh, Royal Scottish Academy, 1947

Edinburgh 1981 *Poussin: Sacraments and Bacchanals,* exh. cat. by H. Macandrew & H. Brigstocke, Edinburgh, National Gallery of Scotland, 1981

Edinburgh 1990 *Cézanne and Poussin: The Classical Vision of Landscape,* exh. cat. by R. Verdi, Edinburgh, National Gallery of Scotland, 1990

F.A.Q.R. B. Woodward & H. de Triqueti, "Catalogue of the Drawings of Nicolas Poussin in the Royal Collection, Windsor Castle", *Fine Arts Quarterly Review* I, 1863, pp.263–74; II, 1864, pp.175–80; III, 1864–65, pp.105–11

F/B W. Friedlaender & A. Blunt, *The Drawings of Nicolas Poussin: Catalogue Raisonné,* 5 vols, London 1939–74

Félibien 1725 A. Félibien, *Entretiens sur les vies et sur les ouvrages des plus excellents peintres anciens et modernes,* Trévoux (Paris), 1725

Fischer 1973 U.V. Fischer, *Giacinto Gimignani,* doctoral thesis, Freiburg University 1973

Forte 1983 J.C. Forte, *Political ideology and artistic theory in Poussin's decoration of the Grande Galerie of the Louvre,* doctoral thesis, Columbia University 1983

Freedberg 1994 D. Freedberg, "Poussin et Sienne", in Paris 1994, pp.62–68

Friedlaender 1914 W. Friedlaender, "Nicolas Poussin als Zeichner", *Zeitschrift für bildende Kunst* N.F. XXV, 1914, pp.313–23

Friedlaender 1929 W. Friedlaender, "The Massimi Drawings at Windsor", *Burlington Magazine* LIV, 1929, pp.116–28, 252–58

Friedlaender 1942 W. Friedlaender, "The Northampton *Venus and Adonis* and the Boston *Venus and Mars*", *Gazette des Beaux-Arts* XXII, 1942(VI), p.24

Friedlaender 1966 W. Friedlaender, *Nicolas Poussin: A New Approach,* London 1966

Goldfarb 1990 H.T. Goldfarb, review of Oberhuber 1988, in *Master Drawings* XXVIII, 1990, pp.92–94

Goldstein 1969 C. Goldstein, "A Drawing by Poussin for his *Moses Defending the Daughters of Jethro*", *Bulletin of the Rhode Island School of Design* LV, 1969, pp.3–15

Hamburg 1958 *Französische Zeichnungen von der Anfangen bis zum Ende des 19. Jahrhunderts,* exh. cat., Hamburg, Kunsthalle, and elsewhere, 1958

Hattori 1994 C. Hattori, "Dessins de Poussin nouvellement révélés", *Revue du Louvre* XLIV, 1994, pp.41–44

Henderson 1977 A. Henderson, "Nouvelles recherches sur la décoration de Poussin pour la Grande Galerie", *Revue du Louvre* XXVII, 1977, pp.255–34

Jouanny 1911 C. Jouanny, "Correspondance de Nicolas Poussin", *Archives de l'art français* n.p. v, 1911

Kamenskaya 1967
T. Kamenskaya, "Some unpublished drawings of Poussin and his studio in the Hermitage", *Master Drawings* v, 1967, pp.390–95

Kauffmann 1965
G. Kauffmann, "Poussins *Primavera*", *Walter Friedlaender zum 90. Geburtstag*, Berlin 1965, pp.92–100

Leicester 1952 *Old Master Drawings*, exh. cat., Leicester, Museum & Art Gallery, 1952

London 1932 *Exhibition of French Art*, exh. cat., London, Royal Academy of Arts, 1932

London 1938 *Exhibition of 17th Century Art in Europe*, exh. cat., London, Royal Academy of Arts, 1938

London 1949 *Landscape in French Art*, exh. cat., London, Royal Academy of Arts, 1949

London 1969 *The Art of Claude Lorrain*, exh. cat. by M. Kitson, London, Hayward Gallery, 1969

London 1986 *Master Drawings in the Royal Collection*, exh. cat. by J. Roberts, London, Queen's Gallery, 1986

London 1993 *The Paper Museum of Cassiano dal Pozzo*, exh. cat., London, British Museum, 1993

Mahon 1960 D. Mahon, "Poussin's Early Development: An Alternative Hypothesis", *Burlington Magazine* cii, 1960, pp.288–304

Mahon 1962 D. Mahon, *Poussiniana: Afterthoughts Arising from the Exhibition*, Paris, New York & London 1962 (first published in *Gazette des Beaux-Arts* lx, 1962(II), pp.1–138)

Martin 1965 J.R. Martin, *The Farnese Gallery*, Princeton 1965

McGrath 1978 E. McGrath, "The Painted Decoration of Rubens's House", *Journal of the Warburg and Courtauld Institutes* xli, 1978, pp.245–77

Mérot 1990 A. Mérot, *Poussin*, Paris 1990

Merz 1991 J.M. Merz, *Pietro da Cortona*, Tübingen 1991

Muchall-Viebrook 1925
T. Muchall-Viebrook, "Über eine Zeichnung von Nicolas Poussin", *Münchner Jahrbuch* N.F. ii, 1925, pp.99–102

Newcastle 1952 *Nicolas Poussin: The Seven Sacraments*, exh. cat., Newcastle, Hatton Gallery, 1952

Oberhuber 1988 K. Oberhuber, *Poussin: The Early Years in Rome. The Origins of French Classicism*, New York 1988

Oxford 1990 *A Loan Exhibition of Drawings by Nicolas Poussin from British Collections*, exh. cat. by H. Brigstocke, Oxford, Ashmolean Museum, 1990

Panofsky 1959 E. Panofsky, *A Mythological Painting by Poussin in the National museum Stockholm*, Stockholm 1959

Paris 1960 *Exposition Nicolas Poussin*, exh. cat. by A. Blunt & C. Sterling, Paris, Louvre, 1960

Paris 1973 *La "Mort de Germanicus" de Poussin du musée de Minneapolis*, exh. cat. by P. Rosenberg & N. Butori, Paris, Louvre, 1973

Paris 1983 *Raphael et l'art français*, exh. cat., Paris, Grand Palais, 1983–84

Paris 1994 *Nicolas Poussin 1594–1665*, exh. cat. by P. Rosenberg & L.-A. Prat, Paris, Grand Palais, 1994

Popham 1946 A.E. Popham, review of Blunt 1945, in *Burlington Magazine* lxxxviii, 1946, pp.283f

Popham 1949 A.E. Popham & J. Wilde, *The Italian Drawings of the Fifteenth and Sixteenth Centuries in the Collection of His Majesty The King at Windsor Castle*, London 1949

Posner 1965 D. Posner, "A Poussin-Caravaggio Connection", *Zeitschrift für Kunstgeschicht* xxviii, 1965, pp.130–33

Prosperi Valenti Rodinò 1994 S. Prosperi Valenti Rodinò, "A Double-Sided Sheet by Poussin", *Master Drawings* xxxii, 1994, pp.158–62

Rome 1977 *Nicolas Poussin 1594–1665*, exh. cat., Rome, Villa Medici, 1977

Rosenberg 1991
P. Rosenberg, review of Oxford 1990, in *Burlington Magazine* cxxxiii, 1991, pp.211f

R/P P. Rosenberg & L.-A. Prat, *Nicolas Poussin, 1594–1665. Catalogue raisonné des dessins*, Milan 1994

Salomon 1938 R. Salomon, "An unknown letter of Nicolas Poussin", *Journal of the Warburg Institute* i, 1938, pp.79–82

Sandys 1632 *Ovid's Metamorphosis Englished, Mythologiz'd and Represented in Figures*, trans. G. Sandys, Oxford 1632

Sdunnus 1990 U. Sdunnus, "The Story of Dryope: A Rare Subject from Ovid's *Metamorphoses*", *Journal of the Warburg and Courtauld Institutes* liii, 1990, pp.312–15

Shearman 1960 J. Shearman, "Les dessins de paysages de Poussin", in *Actes* 1960, I, pp.179–88

Simon 1978 R.B. Simon, "Poussin, Marino, and the Interpretation of Mythology", *Art Bulletin* lviii, 1978, pp.56–68

Spear 1965 R.E. Spear, "The Literary Source of Poussin's *Realm of Flora*", *Burlington Magazine* cvii, 1965, pp.563–9

Standring 1985 T.J. Standring, "A lost Poussin work on copper: *The Agony in the Garden*", *Burlington Magazine* cxxvii, 1985, pp.615–17

Steinitz 1953 K.T. Steinitz, "Poussin, illustrator of Leonardo and the problem of replicas in Poussin's studio", *Art Quarterly* xvi, 1953, pp.40–55

Sutherland Harris 1990
A. Sutherland Harris, review of Oberhuber 1988, in *Art Bulletin* lxxii, 1990, pp.144–55

Sutherland Harris 1994
A. Sutherland Harris, "A propos de Nicolas Poussin paysagiste", *Revue du Louvre* xliv, 1994, pp.36–40

Sydney 1988 *A Study in Genius*, exh. cat. by J. Roberts, Sydney, Art Gallery of New South Wales and elsewhere, 1988

Thomas 1986 T. Thomas, "'Un fior vano e fragile': The Symbolism of Poussin's *Realm of Flora*", *Art Bulletin* lxviii, 1986, pp.225–36

Thompson 1980 C. Thompson, *Poussin's Seven Sacraments in Edinburgh (The Seventh W.A. Cargill Memorial Lecture)*, Glasgow 1980

Thuillier 1960 J. Thuillier, "Per un Corpus Poussinianum", in *Actes* 1960, II, pp.49–238

Thuillier 1969 J. Thuillier, *Nicolas Poussin*, Novara 1969

Thuillier 1974 J. Thuillier, *Tout l'œuvre peint de Poussin*, Paris 1974

Thuillier 1978 J. Thuillier, "Propositions pour Charles Errard, peintre", *Revue de l'art* xl–xli, 1978, pp.151–70

Thuillier 1983 J. Thuillier, "Propositions pour Charles-Alphonse Du Fresnoy, peintre", *Revue de l'art* lxi, 1983, pp.29–52

Thuillier 1994 J. Thuillier, *Nicolas Poussin*, Paris 1994

Turner 1992 N. Turner, "The Drawings of Pietro Testa after the Antique in Cassiano dal Pozzo's Paper Museum", in *Quaderni Puteani 3*, Milan 1992, pp.127–44

Van Helsdingen 1971 H.W. van Helsdingen, "Notes on two sketches by Nicolas Poussin for the Long Gallery of the Louvre", *Simiolus* v, 1971, pp.172–84

Vermeule 1978 C.C. Vermeule, review of F/B, V, in *Art Bulletin* lx, 1978, pp.373f

Vitzthum 1962 W. Vitzthum, "Poussin illustrateur des *Documenti d'Amore*", *Art de France* ii, 1962, pp.262–64

Wild 1958 D. Wild, "Les tableaux de Poussin à Chantilly", *Gazette des Beaux-Arts* i, 1958, pp.15–26

Wild 1966 D. Wild, "Nicolas Poussin et la décoration de la Grande Galerie du Louvre", *Revue du Louvre* xvi, 1966, pp.77–84

Wild 1967 D. Wild, "Charles Mellin ou Nicolas Poussin (2)", *Gazette des Beaux-Arts* x, 1967, pp.3–44

Wild 1980 D. Wild, *Nicolas Poussin*, 2 vols, Zurich 1980

Worthern 1979 T. Worthern, "Poussin's Paintings of Flora", *Art Bulletin* lxi, 1979, pp.575–88